NEVER AGAIN, AGAIN, AGAIN...

NEVER AGAIN, AGAIN, AGAIN...

Genocide: Armenia, The Holocaust, Cambodia, Rwanda, Bosnia and Herzegovina, Darfur

LANE H. MONTGOMERY

RUDER FINN PRESS

To the memory of my father
and to my grandsons, Elliot and Coleman,
who will inherit a global world and outer space.
May their legacy be the gift he left,
one of spirituality rather than religiosity and
awareness rather than injustice.

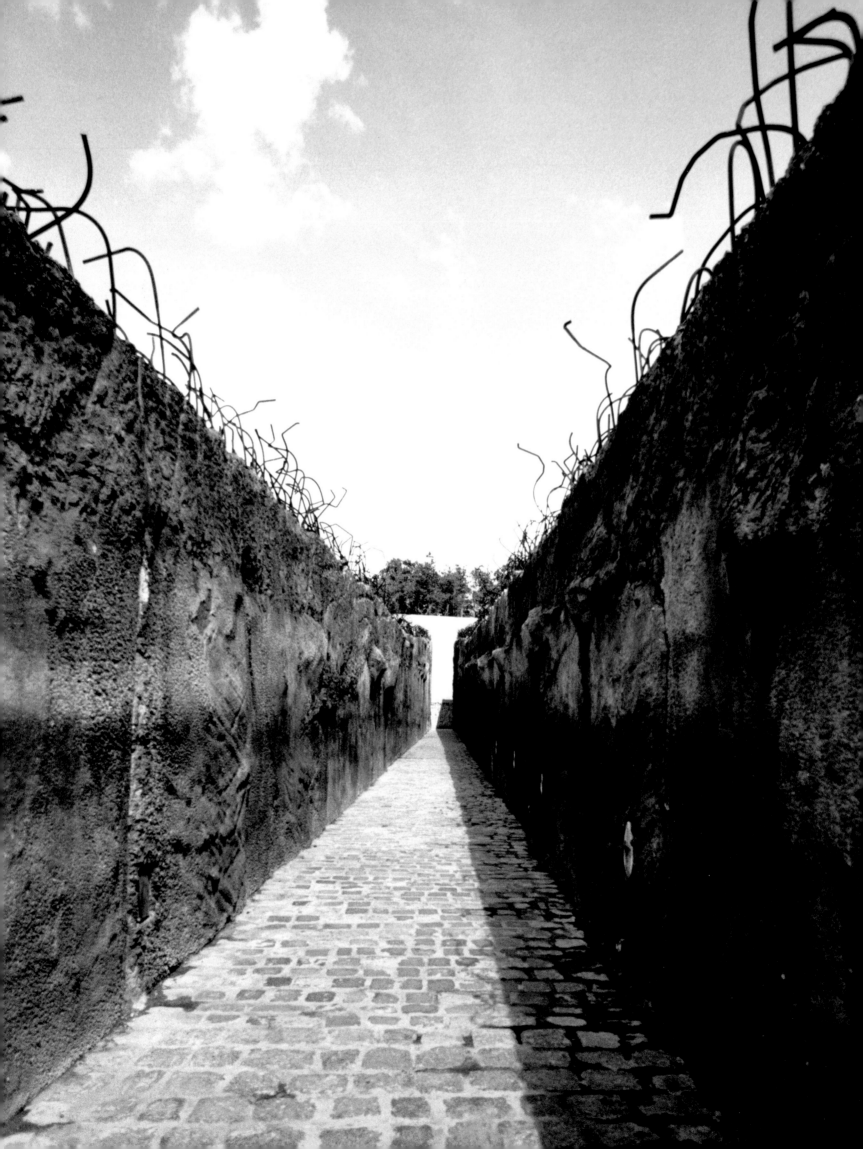

Belzec Holocaust memorial, Poland.

More than 50 million people were systematically murdered in the past 100 years—the century of mass murders. From 1915 to 1923, Ottoman Turks slaughtered up to 1.5 million Armenians. In mid-century, the Nazis liquidated 6 million Jews, 3 million Soviet POWs, 3 million Poles, and 400,000 other "undesirables." Mao Zedong killed 30 million Chinese, and the Soviet government murdered 20 million of its own people. In the 1970s, the communist Khmer Rouge killed 1.7 million of their fellow Cambodians. In the 1980s and the early '90s Saddam Hussein's Bath Party killed 100,000 Kurds. In 1994, Rwanda's Hutus wiped out 800,000 members of the Tutsi minority. Now there is genocide in Sudan's Darfur region.

What is the human flaw that allows genocide to erupt again and again?

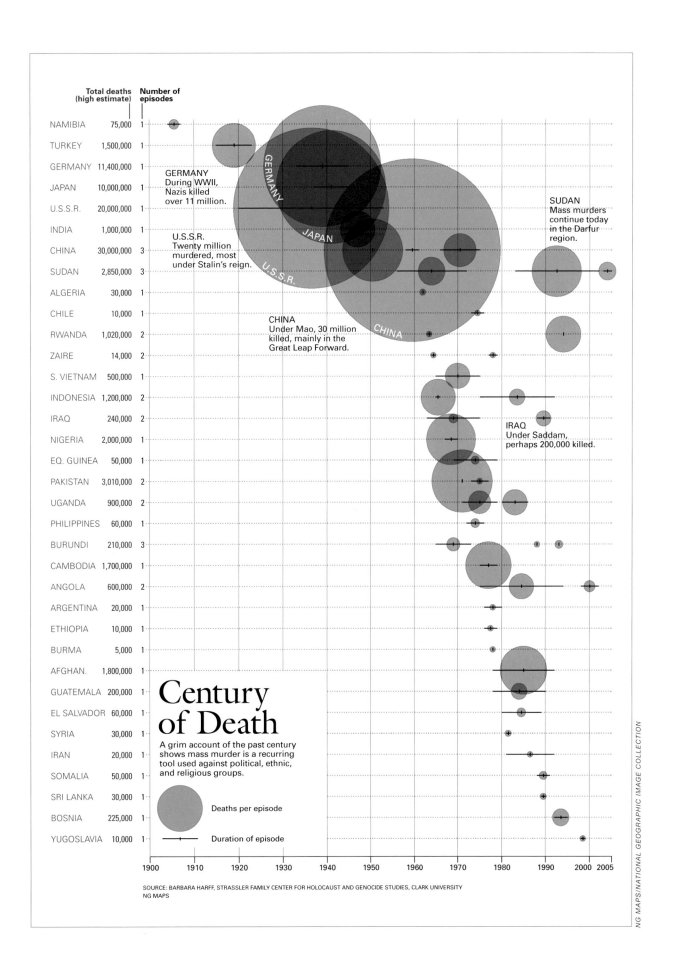

	Total deaths (high estimate)	Number of episodes
NAMIBIA	75,000	1
TURKEY	1,500,000	1
GERMANY	11,400,000	1
JAPAN	10,000,000	1
U.S.S.R.	20,000,000	1
INDIA	1,000,000	1
CHINA	30,000,000	3
SUDAN	2,850,000	3
ALGERIA	30,000	1
CHILE	10,000	1
RWANDA	1,020,000	2
ZAIRE	14,000	2
S. VIETNAM	500,000	1
INDONESIA	1,200,000	2
IRAQ	240,000	2
NIGERIA	2,000,000	1
EQ. GUINEA	50,000	1
PAKISTAN	3,010,000	2
UGANDA	900,000	2
PHILIPPINES	60,000	1
BURUNDI	210,000	3
CAMBODIA	1,700,000	1
ANGOLA	600,000	2
ARGENTINA	20,000	1
ETHIOPIA	10,000	1
BURMA	5,000	1
AFGHAN.	1,800,000	1
GUATEMALA	200,000	1
EL SALVADOR	60,000	1
SYRIA	30,000	1
IRAN	20,000	1
SOMALIA	50,000	1
SRI LANKA	30,000	1
BOSNIA	225,000	1
YUGOSLAVIA	10,000	1

GERMANY
During WWII, Nazis killed over 11 million.

U.S.S.R.
Twenty million murdered, most under Stalin's reign.

CHINA
Under Mao, 30 million killed, mainly in the Great Leap Forward.

SUDAN
Mass murders continue today in the Darfur region.

IRAQ
Under Saddam, perhaps 200,000 killed.

Century of Death

A grim account of the past century shows mass murder is a recurring tool used against political, ethnic, and religious groups.

Deaths per episode

+——+ Duration of episode

1900 1910 1920 1930 1940 1950 1960 1970 1980 1990 2000 2005

SOURCE: BARBARA HARFF, STRASSLER FAMILY CENTER FOR HOLOCAUST AND GENOCIDE STUDIES, CLARK UNIVERSITY
NG MAPS

INTRODUCTION

Lane H. Montgomery

*That men do not learn very much
from the lessons of history
is the most important of all the lessons
that history has to teach.*

—Aldous Huxley

While writing this book, I have had the chance to focus on countries far less fortunate than mine and to have dialogue with people in those countries. My hope is that we can begin to care less about our political biases and more about one another; that we respect and protect the human rights of others no matter what their race or religion for I believe we have arrived at a time and a place that is about the given shortness of our life on this earth—how we treat it and how we leave it.

During my travels for the International Rescue Committee, Americares, and other humanitarian groups in such places as Bosnia, Cambodia, Congo, Ethiopia, Haiti, Kosovo, and Liberia, I have had the privilege of meeting the most dedicated people imaginable—relief workers, doctors, and ordinary men and women trying to help innocent victims of recurring violence.

In 1993, I attended a conference at the Thalia theater in Hamburg, Germany. The conference was called "We Must Never Let It Happen Again." Vanessa Redgrave and

Gunter Grass, author of *The Tin Drum*, were the moderators. In 1999, Gunter Grass was awarded the Nobel Prize for Literature. Seven years later, he revealed the dark secret of his own soul—that he was a Nazi himself. At age 17, Grass volunteered to serve in the elite Nazi branch of the German armed forces, the Waffen SS. From there he witnessed firsthand the Nazi crimes against humanity. Sixty some years later, he has written the truth about his past. Yet, he continues to distance himself by writing about his younger life in the third person, truncating his past from his present. What a difference he might have made if he had found the courage to expose his shame at the conference.

Later, we drove outside Hamburg to the concentration camp, Neuengamme. In the back of the camp, there had been an elementary school, Bullenhauser Damm, where twenty students, ten boys and ten girls ages five to twelve, had been enrolled. They were taken from the camps and used for medical experimentation by SS Doctor Kurt Heissmeyer. Their photographs remained

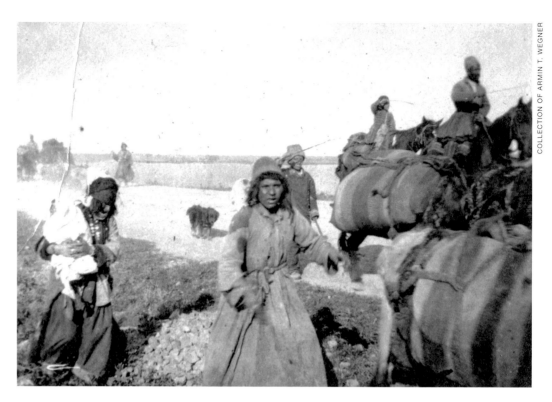

First genocide of the 20th century: Armenian refugees on Igdir road

tacked to a bulletin board, as if they were still in class. In the cellar, we saw where the children had been hanged, two at a time, on April 20, 1945, the day Adolf Hitler celebrated his 56th birthday. Dr. Heissmeyer recalled later that they had hanged them from hooks "just like pictures on the wall" when British troops were only three kilometers from the school.

We stood in the memorial winter rose garden before the spring roses came into bloom. We could not hold back our tears.

The passion and intelligence of the conference attendees, represented by all races, nationalities, and generations, reassured us that our world would never let it happen again. But we did allow it to happen again—and again, and again.

In fact, more genocide has taken place within our lifetime than at any other time in world history, and much of it has happened while we looked on or refused to act.

From 1915 to 1923, Ottoman Turks slaughtered up to 1.5 million Armenians; in mid-century, the Nazis liquidated six million Jews, three million Soviet POWs, two million

> In fact, more genocide has taken place within our lifetime than at any other time in world history, and much of it has happened while we looked on or refused to act.

Poles, and 400,000 other "undesirables;" Mao Zedong killed 30 million Chinese, and Josef Stalin murdered 20 million of his own people. In the 1970s, the communist Khmer Rouge, led by the Sorbonne student, Pol Pot, killed

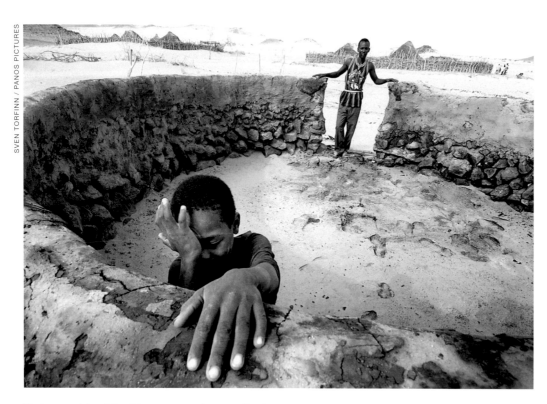

SVEN TORFINN / PANOS PICTURES

First genocide of the 21st century: A young Darfurian boy looks over the remains of his home.

1.7 million of their fellow Cambodians. In the 1980s and early '90s, Saddam Hussein's Bath Party killed 100,000 Kurds. Rwanda's Hutu-led military wiped out 800,000 members of the Tutsi minority in 1994. In the Bosnian village of Srebenicia, the Serbs massacred 7,000 sons and husbands, overnight. And now in Darfur we are witnessing yet another genocide. The atrocities of the *janjaweed* have turned it into a cauldron of evil. While the killing in Darfur goes on, the nation's capital, Khartoum, only 600 miles away—the distance from New York to the Carolinas—has become a tourist destination of condominiums, internet cafes, and skyscrapers.

In the recent past, I attended a Seeds of Peace dinner where Christianne Amanpour, in accepting an award, spoke about how she got her start as a journalist in Bosnia. She described a scene in Sarajevo that was still etched in her mind. During some of the city's heaviest shelling, she watched a little Bosnian girl and Serbian boy act out the reality of their daily lives in the form of play. The little boy was pretending to be a casualty and the girl was pretending to be a nurse. She was binding her friend's make-believe wounds with bandages. In that alley of sniper hell, there was still some innocence.

When asked how she bears up under the evil that she sees and reports, Christianne Amanpour spoke softly: "I care."

We must all care.

Nobel Peace Prize laureate Elie Wiesel's ability to discuss life at its darkest with the apparent ease that most of us bring to every-day conversation can also be daunting. Says Wiesel, "Only human beings can move me to despair; but only human beings can remove me from despair."

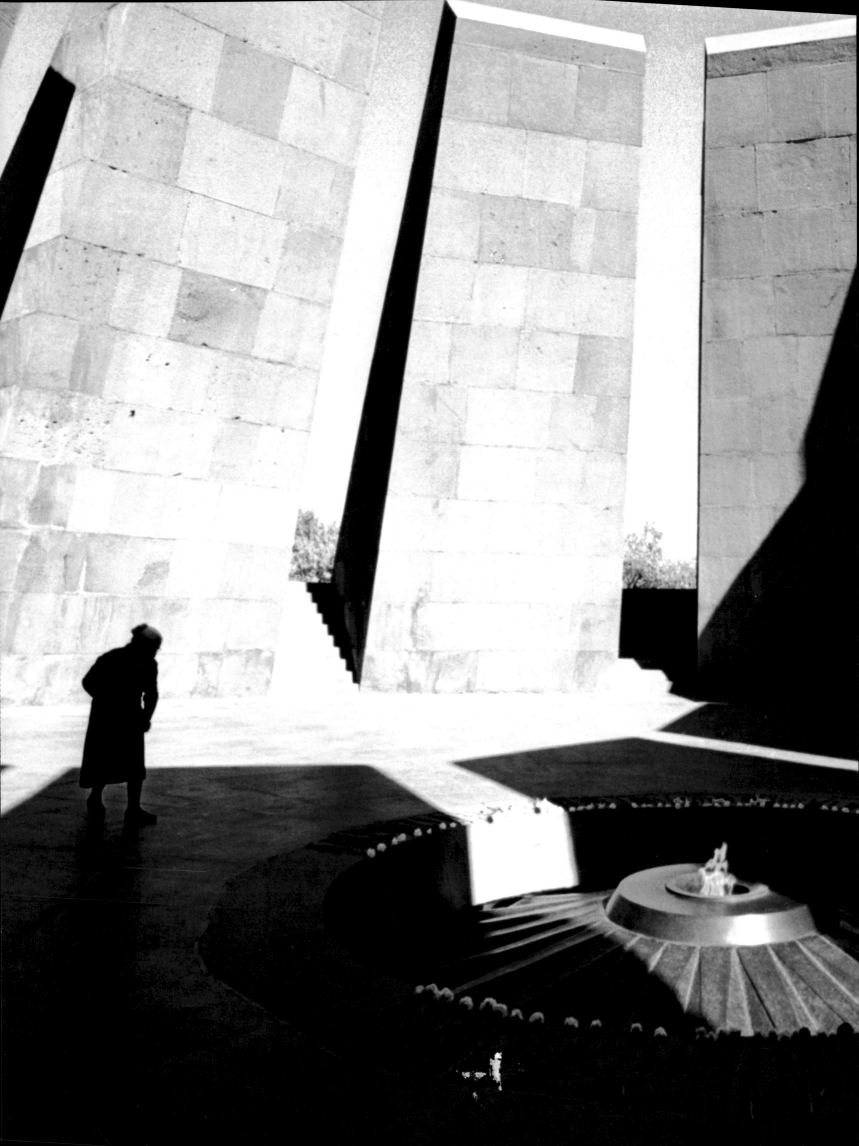

L.H. MONTGOMERY

ARMENIA

The Genocide Monument in Yerevan is a memorial complex dedicated to the memory of the more than one million Armenians who perished in the first genocide of the 20th century.

The population of Soviet Armenia demanded that a memorial monument be constructed, when in 1965, Armenians in other countries commemorated the fiftieth anniversary of the genocide. Completed in 1967, the Genocide Monument has become a pilgrimage site and an integral part of Yerevan's architecture. High on a hill, dominating the landscape, it is in perfect harmony with its surroundings. It overlooks the Ararat Valley and majestic Mount Ararat.

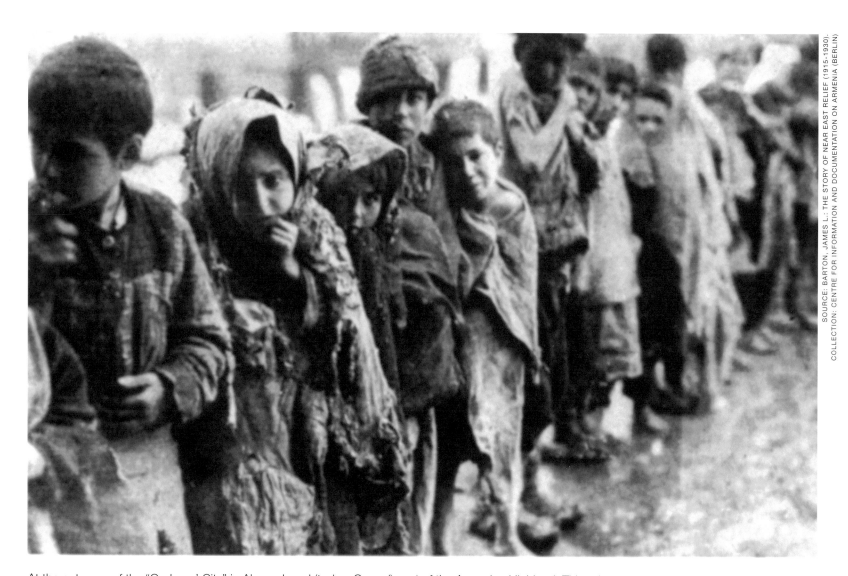

At the entrance of the "Orphans' City" in Alexandropol (today: Gyumri) east of the Armenian Highland. Thirty thousand starving Armenian orphans were under the care of Near East Relief in the Republic of Armenia (May 1918-end 1920). In the winter cold, children in rags were queueing at the entrance, hoping to be allowed in. They were survivors of the Ottoman genocide of 1915–16, most probably escaping from the Ottoman border-provinces of Erzurum and Van, or from areas in Transcaucasia that came under Turkish occupation in 1918 and 1920, resulting in new persecutions and massacres.

This first genocide of the 20th century is the template for genocides to come

Richard G. Hovannisian

Armenian Educational Foundation Professor of Modern Armenian History, University of California, Los Angeles

The Armenian Genocide of 1915 was the supremely violent historical moment that eliminated a people from its homeland and wiped away most of the tangible evidence of its three thousand years of culture. This first full-scale genocide of the 20th century was unprecedented in scope and duration. It may be seen as the culmination of the persecutions and massacres of Armenians that had already occurred in the Ottoman Empire since the 1890s. Or it may be placed in the context of modern nationalism and the great upheavals that brought about the dissolution of a multi-ethnic and multi-religious empire and the emergence in its place of a Turkish nation-state based on a mono-ethnic and mono-religious society.

Mass killings under the cover of war did not begin with the Armenian Genocide. Throughout history, civilian populations have fallen victim to the brutality of invading armies and other forms of indiscriminate killing. In the Armenian case, however, the government openly disregarded the fundamental obligation to protect its citizens and instead turned the full might of the state against one element of the population.

Estimates of the Armenian dead vary widely. A report of a United Nations human rights sub-commission put the figure at "at least one million." The important point in understanding a tragedy of such magnitude is not the precise count of the number who died—that will never be known—but the fact that more than half the Armenian population perished and the rest were forcibly driven from their ancestral homelands. What befell the Armenians was by the will of the government. Although a large segment of the general population participated in the massacres and plunder, many Turks were shocked by what was happening, and some helped to rescue and shelter Armenian women and children.

The defeat of the German and Ottoman empires and the collapse of the Young Turk dictatorship at the end of 1918 presented the Allied Powers with the opportunity to fulfill their pledges regarding punishment of the perpetrators and rehabilitation of the Armenian survivors. A Turkish military court martial tried and actually sentenced to death in absentia several of the notorious organizers of the genocide. Yet no attempt was ever made to carry out the sentences, and thousands of other criminals were neither tried nor even removed from office. The Allied Powers, having become bitter rivals over the spoils of war, failed to act in unison to implement the provisions for Armenian restoration and rehabilitation included in the 1920 Treaty of Sèvres, and instead signed the Treaty of Lausanne three years later that yielded to the demands of the triumphant Turkish Nationalists. The Armenian Question was completely abandoned, and there was no mention of rehabilitation, restitution, or compensation.

In fact, the words "Armenia" or "Armenian" did not even appear in the treaty. The Armenian victims had become invisible.

During the years that followed, the dispersed Armenian survivors concentrated their collective energies on resettlement and the creation of a new diasporan infrastructure of cultural, educational, and religious institutions. Embittered by world indifference, the diasporan communities internalized their frustrations, trauma, and even creative talents. They commemorated the genocide through requiem services and observances, yet on substantive issues they could not make their voice heard in the international arena. Meanwhile, the strategy of the perpetrators and their successor government, that of the Republic of Turkey, was to avoid public discussion of the genocide, believing that in the course of time the survivors would pass from the scene, their children would be assimilated into their host countries, and the issue would be forgotten.

It was not until the fiftieth anniversary of the genocide in 1965 that a revival of Armenian activism began to undermine the Turkish strategy of avoiding discussion of the mass killings of Armenians while continuing to reap the benefits of the confiscated goods and properties of the victims. In its response to this development, the Turkish government launched a concerted campaign of denial that became progressively more sophisticated through the 1970s and '80s. This initiative was aided by certain American and European academics who, rather than adopting the previous unconvincing approach of absolute denial, attempted to give a scholarly veneer to the propaganda by placing the "alleged genocide" in the highly distorted context of the turmoil and exigencies of war. By the 1990s the denial literature had become polished, complete with notations, archival references, and bibliographies. In the face of this tenacious denial, the Armenian worldwide community pursues the struggle to win international recognition of what the entire world acknowledged and knew to be the truth during and in the immediate aftermath of the genocide.

Genocide shapes not only the outlook of the immediate survivors, but also of subsequent generations. Victim groups, rather than viewing the world as a good place with a sense of order, are filled with mistrust and fear of what may come from a horrible world. It becomes essential, therefore, for victims to understand that the terrible events they have experienced are not normal, but rather are aberrations of a generally good world order. Continued denial makes this impossible and reinforces the feelings of insecurity, abandonment, and betrayal. To overcome these emotions, the victims need to share their pain and sorrow, to voice their outrage, to have the world comprehend their suffering, and especially to receive expressions of regret and remorse from the perpetrator side. Only then can a sense of justice and rightness be restored. Until that time, the pain and the rage fester and the healing process is blocked.

For the descendants of the perpetrators, it is of vital importance to engage in introspection, to face and learn from their history, to question how such violations could have occurred, to examine what there was and may still be in their society that led them to resort to genocide, and to find some redemption through appropriate acts of contrition, beginning with acceptance of the truth. If they are unable or unwilling to deal with the truth and instead try to maintain a righteous self-image, then they may again be placed on a path toward the victimization of other groups. The plight of the Kurds in the former Armenian provinces of the Ottoman Empire (now referred to as Eastern Anatolia) is a case in point.

It has been said that powerful states seek to vanquish not only the people they subjugate, but also the cultural mechanisms that would sustain vital memory of historical crimes. Holocaust scholar Terrence Des Pres has written that national catastrophes can be survived only if those to whom disaster happens can recover themselves through knowing the truth of their suffering. And the great Czech writer Milan Kundera has rightfully observed that "the struggle of man against power is the struggle of memory against forgetting."

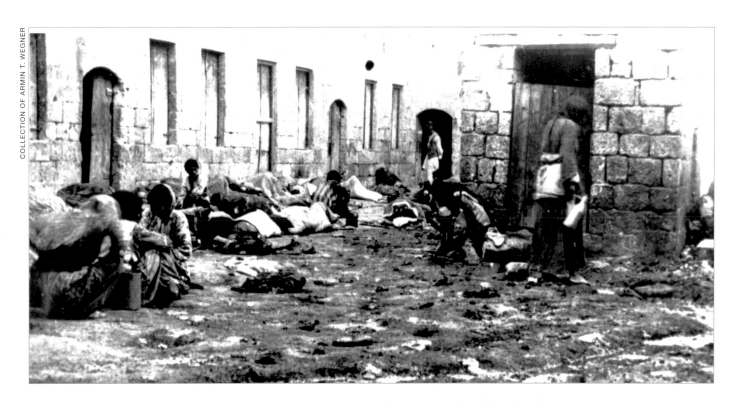

1915: Armenian deportees sleeping in the street—mostly women who appear to be without families.

ARMENIA TIMELINE

For three thousand years a thriving Armenian community existed in the region just east of Asia Minor at the crossroads of three continents: Europe, Asia, and Africa. The snow-capped peak of Mount Ararat was the focal point of the ancient Armenian kingdom dating back to the first millennium B.C. In about 300 A.D. Armenia became the first nation to adopt Christianity. This was followed by the invention of the Armenian alphabet and a golden age of literature, art, and architecture.

11TH CENTURY
After nearly 2,000 years of statehood —whether independent, autonomous, or tributary—Armenia is invaded by the Turks, beginning several hundred years of Turkish Muslim rule.

16TH CENTURY
Armenia is absorbed into the Ottoman Empire headed by Turkish Sultans.

19TH CENTURY
By 1800, the Ottoman Empire is in decline because it has not kept up with the current innovation and industrial might of Europe. The once invincible Turkish army now repeatedly loses battles to modern European armies. By the end of the century, as the empire falls apart, it is the Armenians and the Arabs who remain under the rule of the Bloody Sultan, Abdul Hamid. Young Armenians, aware of the modern world, call for political reform, an end to discrimination against Christians, and equality before the law. The Sultan responds with persecutions rather than promises. Hundreds of Armenians are massacred in their villages during 1895-1896.

1908
Reform-minded Turkish civic and military leaders, calling themselves the "Young Turks," force the Sultan to restore a constitutional government and basic rights. The Armenians in Turkey hold joyous rallies to salute this sudden turn of events. Joint celebrations of Muslims and Christians call for "Liberty, Equality, Justice."

1909
The honeymoon is short-lived, as 30,000 Armenians are massacred in the region of Cilicia.

1913

The extreme nationalist wing of the Young Turks seizes control in a coup. The top Young Turk leaders, Mehmet Talaat, Ismail Enver, and Ahmed Jemal, are intent on creating a new Turkish empire based on one language and one religion. However, the homeland of Armenia, with a population of two million Christian Armenians —10% of the empire's population—lies in the middle of their planned expansion east.

1914

As World War I erupts, the Young Turk dictators, who have sided with Germany and Austria-Hungary against the Allied powers, see the perfect opportunity to solve the "Armenian problem" once and for all. Under cover of a world conflict, disturbing atrocities against the civilian population go almost unnoticed. The Turks begin by disarming the entire Armenian population under various pretexts. They expel the 40,000 Armenians serving in the Turkish Army and place them into unarmed labor battalions to work as human pack animals. Coded telegrams are then sent to all provincial governors with orders to begin the elimination of the Armenian people within their provinces.

1915

On April 24, on the eve of Easter Sunday, the priest, Krikoris Balakian, writes: *"It seemed as if on one night, all the prominent Armenians of the capital— assemblymen, representatives, pro- gressive thinkers, reporters, teachers, preachers, doctors, pharmacists, dentists, merchants, and bankers—had made an appointment in those dim cells of the prison where they were*

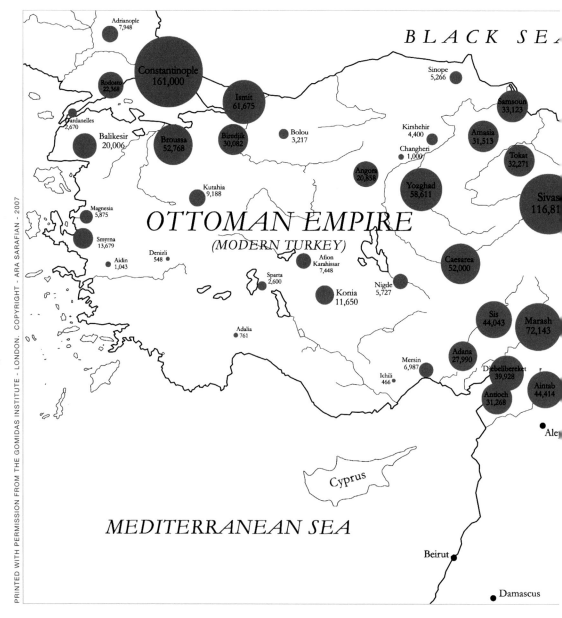

brought. More than a few people were still wearing their pajamas, robes, and slippers…when finally taken to a special train which was waiting to take us to the depths of Asia Minor where, except for a few cases, we would all meet our deaths. With the lights out, the doors of the cars shut, and with police and military posted everywhere, the train started…and so we began to move, further and further away from the places of our lives, each of us leaving behind grieving and unprotected *mothers, sisters, wives, children, possessions, wealth, and everything else…we headed to regions unknown and unfamiliar, to be buried forever."*

In what becomes known as "The Death March," more than a million Christian women and children are driven for weeks over mountains and deserts, often stripped naked, preyed upon, raped, tortured, and abused. Many take their own lives and their children's by flinging themselves from cliffs and into rivers

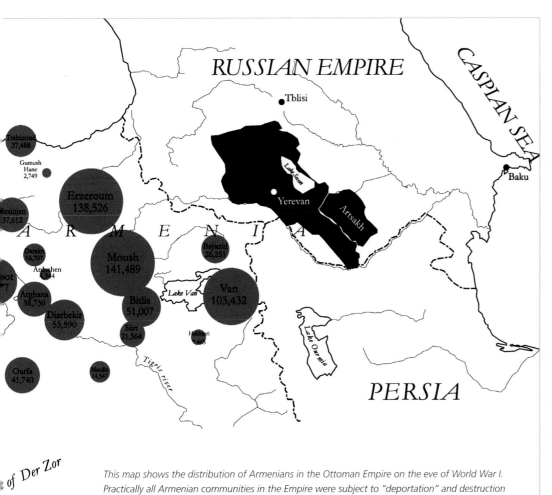

This map shows the distribution of Armenians in the Ottoman Empire on the eve of World War I. Practically all Armenian communities in the Empire were subject to "deportation" and destruction in 1915. Almost all communities were wiped out by the end of 1916. The statistical information appearing on this map is based on Raymond Kevorkian and Paul Paboudjian, Les Arméniens dans l'Empire ottoman a la vielle de genocide, Ed. ARHIS, Paris, 1992. This map was originally drawn for Ara Sarafian (ed.), United States Official Records on the Armenian Genocide 1915–17 (Gomidas Institute, 2005)

rather than prolonging their suffering and humiliation. The corpses are left to decompose and litter the landscape. The survivors are put in open air concentration camps similar to what the Jews would later experience.

The Allies coin the term "crimes against humanity" in warning the Ottoman government. No Allied power ever came to the aid of the Armenians.

1916

As Henry Morgenthau leaves his post as U.S. Ambassador to Turkey he writes: *"The failure to stop the destruction of the Armenians has made Turkey for me a place of horror, and I found intolerable my further daily association with men who, however gracious and accommodating and good natured they might have been to the American Ambassador, were still reeking with the blood of nearly a million human beings."*

1918

Turkey surrenders to the Allies. The Young Turks flee the country.

Former President Theodore Roosevelt berates President Wilson for his refusal "to take effective action on behalf of Armenia. The Armenian massacre," Roosevelt concludes, "was the greatest crime of the war and failure to act against Turkey is to condone it. The failure to deal radically with the Turk fiendish horror means that all talk of guaranteeing the future peace of the world is mischievous nonsense…(and that) the announcement that we meant 'to make the world safe for democracy' was insincere claptrap."

1920s

Former Interior Minister Talat Pasha is assassinated in Berlin by an Armenian who had been left for dead in a pile of corpses. Jemal Pasha is hunted down and killed, and Enver Pasha dies in battle in central Asia. The genocide in Armenia, the first in the 20th century, has been spoken of as the kindling for the Holocaust.

1939

The half-hearted reaction of the world's great powers to the plight of the Armenians is duly noted by Adolf Hitler. In telling his generals that he has decided to conquer Poland, he writes: *"Thus for the time being I have sent to the East only my 'Death's Head Units' with orders to kill without pity or mercy all men, women, and children of Polish race or language. Only in such a way will we win the vital space that we need…Who still talks nowadays about the Armenians?"*

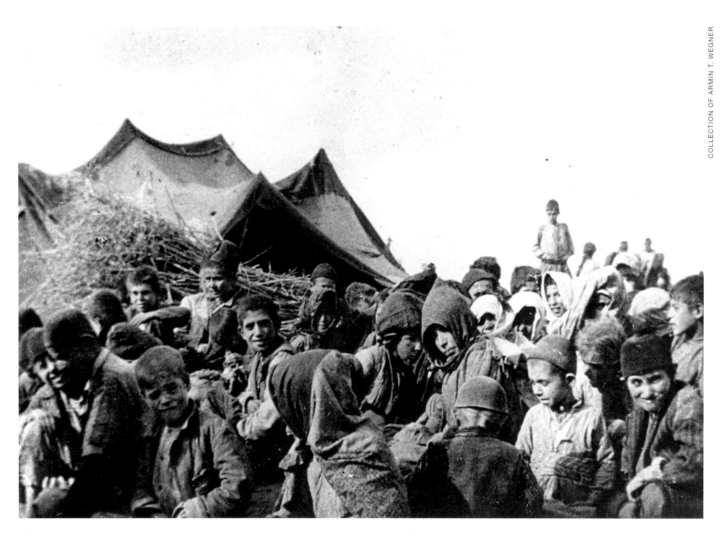

1915: Orphaned Armenian children in the open, all in worn-out clothing, with many covering their heads from the desert sun.

The effective manner in which the young Turks annihilated the Armenian population without being brought to justice impressed the Nazi leadership as they contemplated a similar initiative with respect to the Jews. High-echelon Nazi leaders who served alongside Turkey in World War I gained possession of intimate details of the Armenian genocide. An example is General Hans von Seeckt, Chief Ottoman General Staff (1917-1918) who assisted the seven top Turkish authors of the Armenian genocide in their escape from Istanbul.

In 1920, when von Seeckt met with Adolf Hitler, von Seeckt declared that German policy should be "to prepare for the next war."

Dr. Max Erwin Scheubner-Richter's reports on the massacres of the Armenians are preserved. His periodical claims that Hitler modeled his attack on the Jews based on many of the devices used against the Armenians such as:
"Wartime deportations; extirpation through exhaustive labor; death marches; incitement of other people for the purpose of enlisting their help in the destruction of the victim population; natural dissemination through attrition by way of artificially induced hardships involving exposure to harsh climatic conditions, starvation and epidemics; shameless attacks of enrichment through the appropriation of the possessions of the deportees; and the creation of concentration camps." [1]

In one of his World War I reports, von Scheubner-Richter characterizes the city-dwelling Armenians as "these Jews of the Orient" who are wily businessmen. [2]

2006
According to the Former Turkish Ambassador Gunduz Aktan:
"The Turkish people believe that what happened to the Armenians was not

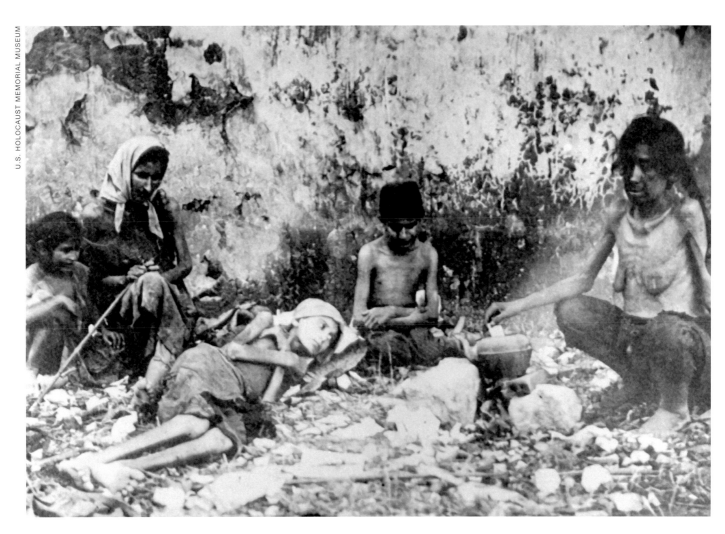

Starving Armenian refugees cook a meager meal.

genocide. It was relocation to another part of the Ottoman Empire of only eastern Anatolian Armenians with an aim of creating an independent state of their own in areas where they were only in minority by ethically cleansing the majority Turks. Many Armenians perished as well. The crucial question is why the Armenians are not content with the words tragedy, or catastrophe or disaster, but insist on genocide. What determines genocide is not necessarily the number of casualties or the cruelty of the persecution, but the intent to destroy a group. Turks have never harbored any anti-Armenianism. The victims of genocide must be totally innocent." [3]

"Today I shall call this genocide...I have no doubts about what happened...I believe we must call a spade, a spade." —John Evans, United States Ambassador to Armenia, Yerevan, 2006

OCTOBER 10, 2007

The U.S. House Foreign Relations Committee passes a majority vote to condemn the "genocide" of Armenians in 1915 by the Ottoman government. Ronald Reagan is the only American president to have publicly used the term "genocide" while in office. The National Assembly of France approved legislation in 2006 that made it a crime punishable by law to deny the

Armenian genocide. One would hope that the Turks in their ambition to become a member of the European Union would accept the ancestral shame and move on into the present. By continuing to deny a well documented fact, they become their own worst enemy. Perhaps it will take yet another younger generation in Turkey to stop their denial of a hundred year old inconvenient truth.

1 Dadrian, Vakhan N., *The Historical and Legal Interconnections between the Armenian Genocide and the Jewish Holocaust: From Impunity to Retributive Justice* (Yerevan, Armenia, 2004)

2 Ibid.

3 Goldberg, Andrew, *The Armenian Genocide* (television documentary), Two Cats Productions in association with Oregon Public Broadcasting, New York, NY, 2006

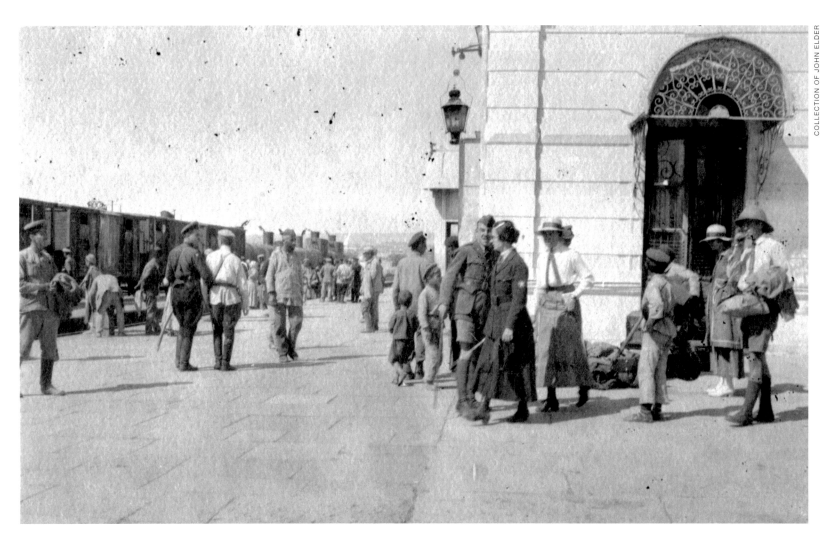

Erivan train station before the genocide of 1915.

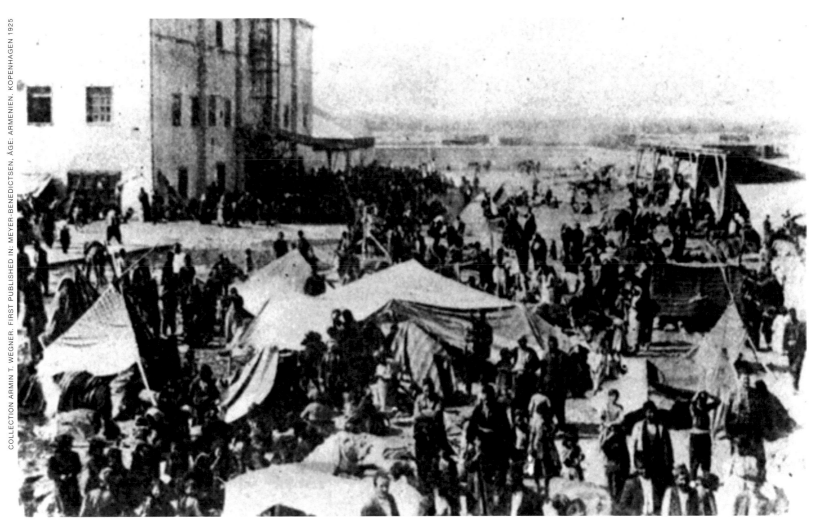

A typical stop on the deportation route of the Ottoman Armenians in 1915–16. Makeshift tents were erected by the deportees without any support by authorities, for protection from burning summer heat as well as from cold in the nights.

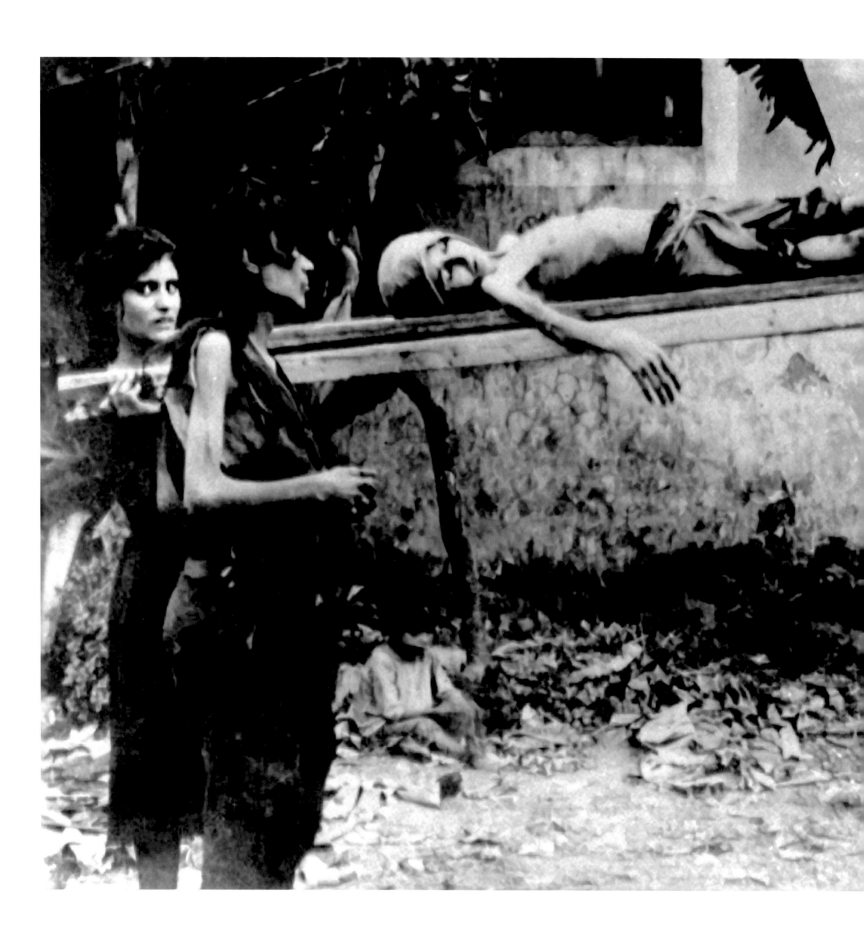

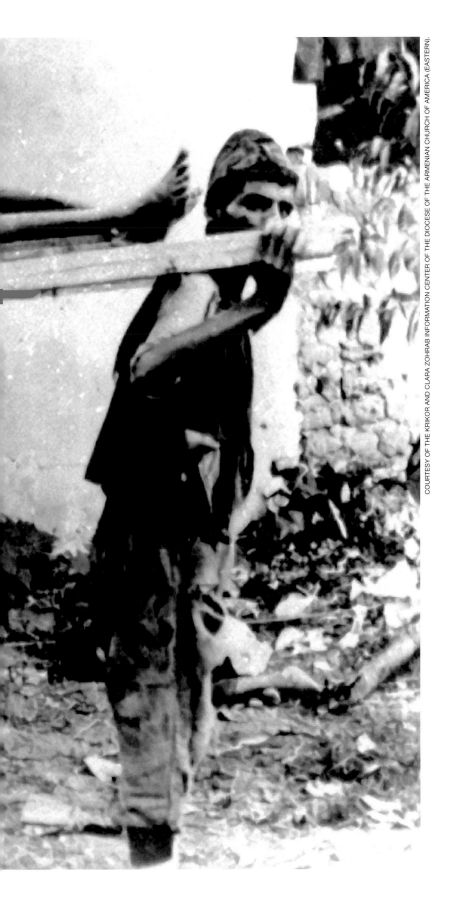

Starving Armenian refugees remove the body of a fellow who died from starvation.

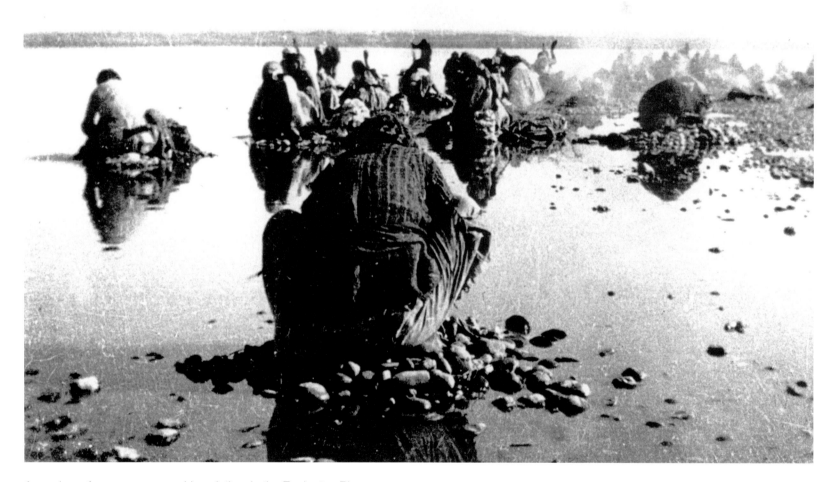

Armenian refugee women washing clothes in the Euphrates River.

1915: Armenian deportees—women, children and elderly men. Woman in foreground is carrying a child in her arms, shielding it from the sun with a shawl; man on left is carrying bedding; no other belongings or food are noticeable among the effects being carried. All are walking in the sun on an unpaved road with no means of shelter from the elements.

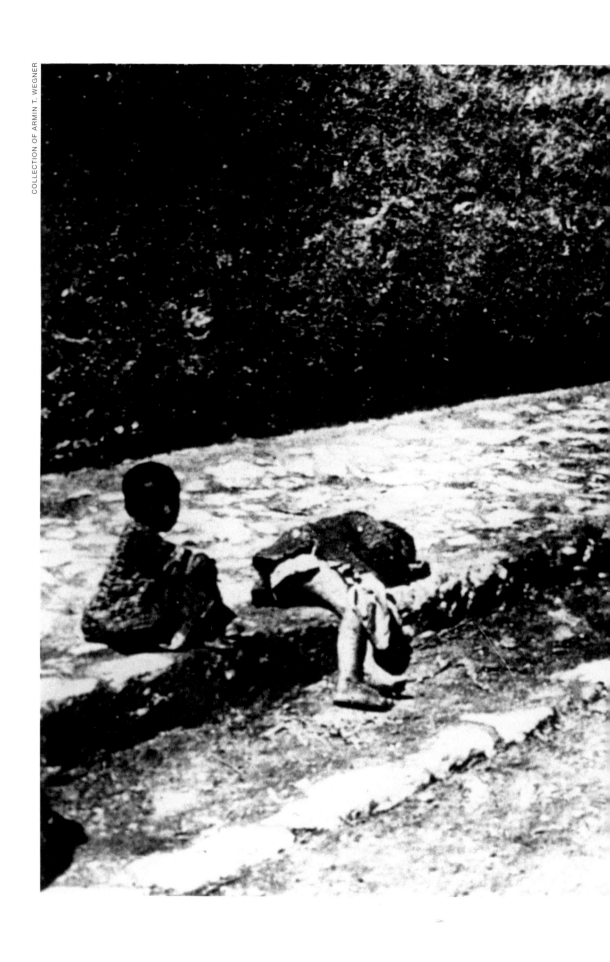

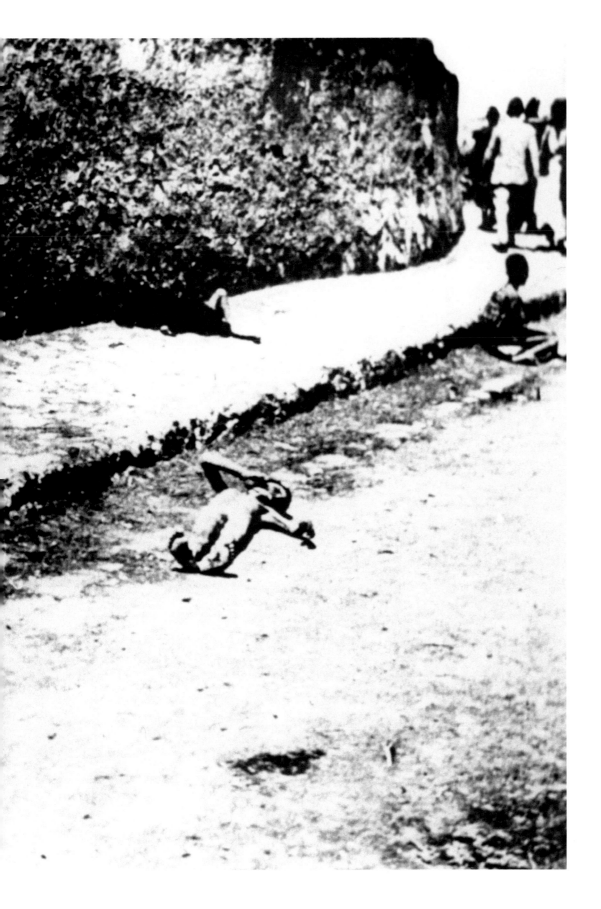

"Abandoned and murdered small children of the (Armenian) deportees," according to the photographer, 1915-1916. Three are dead including a stripped boy in the gutter.

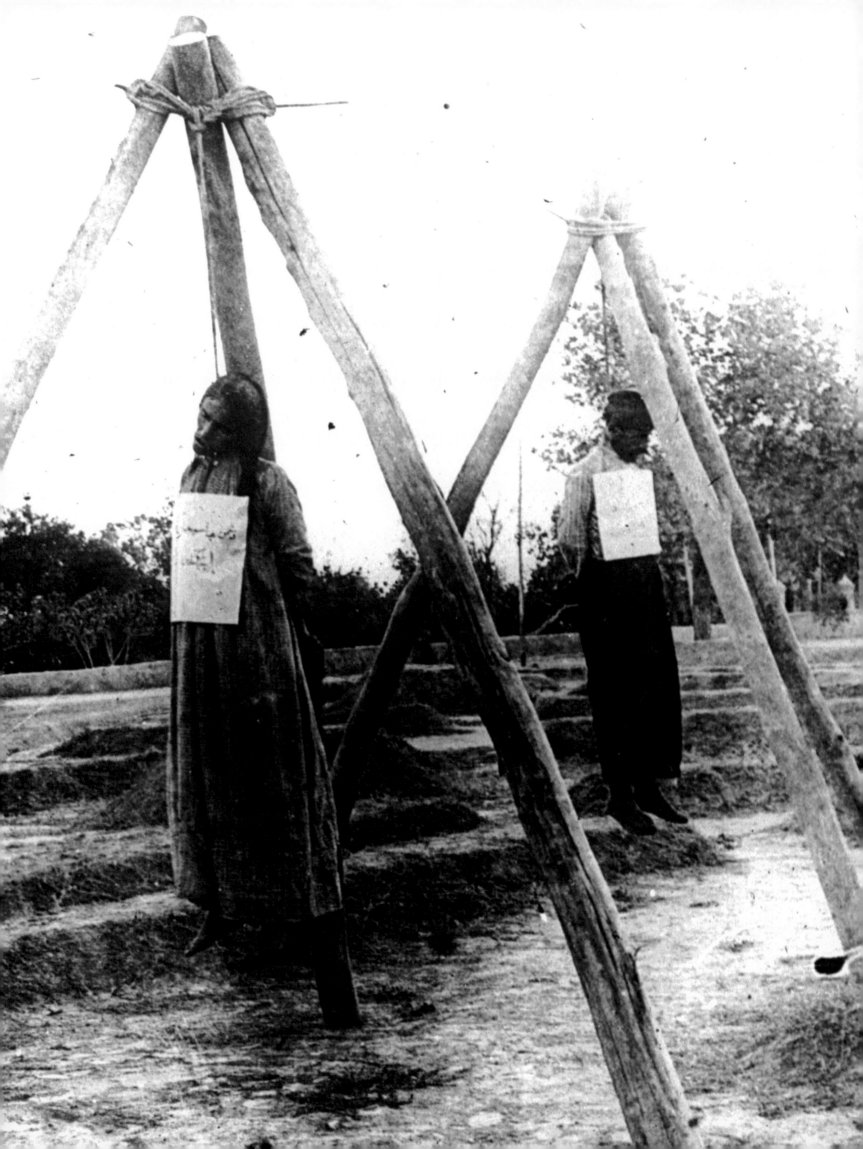

During World War I, Ottoman Christians were frequently tried and publicly executed for alleged high treason. Often the pretext for their hanging was invented. For example, the possession of a prayerbook from Western missionaries could lead to an accusation of treason. This photograph from the Armin T. Wegner collection shows the rare case of a woman publicly executed. It is presumed that both executed civilians are Armenians. The mode of execution is typical: hanging from a "tripod" gallows with the official verdict written on paper and hung around the executed person's neck.

"Nothing emboldens a criminal so much as the knowledge he can get away with a crime. That was the message the failure to prosecute for the Armenian massacre gave to the Nazis. We ignore the lesson of the Holocaust at our own peril…"

—David Matas, Canadian expert on international law

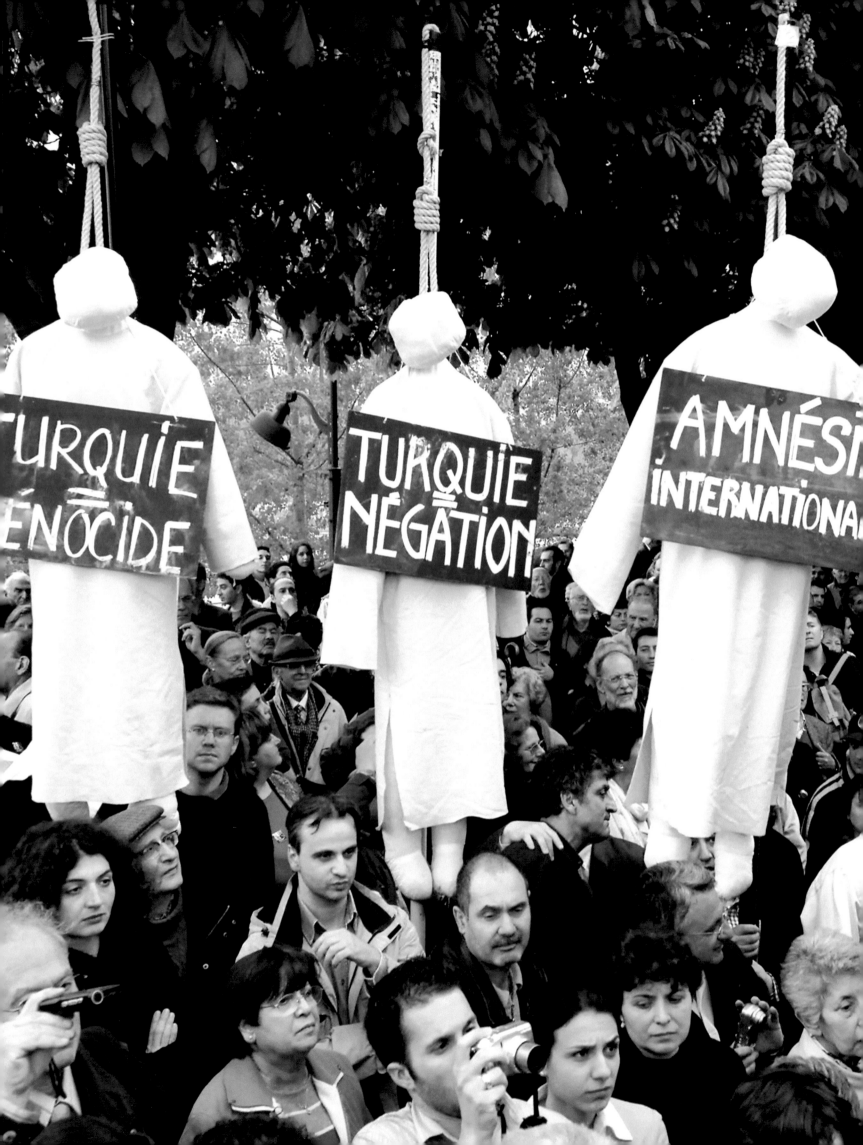

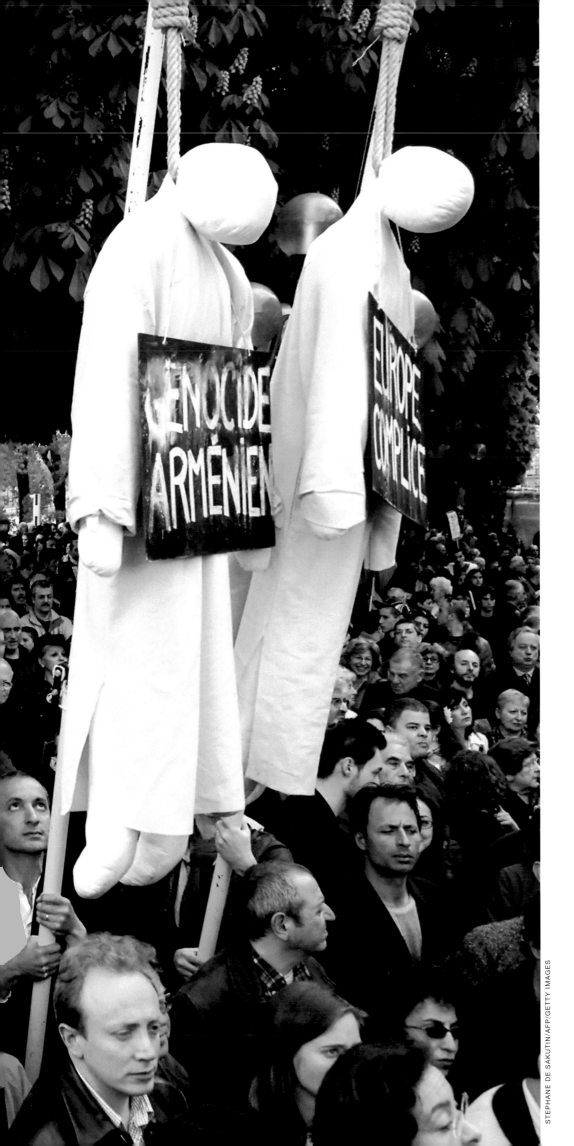

On October 12, 2006, The National
Assembly of France defied appeals by
Turkey and approved legislation that
made it a crime to deny that the mass
killings of the Armenians during and after
World War I were genocide. The law set
a rule of fines of about 45,000 euros
($56,000) and a year in prison for anyone
denying the genocide. The subject
remains taboo in Turkey and may affect
their ability to enter the European Union.

Jews and Armenians shared a common
fate because their victimizations were not
prevented. Time and unfolding events
will show whether the civilized world will
have the forethought to preserve the
legacy of Nuremberg by establishing a
permanent International Criminal Court.

Paris, April 24, 2005: People attend
commemorations marking the 90th
anniversary of the Armenian genocide.

STEPHANE DE SAKUTIN/AFP/GETTY IMAGES

ARMIN T. WEGNER

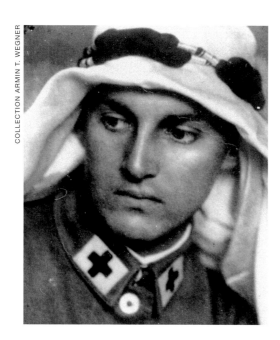

COLLECTION ARMIN T. WEGNER

Armin Wegner, the World War I German medic, whose photographs document the suffering of the Armenian people during the genocide by the Turks in 1914-1916, was born into an aristocratic Prussian family in 1886. He was only nine years old when he read of the persecution of the Armenians by the Ottoman Empire's Bloody Sultan, Abdul Samid, in 1895 from a newspaper on his family's dining table. The article made a lasting impression on him. The remains of his own famous photographs and those of his collection constitute much of the documented proof that the Armenian Genocide occurred.

At the outbreak of the war, Wegner enrolled as a volunteer nurse in Poland during the winter of 1914-1915. He received the Iron Cross for attending to the wounded under fire. Following the military alliance of Germany and Turkey in 1915, Wegner was assigned to the Middle East. Ignoring the orders of the Turkish and German authorities who suppressed the news and visual evidence of the Armenian massacre, Wegner collected documents and took hundreds of photographs in the Armenian deportation camps.

He smuggled this evidence out through foreign consulates to Germany and the United States. When he was discovered, he was arrested by the Germans at the command of the Turkish government and was made to serve in cholera wards. In 1916, by then ill himself, he left Baghdad for Constantinople. Hidden in his belt were photographic plates with images of the Armenian Genocide. He was recalled to Germany. Deeply moved and unable to forget the tragedy of the Armenian people, Wegner became an active pacifist. In February of 1919, Wegner's "Open Letter to President Wilson" appealing for the creation of an independent Armenian state was published in *Berliner Tageblatt*.

In 1933, Wegner wrote an appeal "For Germany" addressed to Adolf Hitler, which was a bold appeal to the Nazi "Boycott of the Jewry." This led to his arrest by Martin Borman, followed by torture at the hands of the SA (Sturmabteilung) brownshirts and imprisonment in seven jails and three concentration camps before he was released in 1936.

Wegner returned to Germany but after several months he foresaw what was to become of his homeland. He decided to leave forever and moved to Italy, stating at the time that he never again wished "to touch the hands of this people which committed such unspeakable crimes to my Jewish brothers."

He married twice—both times to Jewish women—and he continued to dedicate a large part of his life to fight for Armenian and Jewish human rights.

In 1968, he received an invitation to Armenia to be awarded the Order of Saint Gregory the Illuminator from the Catholics of All Armenians.

Armin Wegner died in Rome at the age of 92, in 1978. A portion of his ashes was carried to the Armenian Genocide Memorial in Yerevan and consecrated there.

MORGENTHAU AND TALAAT PASHA

*"One thing remains to be said of
Armenia: The whole people of this country
were massacred and cleansed in the worst
atrocity the world has seen since the birth
of Jesus Christ. That country should
'never again' and under no conditions be
left in the hands of Turkey."*
– *London Times* and *The Guardian*, 1916

On the desecration of Armenian churches, Morgenthau wrote:

"I do not believe that the darkest ages ever presented scenes more horrible than those which now took place all over Turkey. Nothing was sacred to the Turkish gendarmes; under the plea of searching for hidden arms, they ransacked the churches, treated the altar tools and sacred utensils with no dignity, and even held mock ceremonies in imitation of the Christian sacraments. They would beat the priests into insensibility, under the pretense that they were the centers of sedition...When they could discover no weapons in the churches, they would sometimes arm the bishops and priests with guns, pistols, and swords...then try to put them before court-martial for possessing weapons against the law, and march them in this condition through the streets, merely to arouse the fanatical wrath of the mobs...In some cases the gendarmes would nail hands and feet to pieces of wood— evidently in imitation of the Crucifixion..." [1]

Ambassador Morgenthau rallied back and forth between observing the killing fields and the American community and the press back home. The Ambassador was a man of high moral conscience and not afraid to confront boldly the leaders of the Ottoman government about its treatment of the Armenians. When the evidence became overwhelming, Ambassador Morgenthau directly confronted Mehmet Talaat Pasha about his government's treatment of the Armenians.

"Why are you so interested in the Armenians?" Mehmet asked Morgenthau. "You are a Jew. These people are Christians...why can't you let us do with these Christians as we please?"

Indignant, Morgenthau, replied:

"You don't seem to realize that I am not here as a Jew but as the American ambassador My country contains something more than 97,000,000 Christians and something less than 3,000,000 Jews. At least, in my ambassadorial capacity, I am 97 per cent Christian. But after all, all that is not the point. I do not appeal to you in the name of any race or any religion but merely as a human being...the way you are treating the Armenians...puts you in the class of backward, reactionary peoples."

"We treat the Americans all right," Mehmet answered. "I don't see why you should complain."

"The Americans are outraged by your persecutions of the Armenians." [2]

"My failure to stop the destruction of the Armenians has made Turkey for me a place of horror, and I found intolerable my further daily association with men who, however gracious and accommodating and good natured they might have been to the American Ambassador, were still reeking with the blood of nearly a million human beings." [3]

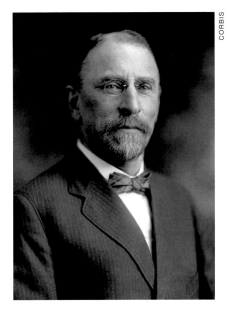

U.S Ambassador to the Ottoman Empire, Henry Morgenthau, Sr. (1856-1946)

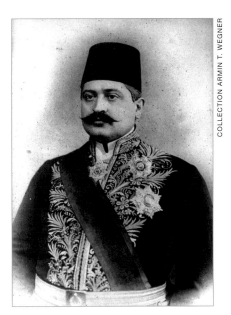

Mehmet Talaat Pasha (1874-1921)

1, 2, 3 Morgenthau, Henry, *Ambassador Morgenthau's Story*, Wayne State University Press, Detroit, MI, 2003

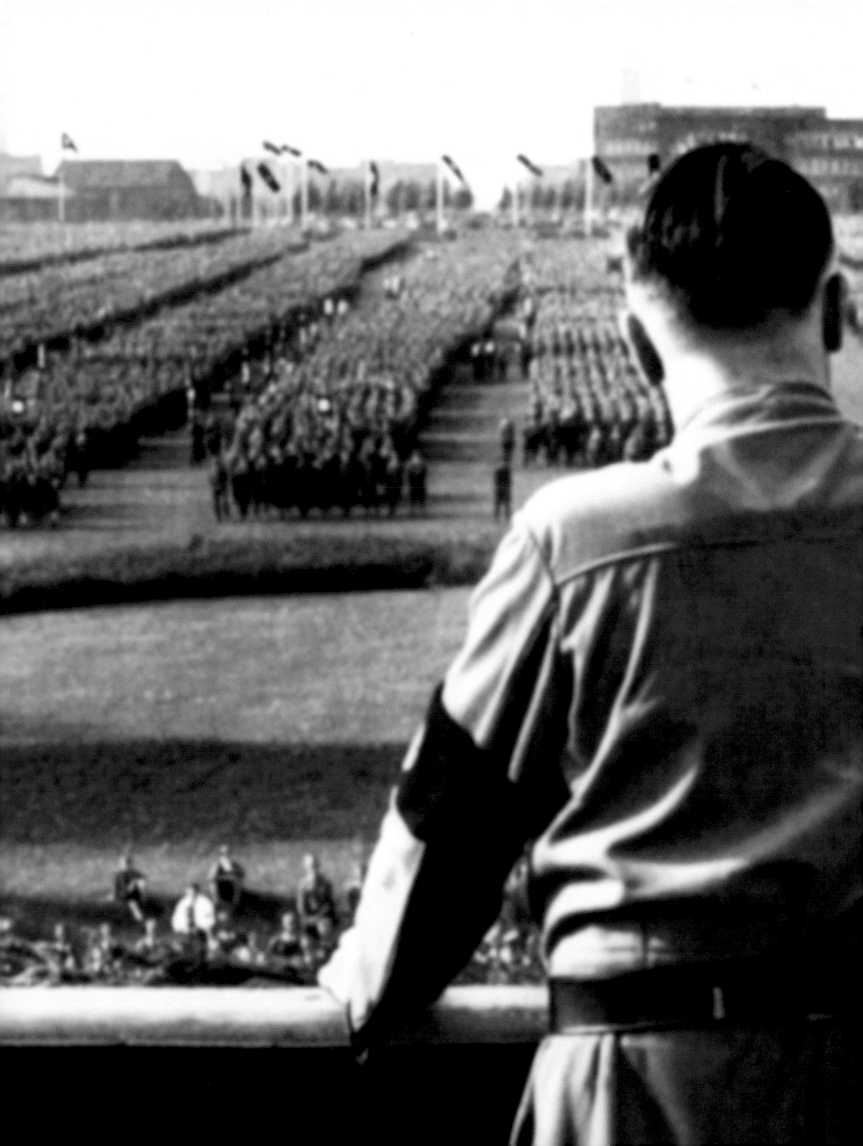

THE
HOLOCAUST

*"Let them speak of their shame,
I speak of mine."*

—Bertolt Brecht

Hitler at SA rally at Dortmund—1933

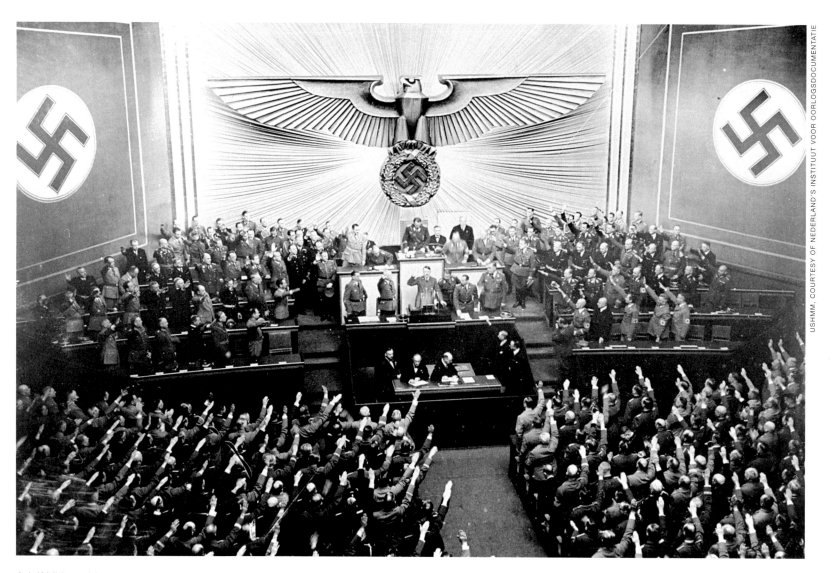

Adolf Hitler addresses the Reichstag. Above Hitler stands the Reichstag president, Hermann Goering.

"In this hour the German government renews before the German people and before the entire world its assurance…that it does not intend in rearming Germany to create an instrument for military aggression but, on the contrary, exclusively for defense and thereby for the maintenance of peace…Germany neither intends nor wishes to interfere in the internal affairs of Austria, to annex Austria or to conclude an Anschluss…"

—Adolf Hitler, March 1938

The diabolical plans of tyrants

Rabbi Arthur Schneier

President, Appeal of Conscience Foundation; Senior Rabbi, Park East Synagogue, New York City

First they came for the Communists, and I didn't speak up, because I wasn't a Communist...Then they came for the Jews, and I didn't speak up, because I wasn't a Jew...Then they came for the Catholics, and I didn't speak up because I was a Protestant...Then they came for me and, by that time, there was no one left to speak for me....

—Pastor Martin Niemoller

As a survivor of the Holocaust, I was a victim of both Nazi oppression and the world's silence in the face of such inhumanity. Growing up in Vienna, I experienced first hand the horrors of Kristallnacht on November 10, 1938. My mother and I realized our situation was dire. We had to leave our hometown and country. We fled to Hungary where my grandparents had been living and which, up until March 19, 1944, stood outside the clutches of Nazi Germany. By May, 1944, almost all of the Jews living in Hungary had been rounded up including my grandparents and close relatives. They were thrown into ghettos where they languished until their deportation to Auschwitz and other concentration camps. With the exception of Budapest, the Nazis and the Hungarian fascist collaborators cleansed the countryside of 435,000 Jews. My survival came by courtesy of a Swiss Safety Pass issued in the office of Swiss Consul General Carl Lutz.

I was one of the few fortunate ones who lived to see another day thanks to the concern and the kindness of a stranger. Most of my kinsmen went to their deaths as the world remained idle and unmoved by our suffering.

In Judaism there is a critically important concept known as "Zachor." We bear witness to the tragedies that have befallen our people in the hope that no people should suffer from similar barbarism in the future. "Zachor" is achieved primarily through educating children. By teaching subsequent generations about the Holocaust, we hope to sensitize them to human suffering and make them intolerant of genocide.

An important lesson to be learned from the Holocaust is that the diabolical plans of tyrants need to be taken at face value. They mean what they say. Nazi genocidal extremism could be perceived in the early writing of Hitler. Yet, the threat of Nazism was not taken seriously. The movement was considered on the fringe with no real expectation of assuming power. Later, upon assuming power, it was taken for granted that the responsibilities of governing a country would force the Nazis to moderate their policies. We now know that nothing will deter tyrants from pursuing their inhumane agendas. Once in control, they will abuse the democratic process by using the ballot box to ascend to power and crush all dissent.

Although the Holocaust was in many ways unique in the annals of genocide, sadly, man's inhumanity to man continues to this very day in Darfur, Sudan. It is incumbent upon all of us, and especially Holocaust survivors such as I am, to protest against this horrific crime. There are tragic consequences to be silent in the face of evil.

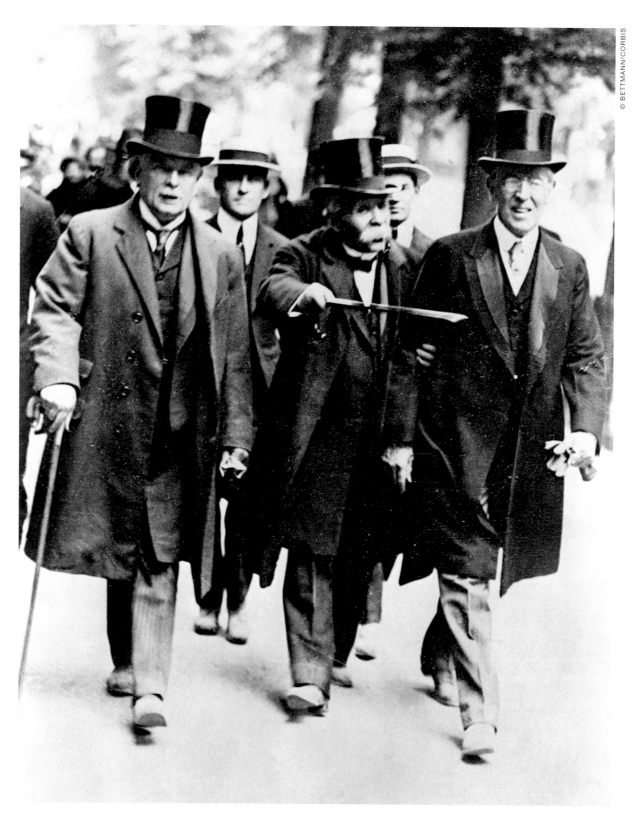

British Prime Minister David Lloyd George (left), French Prime Minister Georges Clemenceau (center) and American President Woodrow Wilson (right) on their way to the Versailles Peace Conference, 1919.

TREATY OF VERSAILLES

Revenge and reconciliation are incompatible.

—Jay Winter, Cambridge University

In the winter of 1919, the peacemakers gather in a Paris that has lost her looks. The Seine overflows its embankment and the Tuileries gardens are pocked from cannon shells. Refugees, rubble and broken windows border the boulevards. Woodrow Wilson is the first American president to cross the Atlantic. The son of a Presbyterian minister, Wilson comes to Paris to preach peace to a splintered Europe after the Great War.

At the end of six months of negotiations, the Treaty of Versailles (1919) is signed at the Paris Peace Conference, which officially ends World War I. However, it is only an intermission before World War II. Germany is not invited. Terms imposed by the Treaty include forcing Germany to return Alsace and Lorraine to France, and to give up a portion of her eastern land to form part of Poland. Germany's ability to provoke war again is limited by restrictions on the size of its military. It is also forced to acknowledge and to respect the independence of Austria. Germany's foreign minister, Hermann Muller, undersigns the Treaty on June 28, 1919 in absentia.

The Treaty is ratified by the League of Nations on January 10, 1920, humiliating Germany and contributing to the collapse of the Weimar Republic in 1933. It also ushers in the creation of Woodrow Wilson's League of Nations, with the goal of arbitrating international disputes and thereby avoiding future wars. But not all of Wilson's Fourteen Points are realized since Wilson is compelled to compromise with three of the "Big Four"— Clemenceau, Lloyd George and Italy's Vittorio Orlando. France's Clemenceau, known as "Le Tigre," is the most ferocious in his desire for revenge against the Germans for fighting the western front of the war primarily on French soil. Clemenceau also has disdain for the American president, "What ignorance of Europe and how difficult all understandings were with him! God himself was content with ten commandments. Wilson modestly inflicted fourteen on us..."[1] The United States Senate ultimately refuses to sign the Treaty and makes a separate peace with Germany.

The Treaty of Versailles clearly crippled Germany's economy in the early 1920s and left her vulnerable to the equally devastating Great Depression of the early 1930s, bringing on support for the Nazi government. The implementation of reparations failed to punish Germany as it refused to repay most of her foreign loans (some 33 billion dollars) and indemnity debt.

With Neville Chamberlain's trust, Hitler begins to remilitarize Germany and is allowed to annex enormous territories in the 1930s. Thus, Germany becomes powerful enough to threaten European peace once again.

1 MacMillan, Margaret, *Paris 1919*, Random House, Inc., New York, NY, 2001

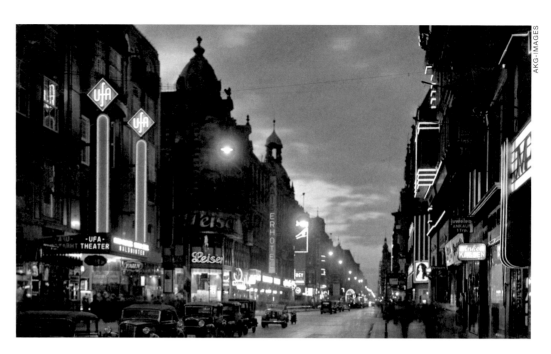

Friedrichstrasse, Berlin: Traffic at night in the middle of the city.

UNDERNEATH THE FAÇADE OF GLAMOUR, DARK SHADOWS ARE EMERGING

Berlin in the 1920s

The Golden Twenties in Berlin is vibrant. It is a talented bohemia, on fire in architecture and design (Bauhaus), film (Fritz Lang, *Metropolis*), music (Bertolt Brecht and Kurt Weill, *Threepenny Opera*), psychology (Jung) and fashion. Berlin is the largest industrial center on the continent and the cultural and intellectual center of Europe. German Expressionism is an influential movement that infects the world. Astrology, the occult, and esoteric religions become acceptable after the horrors of World War I.

Politically, radical ideas on both the left and the right are feverish in the wild and exciting atmosphere of 1920s Berlin. Clashes between left-wing communists and right-wing fascists feed the press. Underneath this façade of glamour, dark shadows are emerging in Germany pointing to coming times of insanity and murder. Raw expressionism begins to mirror the confusion and fear within the country.

By 1929, the Weimar Republic is losing its struggle with spiraling inflation. The crash of the stock market in America weakens Germany further and by 1932, only half of the country is employed.

Against the background of economic chaos, the National Socialist German Workers' (Nazi) Party gains momentum. With the help of wealthy industrialists and the military, Adolf Hitler slowly gains popularity over the communists. With his gift for oration, he is seen as a savior throughout his country. The young are especially impressed with his emotional rhetoric, which preaches the return of glory and racial purity to Germany. Some weep with joy and gratitude upon hearing Hitler speak of destroying the Weimar Republic, and scorching it for surrendering Germany to the impoverishing terms of the Treaty of Versailles. Hitler convinces his audience that there could be only one father, one leader, one Fuhrer.

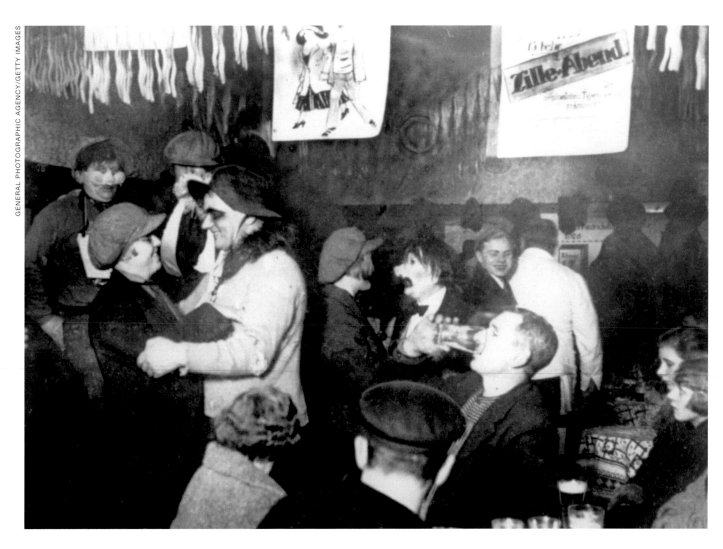

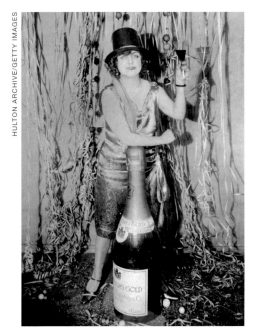

Top: A party at an underground club in Berlin.

Bottom left: A woman at a New Year's Eve party leans on an oversized bottle of champagne while making a toast, Germany.

Bottom right: Cabaret poster, 1919. (Bier-Cabaret / im Lichtprunksaale der Passage / Senta Soeneland)

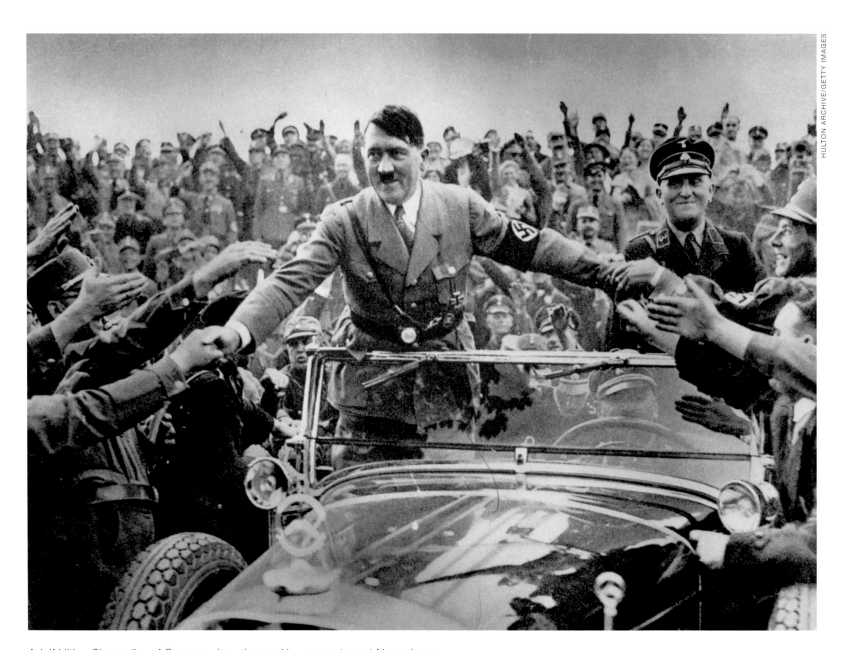

Adolf Hitler, Chancellor of Germany, is welcomed by supporters at Nuremberg.

MEIN KAMPF

In 1923, after the unsuccessful Beer Hall Putsch and subsequent riots in Munich, Adolf Hitler was imprisoned for nine months, during which time he dictated *Mein Kampf* (My Struggle) from his prison cell, to Rudolph Hess. Hitler finished the book at an inn at Berchtesgaden.

In this manic oratory, Hitler divided the human race into categories based upon physical appearance. He placed the Aryan race—the Germanic ideal with blonde hair, blue eyes and fair skin—at the top. This was the master race All others were declared racially inferior, the *Untermenschen*. The Jews and Slavic peoples—Poles, Czechs and Russians—were assigned to this group.

Jews especially were considered parasites and the mortal enemy of Aryan humanity:

"With satanic joy in his face, the black-haired Jewish youth lurks in wait for the unsuspecting girl whom he defiles with his blood, thus stealing her from her people. With every means he tries to destroy the racial foundations of the people he has set out to subjugate. Just as he himself systematically ruins women and girls, he does not shrink back from pulling down the blood barriers for others, even on a large scale. It was and it is Jews who bring the Negroes into the Rhineland, always with the same secret thought and clear aim of ruining the hated white race by the necessarily resulting bastardization, throwing it down from its cultural and political height, and himself rising to be its master. For a racially pure people which is conscious of its blood can never be enslaved by the Jew. In this world he will forever be master over bastards and bastards alone.

And so he tries systematically to lower the racial level by a continuous poisoning of individuals. And in politics he begins to replace the idea of democracy by the dictatorship of the proletariat."
—*Mein Kampf*: Vol. 1: A Reckoning, Chapter XI, Nation and Race.

But they were not alone…

"If for a period of only 600 years those individuals would be sterilized who are physically degenerate or mentally diseased, humanity would not only be delivered from an immense misfortune but also restored to a state of general health such as we at present can hardly imagine…If a people and a State take this course to develop that nucleus of the nation which is most valuable from the racial standpoint and thus increase its fecundity, the people as a whole will subsequently enjoy that most precious of gifts which consists in a racial quality fashioned on truly noble lines."
—*Mein Kampf*: Vol. II, The National Socialist Movement: Chapter II: The State

Mein Kampf should have served as a warning to the world. It was a warning the world ignored.

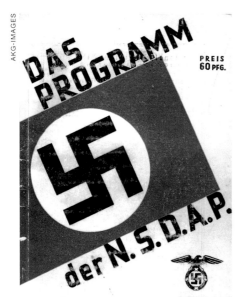

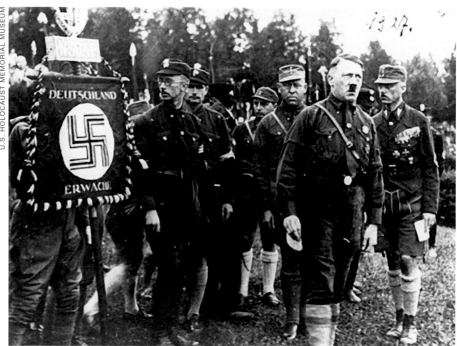

Left: Title page to Gottfried Feder's *Das Programm der N.S.D.A.P. und seine weltanschaulichen Grundgedanken*
(*The Programme of the NSDAP and its Ideological Foundations*). 41.-50. ed. Munich (F. Eher) 1931.
Right: Adolf Hitler speaking at the third Nazi Party Congress in Nuremberg, August 19, 1927. Behind him are Heinrich Himmler, Rudolf Hess, and Gregor Strasser. The banner reads "Germany Awake."

THE HOLOCAUST TIMELINE

It has been said that as World War I was ending, World War II was beginning. The word Holocaust means "total destruction by fire," and that is an appropriate metaphor for what the Nazi regime in Germany did to the Jewish population of Europe during World War II. They did not succeed in eliminating the Jews from the world, but before it was all over, some six million were dead.

1919
Treaty of Versailles is signed. Germany loses territory and arms.

1920
At the Salzburg Congress, the swastika becomes the official emblem of the Nazi Party. The clockwise Nazi version of the swastika means hate and death, anti-Semitism and terror, while the counter-clockwise version represents the ancient symbol of life and good luck.

1921
The Nazi Party, formally named the National Socialist German Workers' Party is founded in Munich. A former World War I corporal, Adolf Hitler, becomes its leader. Soon the Nazi Party is Hitler's Party, dedicated to crushing the Weimar Republic.

"The Nazi Party regards Christianity as the foundation of our national morality and the family as the basis of national life…"
—Adolf Hitler in a radio address

1923
On November 8, 1923, Hitler and his brown-shirted Storm Troopers (the SA, "sturmabteilung") invade a beer hall in which the Bavarian government is holding a meeting. Despite some initial popular support, the attempted coup, known as the "Beer Hall Putsch" ends in failure. Hitler serves nine months in Landsberg prison where he writes *Mein Kampf*.

1929
Germany is hit by a stock market crash second only to that in the United States. The mark crashes at 4 million marks to the dollar. This more than anything else contributes to the rise of Adolf Hitler, who promises a policy that will rescue Germany from debt, restore prosperity and liquidate the past.

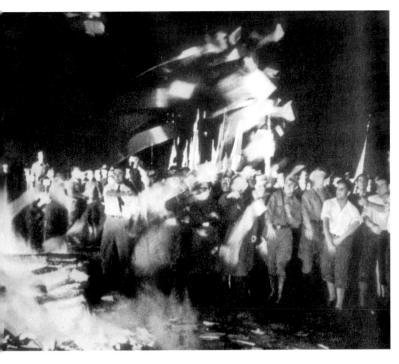 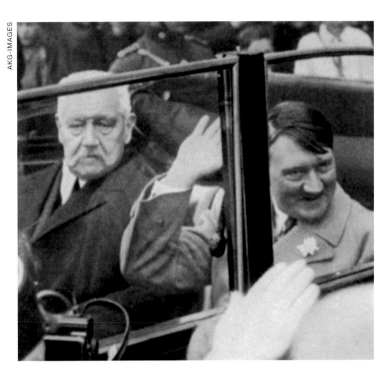

AKG-IMAGES

Left: Students and National Socialists throw black-listed literature into the fire on the Berlin Opernplatz, May 10th, 1933.
Right: Reich President Paul von Hindenburg and Nazi leader Adolf Hitler, the newly appointed Chancellor of Germany, ride in an open car during a parade, Germany.

1930
The Nazi Party becomes the second largest political party in Germany.

1933
JANUARY
Adolf Hitler is appointed Chancellor of Germany.

FEBRUARY
Nazis burn the Reichstag building to create a crisis atmosphere.

Emergency powers are granted to Hitler.

MARCH
The first concentration camp for Jews opens at Dachau, 12 kilometers from downtown Munich.

APRIL
Nazis stage a boycott of Jewish shops and businesses.

The Gestapo is born. With unrestricted power of arrest and confinement, these "secret police" change the face of German social and cultural history.

MAY
Burning of books throughout Germany.

JULY
Nazi Party is declared the only legal party in Germany.

SEPTEMBER
Nazis prohibit Jews from holding land.

OCTOBER
Jews are prohibited from becoming newspaper editors.

NOVEMBER
Nazis pass a law against "Habitual and Dangerous Criminals," which sends beggars, homosexuals, gypsies, and the homeless to concentration camps.

1934
MAY
Jews are denied national health insurance.

JUNE
Night of the Long Knives—Hitler and Goering conduct a purge of the SA.

JULY
The SS (the most elite paramilitary "protection corps") is made independent from the SA.

AUGUST
President von Hindenburg dies. Hitler becomes Fuhrer and receives 90% approval from the German voters.

1935
MAY
Nazis ban Jews from serving in the military, though they had served in WWI.

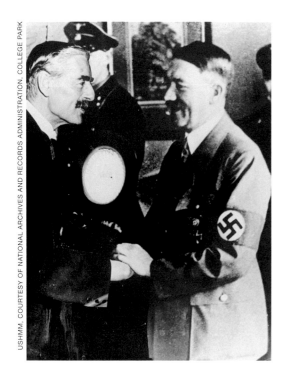

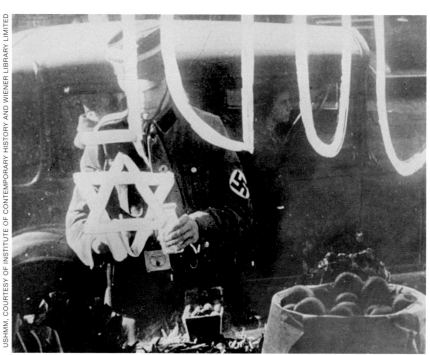

Left: Adolf Hitler greets Neville Chamberlain upon the British Prime Minister's arrival in Munich, September 29, 1938.
Right: An SA member paints the word 'Jude' and a Jewish star on the window of a Jewish-owned business.

SEPTEMBER
Nuremberg Race Laws against Jews decreed. "Law for the Protection of German Blood and Honor" is passed to prevent marriage and sexual relations between Jews and non-Jews.

1936
MARCH
SS Death's Head units are established to guard concentration camps.

AUGUST
Olympic games begin in Berlin. Hitler and top Nazis refrain temporarily from actions against the Jews. The American sprinter, Jesse Owens, wins four gold medals and becomes the star of the Olympic games. Hitler refuses to be photographed with Owens because he is a Negro.

1937
JANUARY
Jews banned from professional occupations. Also denied tax deductions. This deterioration of the nation causes Pope Pius XI to condemn the Nazi doctrine. Germany begins to remilitarize and defaults on nearly all of its war reparations. It is allowed to annex territories under the nose of Neville Chamberlain.

1938
MARCH
Nazi troops enter Austria. The SS is immediately placed in charge of Jewish affairs under Adolf Eichmann.

APRIL
Nazis order Jews to register wealth and property.

JULY
Nazis order Jews over the age of 15 to apply for identity cards that must be shown on demand to police officers. Jewish doctors are prohibited by law from practicing medicine.

AUGUST
Nazis destroy the synagogue in Nuremberg. Jews are required to add "Israel" (male) or "Sarah" (female) to their names on all legal documents and passports.

SEPTEMBER
Jews are prohibited from all legal practices. Aryan (the Nazi "Superman" race) doctors are not to treat Jewish patients.

OCTOBER
Law requires Jewish passports to be stamped with a large red "J".

Germans occupy the Sudetenland province of Czechoslovakia.

NOVEMBER
Kristallnacht—The Night of Broken Glass
Hundreds of synagogues are destroyed. Over 7,000 Jewish stores have their windows smashed in and are then looted. Jewish cemeteries are desecrated.

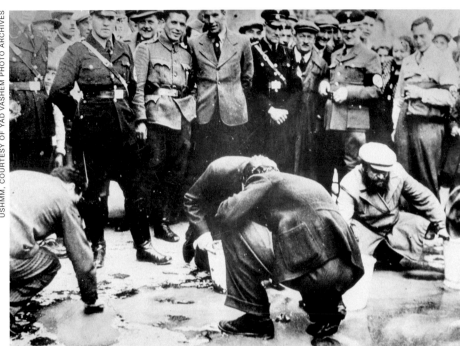

USHMM, COURTESY OF YAD VASHEM PHOTO ARCHIVES

Left: Germans walk past a Jewish-owned business destroyed during Kristallnacht.
Right: Austrian Nazis and local residents look on as Jews are forced to get on their hands and knees and scrub the pavement.

In the middle of the night, Nazis pull Jewish men onto the street, forcing them on hands and knees to scrub the street with toothbrushes. Some elderly Jews, under such humiliation, kill themselves. Yet, the police still round up 35,000 men and send them to concentration camps. They are subsequently released due to the outrage in British newspapers calling Germany's actions a return to the dark ages and an "orgy of savagery."

DECEMBER
Hermann Goering is appointed to resolve "the Jewish Question."

1939
JANUARY
SS officer Reinhard Heydrich is ordered by Goering to speed up the emigration of the Jews.

Hitler threatens Jews in Reichstag speech: *"In the course of my life, I have very often been a prophet, and have usually been ridiculed for it. During the time of my struggle for power it was only the Jewish race that received my prophecies with laughter when I said that I would one day take over the leadership of the State, and with it that of the whole nation, and that I would then among other things settle the Jewish problem. Their laughter was uproarious, but I think for some time now they have been laughing on the other side of their face. Today, I will once more be a prophet: if the international Jewish financiers in and outside Europe should succeed in plunging the nations once more into a world war, then the result will not be the Bolshevizing of the earth, and thus the victory of Jewry, but the annihilation of the Jewish race in Europe!"*

MARCH
Nazi troops seize Czechoslovakia.

AUGUST
Germany and the Soviet Union sign a non-aggression pact called the Molotov-Ribbentrop agreement.

SEPTEMBER 1, 1939
Nazis invade Poland (the Jewish population is 3.35 million, the largest Jewry in Europe.) At 4:30 in the morning, Hitler's invasion starts. This invasion, known as "Operation White," begins World War II.

SEPTEMBER 8
SS Officer Reinhard Heydrich issues instructions to SS Einsatzgruppen (the paramilitary killer squads) to gather the Polish Jews in settlements near railroads prior to sending them to work camps. He also orders the SS Einsatzgruppen to kill the aristocracy of the non-Jewish Poles.

SEPTEMBER 27
Warsaw surrenders to the Nazis.

SEPTEMBER 29
Germany and the Soviets partition Poland. More than 2 million Jews now reside in

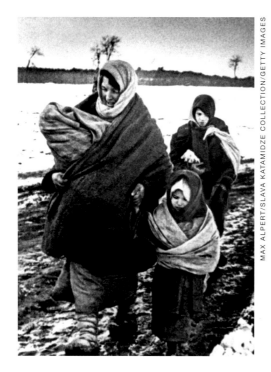

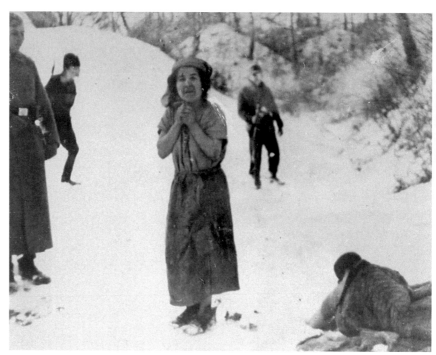

Left: Russian women and children walking to eastern Russia after the German invasion, 1941.
Right: A woman about to be executed in the Belzec concentration camp, Poland.

Nazi controlled areas. The Soviet area has 1.3 million Jews. Poland is to be governed by German civil authorities under the autocratic leadership of Hans Frank, who says, "All Jews must be wiped from the face of the earth."

1940
JANUARY
Polish Jews over the age of ten must wear an identifying yellow star on their outer clothing. Jewish bank accounts are frozen. They are allowed to withdraw only $50 per week.

Auschwitz is chosen as a hybrid camp near Krakow.

APRIL
Nazis invade Denmark and Norway

The first major ghetto is built at Lodz, Poland, with 230,000 Jews locked inside.

MAY
More than 3,000,000 Jews are in Hitler's clutches.

NOVEMBER
The Krakow ghetto is sealed off (pop. 70,000 Jews). The Warsaw ghetto is sealed off (pop.400,000 Jews). Mass deportations of Jews, Gypsies, and Poles from other Nazi-occupied countries to the over-crowded ghettos send thousands more. Hungary, Romania and Czechoslovakia become Nazi allies.

1941
MARCH
Heydrich is given the job of monitoring SS Einsatzgruppen in occupied Poland.

APRIL
Nazis invade Yugoslavia (Jewish pop. 75,000) and Greece (Jewish pop. 77,000)

JUNE
Germany attacks the Soviet Union. In doing

so it breaks the Molotov-Ribbentrop pact between the two nations.

JULY
As the German army advances, SS Einsatzgruppen follow along and conduct mass murder of Jews in seized lands. Heydrich orders the execution of all Jewish prisoners of war.

SEPTEMBER
The Vilna ghetto in Lithuania is established, containing 40,000 Jews.

OCTOBER
Germans advance on Moscow ("Operation Typhoon").

NOVEMBER
Theresienstadt camp is established near Prague. The Nazis will use it as a model ghetto for propaganda purposes.

Outside Riga, a mass shooting of Latvian and German Jews takes place.

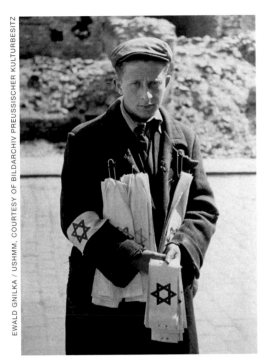

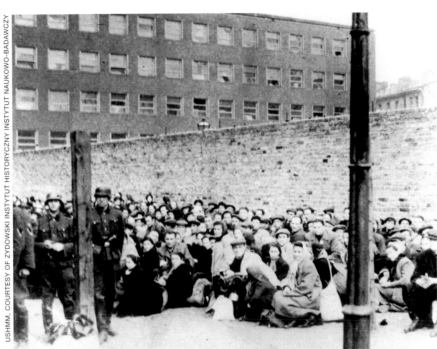

Left: A youth sells armbands on the street in the Warsaw ghetto.
Right: Jews who have been rounded-up in the Warsaw ghetto are seated on the ground in the Umschlagplatz awaiting deportation.

DECEMBER
In occupied Poland, near Lodz, Chelmo extermination camp becomes operational. Jews taken there are placed in mobile gas vans and are driven to a burial place while carbon monoxide from the engine exhaust is fed into the sealed rear compartment.

Lvov ghetto is formed.

Nazis begin to shoot women and children at close range.

1942
JANUARY
Death camps begin operations. Poland is the site of six major concentration camps set up to kill Jews: Lublin, Kulmhof, Auschwitz, Treblinka, Sobibor, and Belzec.

Mass killings of Jews using Zyklon-B begin at Auschwitz-Birkenau with the bodies being buried in mass graves in a nearby meadow.

The Wannsee Conference accelerates the elimination of the Jews. At Hitler's order, Goering instructs Heydrich to present plans for the "Final Solution" to the Jewish problem. The goal is to kill 12 million Jews. The conference is attended by many conservative German lawyers who raise their glasses to toast and accept the goals sought by the conference.

MARCH
Poland becomes the Nazi regime's dumping ground for Jews from all over Europe. Hundreds of thousands of Jews also perish in Lithuania, Latvia, Romania, Hungary, Russia, Germany.

Belzec extermination camp in Poland is operational.

APRIL
The first transports of Jews arrive at Majdanek concentration camp, Lublin, Poland.

MAY
In occupied Poland, Sobibor extermination camp becomes operational. The camp is fitted with three gas chambers using carbon monoxide piped in from engines, but will later substitute Zyklon-B.

JUNE
Gas vans used in Latvia. SS reports state that 97,000 persons have been "processed" in mobile gas vans.

The New York Times reports via the London Daily Telegraph that more than 1,000,000 Jews have been killed by Nazis.

JULY
Himmler grants permission for sterilization experiments at Auschwitz. Deportations from Holland begin to Auschwitz. Deportations begin from the Warsaw ghetto to Treblinka, the new extermination camp in Poland.

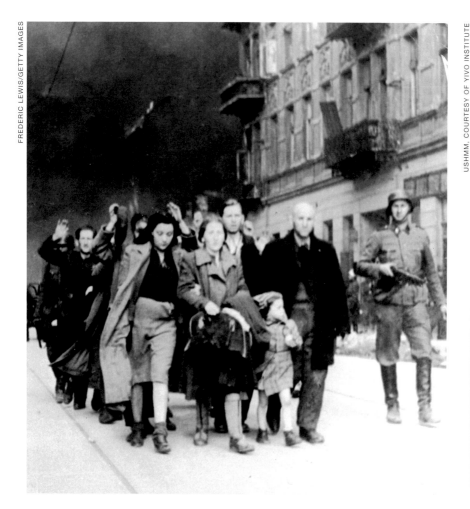

Left: Captured Jewish civilians who participated in Jewish ghetto uprisings are marched out of the Warsaw by Nazi troops, April 19, 1943.

Right: Elderly Jews are transported by wagon to an assembly point during the *Gehsperre* (curfew) action in the Lodz ghetto.

OCTOBER

Himmler orders all Jews in concentration camps in Germany to be sent to Auschwitz and Majdanek. The first transport from Theresienstadt arrives at Auschwitz.

DECEMBER

Exterminations at Belzec cease after an estimated 600,000 Jews have been murdered. The camp is dismantled and plowed.

1943
JANUARY

The number of Jews killed by SS Einsatzgruppen passes one million.

FEBRUARY

Germans surrender at Stalingrad in the first big defeat of Hitler's armies.

MARCH

The Krakow ghetto is liquidated. Three newly built gas chambers and crematoriums open at Auschwitz.

APRIL

The Warsaw ghetto is liquidated. Jewish resistance begins in January and continues into May as Jews fight bravely to the end. More than 300 German soldiers are killed in the uprising.

NOVEMBER

Nazis carry out "Operation Harvest Festival" in occupied Poland, killing 18,000 at Majdanek

1944
JANUARY

The severe Russian winter aids the army in pushing back the Germans and ends their 900-day seige of Leningrad.

MARCH

Nazis occupy Hungary (Jewish pop. 725,000). Eichmann arrives with Gestapo.

JUNE

Half of the Jews from Hungary (381,661) arrive at Auschwitz.

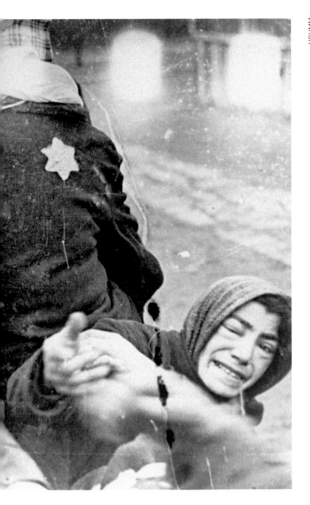
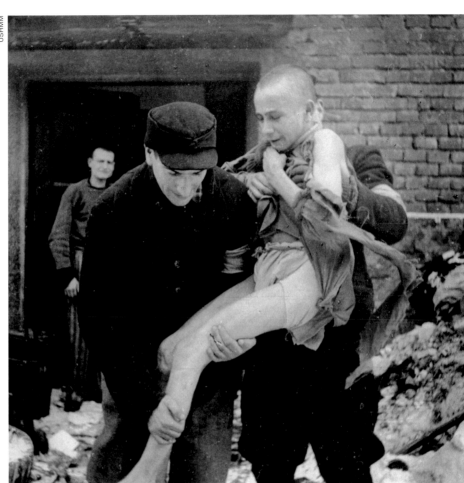

Right: Members of the Red Cross carry 15-year old Ivan Dudnik out of a building at Auschwitz after its liberation by Soviet troops, on January 26, 1945.

Himmler orders liquidation of all Jewish ghettos in occupied Poland.

AUGUST
Soviet troops liberate their first concentration camp at Majdanek and enter Romania.

OCTOBER
Nazis seize control of the Hungarian puppet government which resumes deporting Jews. Eichmann arrives in Hungary.

Soviet troops capture Riga and liberate Salaspiels camp.

Hungarian Jews are next on the list as the Red Army closes in on Hungary. SS Colonel Adolf Eichmann returns to liquidate the Hungarian Jewry. The Nazis crush 437,000 Hungarian Jews into 147 cattle cars, and drown others in the Danube.

1945
JANUARY
Soviets liberate Budapest, freeing more than 60,000 Jews.

Soviet troops invade eastern Germany.

Liberation of Warsaw by the Soviets.

Soviet troops liberate 66,000 from Auschwitz.

APRIL
Allies liberate Buchenwald.
U.S. 7th Army liberates Dachau.
Hitler commits suicide in his bunker in Berlin.

U.S. troops free 33,000 inmates from concentration camps.

Hermann Goering is captured by members of U.S. 7th Army.

NOVEMBER 19, 1945 – OCTOBER 1, 1946
The Nuremberg trials take place. All of the defendants deny any knowledge of the truth about the concentration camps.

THE MOLOTOV-RIBBENTROP PACT

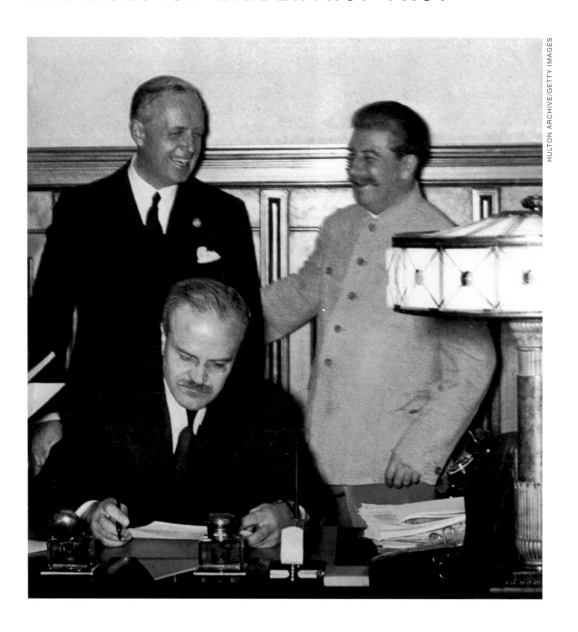

AUGUST 19, 1939—SIGNING OF THE NON-AGGRESSION PACT

Hitler was preparing an imminent attack on Poland. Realizing, he could not fight a war on two fronts, he engaged the Soviets and their military strength. As a gift for Soviet cooperation, Hitler promised them the Baltics (Estonia, Lithuania and Latvia). Poland was to be divided between Germany and Russia. The pact agrees that neither country will attack the other. It has a duration clause of ten years. It lasts two.

Above: Joachim von Ribbentrop, German foreign minister (left), Soviet premier Joseph Stalin (right), and Viachislav Mikhailovich Molotov (seated), Soviet foreign minister, sharing a joke at the signing of the Molotov/Ribbentrop Pact, a.k.a. the Soviet-German Non-Aggression Treaty.

Joachim von Ribbentrop (1893–1946)

GENERAL PHOTOGRAPHIC AGENCY/GETTY IMAGES

JUNE 22, 1941, BERLIN— BREAKING OF THE PACT

...The telephone in the Soviet Embassy in Berlin rings at three in the morning awakening Counselor Valentin Berezhkov...a voice that is unfamiliar says that Foreign Minister Joachim von Ribbentrop wishes to see Ambassador Dekanozov immediately...

...When Berezhkov and Dekanozov emerge on the Unter den Linden, they find a black Mercedes waiting. A uniformed officer of the SS Totenkopf Division, death's head emblem gleaming on his cap, escorts them. Over the Brandenburg Gate, the first rays of sun are already visible...the two Russians walk up a long staircase and down a corridor to von Ribbentrop's suite. The corridor is lined with uniformed men who snap to a smart salute and click their heels...

They enter von Ribbentrop's suite, a vast room with a desk at the far end where von Ribbentrop sits in his grey-green minister's uniform...As they sit at the table, von Ribbentrop begins to speak, slurring his words...it is obvious he is in fact, intoxicated. He presents Dekanozov a memorandum detailing Nazi allegations...stating that the Soviet forces have repeatedly violated the German state frontiers...the Fuhrer could not endure such a threat and has ordered appropriate military

Ribbentrop cuts him off sharply, rises a bit unsteadily and says, "The Fuhrer ordered me to announce to you officially these defensive measures."

countermeasures. Dekanozov interrupts...von Ribbentrop cuts him off sharply, rises a bit unsteadily and says, "The Fuhrer ordered me to announce to you officially these defensive measures."...The Russians rise...As the Russians near the door, von Ribbentrop hurries after them. Speaking rapidly, the words tumbling one after another in a hoarse whisper, he says, "Tell Moscow that I was against the attack."

The Germans had dropped bombs on Soviet, Lithuanian and Ukrainian soil an hour earlier.

—Harrison E. Salisbury, *The 900 Days*

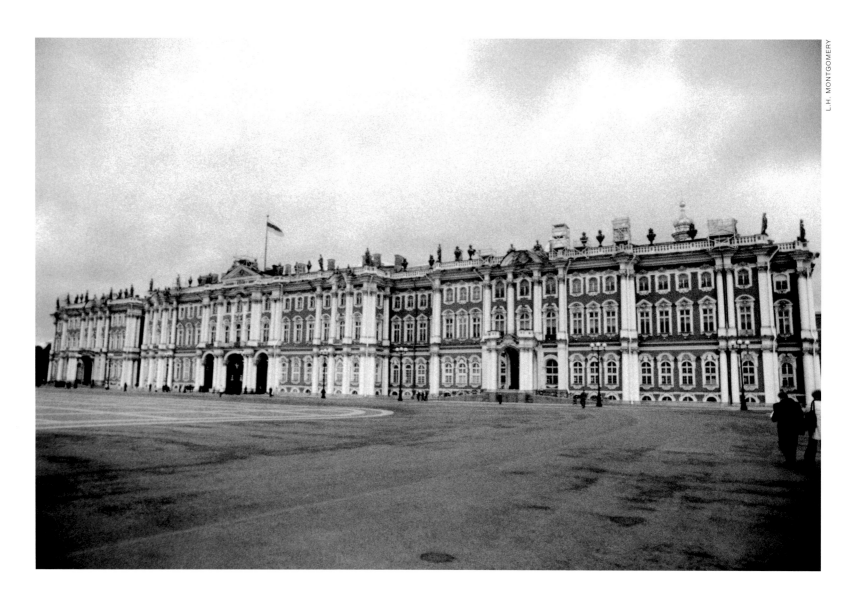

L.H. MONTGOMERY

THE HERMITAGE
JUNE 22, 1941 — NOON

Molotov's broadcast:

> *Men and women, citizens of the Soviet Union, the Soviet Government and its head, Comrade Stalin, have instructed me to make the following announcement:*
>
> *At 4 A.M., without declaration of war and without any claims being made on the Soviet Union, German troops attacked our country, attacked our frontier in many places and bombed from the air Zhitomir, Kiev, Sevastopol, Kaunas and other cities… This attack has been made despite the fact that there was a nonaggression pact between the Soviet Union and Germany, a pact the terms of which were scrupulously observed by the Soviet Union. We have been attacked although during the period of the pact the German Government had not made the slightest complaint about the U.S.S.R.'s not carrying out its obligations…The government calls upon you, men and women citizens of the Soviet Union, to rally even more closely around the glorious Bolshevik Party, around the Soviet Government and our great leader, Comrade Stalin. Our cause is just. The enemy will be crushed. Victory will be ours.*

Only a few wondered why it is Molotov, not Stalin, who speaks to the country. And certainly none, outside the innermost circle of the Kremlin suspect the truth—that Stalin has been thrust into traumatic depression from which he would not emerge for many days and weeks.

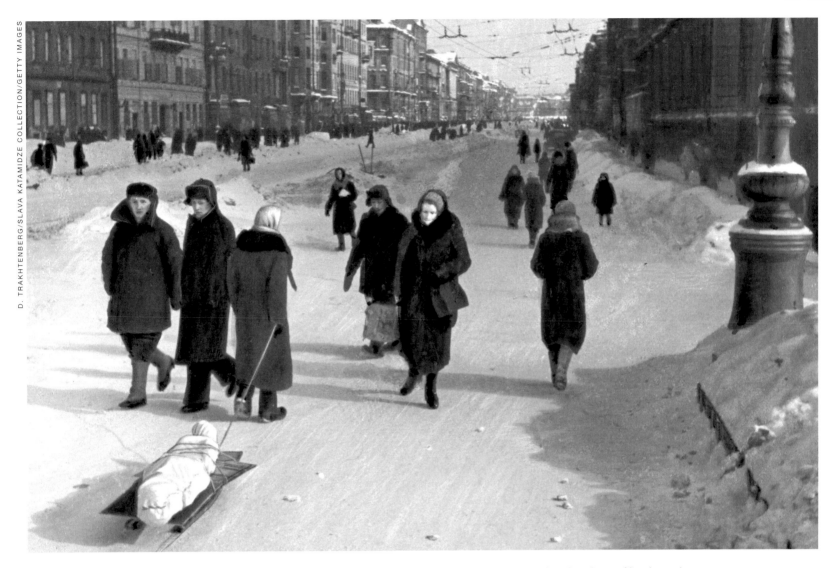

A woman carries away a corpse on a sledge down Nevski Prospect, Leningrad's main avenue, during the siege of Leningrad.

SIEGE OF LENINGRAD

In December they began to appear – the sleds of the children, painted bright red or yellow, narrow sleds with runners, sleds for sliding down hills, Christmas presents, small sleds, big enough for a boy taking a belly-flopper…The children's sleds, suddenly they were everywhere – on the Nevsky, on the broad boulevards, moving toward Ulitsa Marat, toward the Nevskaya Levra, toward Piskarevsky cemetery, toward the hospitals…The squeak, squeak, squeak of the runners sounded louder than the shelling. It deafened the ears. On the sleds were the ill, the dying, the dead….

— Harrison E. Salisbury, *The 900 Days*

The original figure announced by the Soviet Government of deaths by starvation – civilian deaths by hunger in the city of Leningrad alone – was 632,253. To this were added deaths in nearby Pushkin and Peterhof, bringing the total of starvation deaths to 641,803. These figures were attested to by the Leningrad City Commission to Investigate Nazi Atrocities and were submitted at the Nuremberg Trials in 1946.[3]

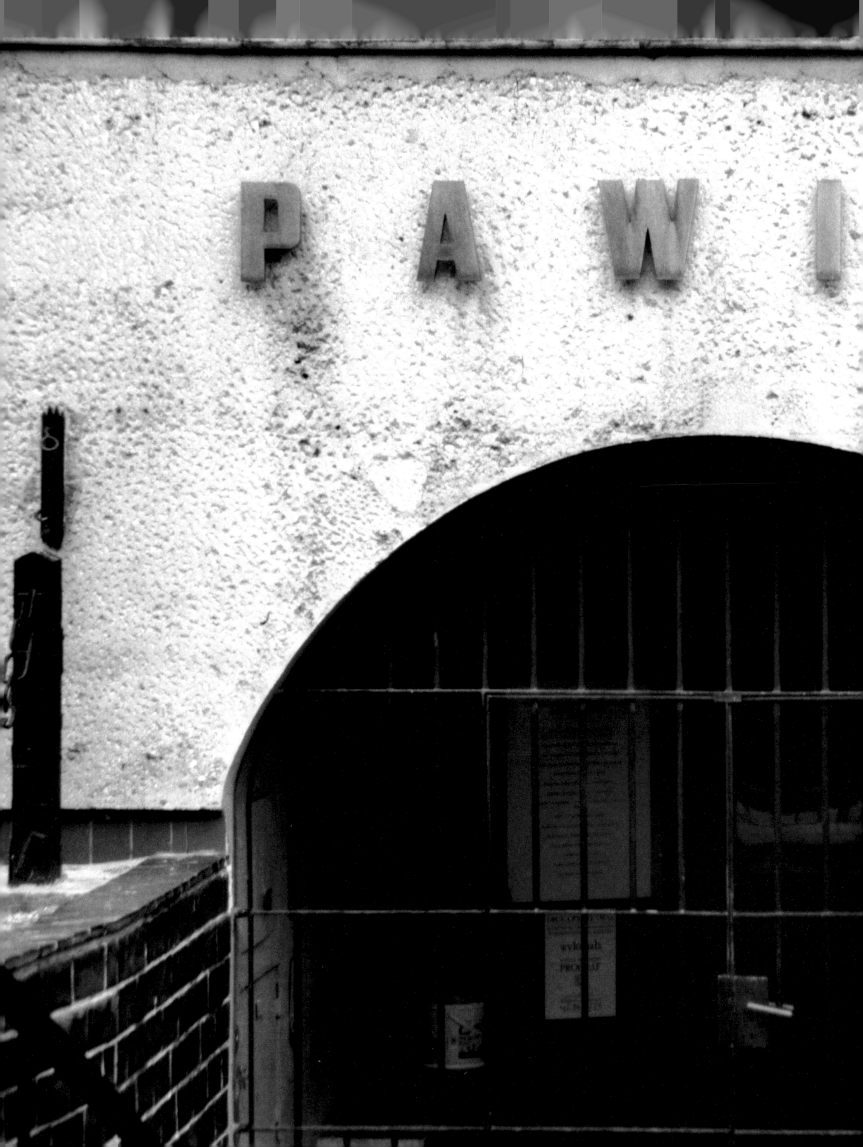

WARSAW

The notorious Warsaw Pawiak prison was turned into the Gestapo's personal place of torture and execution of Polish citizens.

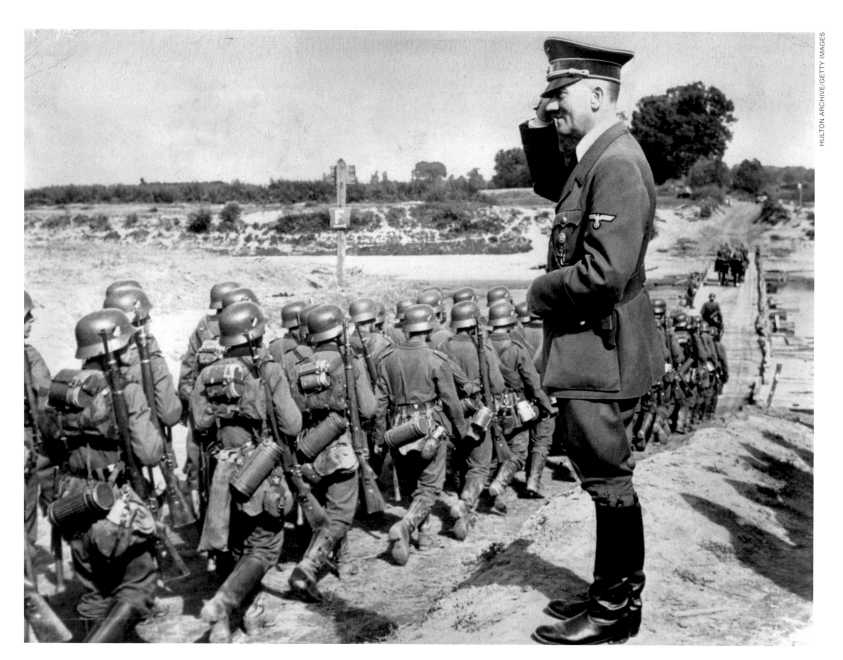

Hitler saluting German troops after the invasion of Poland, 1939.

HULTON ARCHIVE/GETTY IMAGES

SEPTEMBER 1, 1939

"Operation White" marked the beginning of Germany's invasion of Poland. Immediately upon entering Warsaw the Germans began the annihilation of the Polish intellectual elite.

> *The same day at three-fifteen in the afternoon, Warsaw Radio went off the air. A recording of Rachmaninov's Piano Concerto in C Minor was being broadcast, and just as the second, beautiful, peaceful movement was coming to an end, a German bomb destroyed the power station. The loud-speakers fell silent all over the city…*
>
> — Wladyslaw Spzilman, *The Pianist*

L.H. MONTGOMERY

PALMIRY FOREST

German-directed upheavals in the Polish population are immediate and drastic. At first, Nazis captured victims from the intellectual community, took them to the forests of Palmiry and shot them there in secret. There are 2,115 buried here, but only one Star of David. During the first months of the war, tens of thousands of Polish intellectuals, including many teachers and religious leaders are killed.

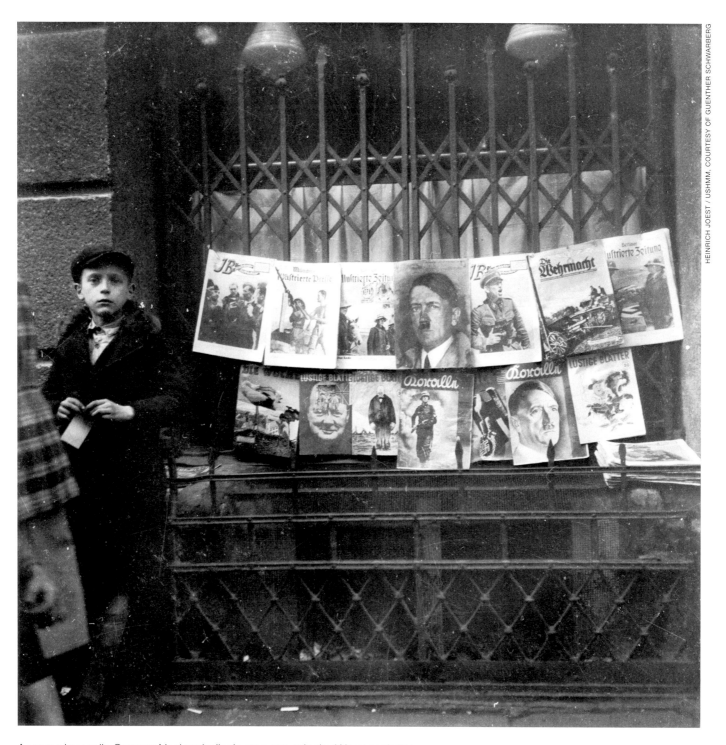

A young boy sells German Nazi periodicals on a street in the Warsaw ghetto.

…In the surrounding silence of night, the cries of hungry beggar children are terribly insistent and no matter how hard your heart, eventually you have to throw a piece of bread down to them…they are afraid of nothing and no one… It is a common thing for beggar children like these to die on the sidewalk at night.

—Moshe Ayalon *Jewish Life in Breslau 1938-1941*

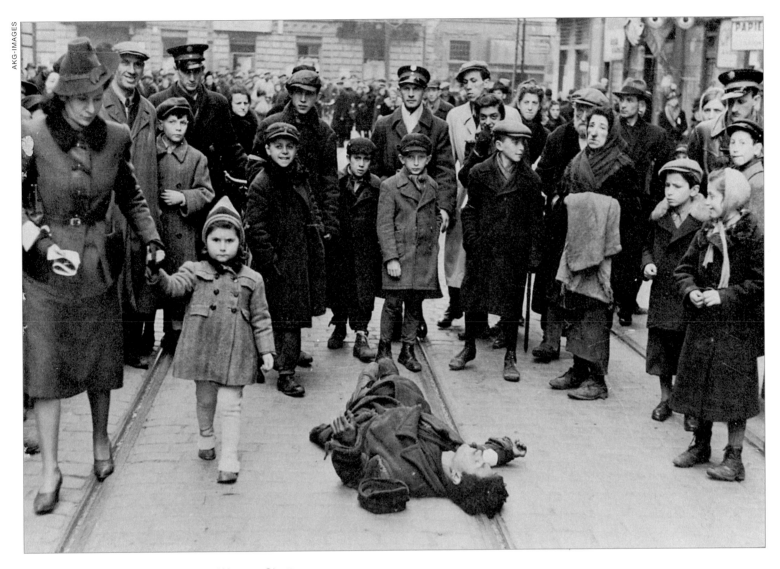

Victims of hunger and typhoid in the Warsaw Ghetto.

By 1941, the Poles are crushed by Nazi occupation, looking daily to the east for Soviet aid, or for Allied food drops, or even better for RAF liberation. Due to Winston Churchill. the RAF risk their lives daily by making "fly overs" to drop supplies and ammunition into the waiting arms of the Warsaw Home Army. The RAF pay dearly. For every ton of dropped supplies, one aircraft is shot down.

In the beginning of 1942, the surviving Warsaw Jews from the ghetto are "resettled" to the death camp in Treblinka.

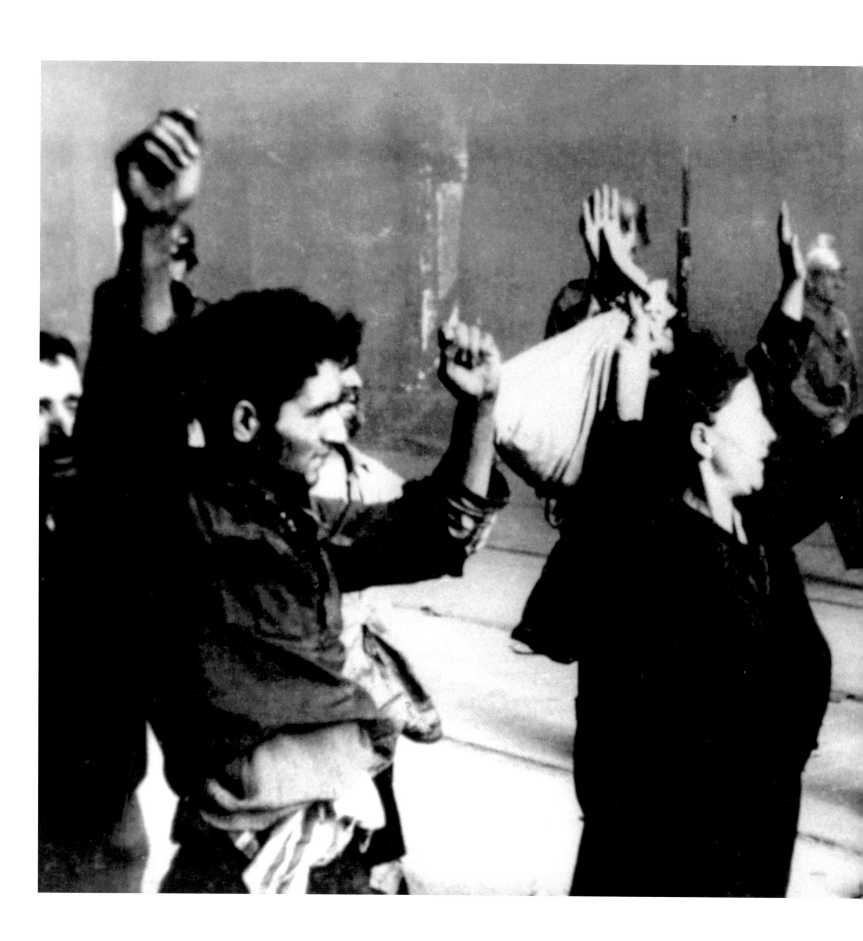

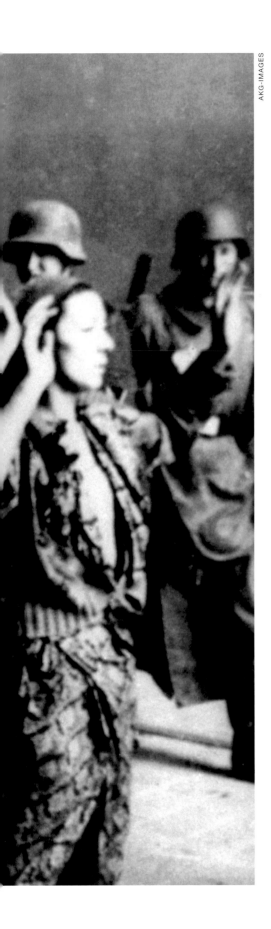

AKG-IMAGES

*...We write a letter to the awe-inspiring cracking of guns of the German squads
carrying out the public mass executions in the streets of our towns...950 hostages,
seized in the streets or dragged out of their homes, have been shot in Warsaw—only
in groups of 10 to 100... There is no doubt that the Germans will go on killing our
youth, workers, peasants and educated classes...Transports to concentration camps
continue in endless procession...the crematories in the camps burn day and night...
our losses have mounted to 5-6 million dead—of whom 2.5 million are Polish citizens
of Jewish faith, who were murdered for the simple reason that they were born Jews.*[1]

— Stanislaw Mikolajczyk,
Central Executive Committee of the Polish Socialist Party,
Warsaw, January 10, 1944

Units of the Waffen-SS and the police use extreme force to quash the uprising in the
Warsaw ghetto. Jewish resistance fighters are led away with their hands in the air.

1 Report by Warsaw Poles to Deputy Prime Minister Clement Attlee, Courtesy of Hoover Institute Archives, Stanford, California

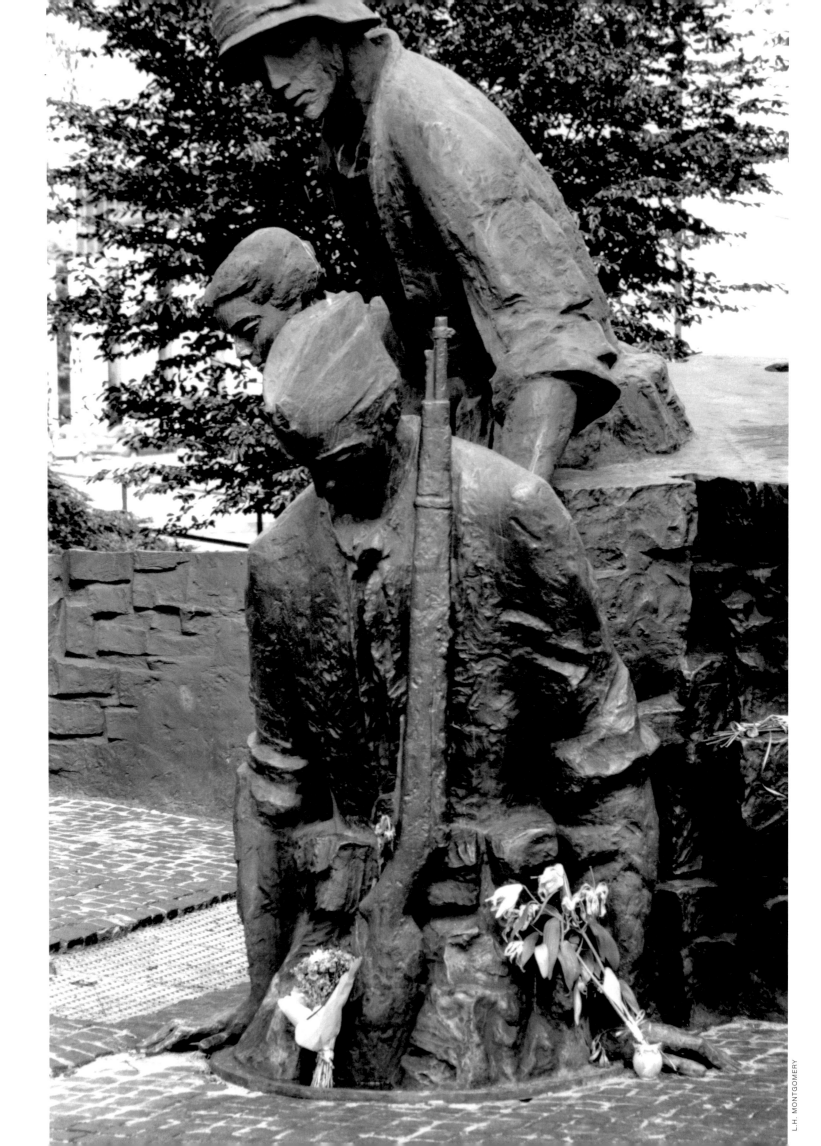

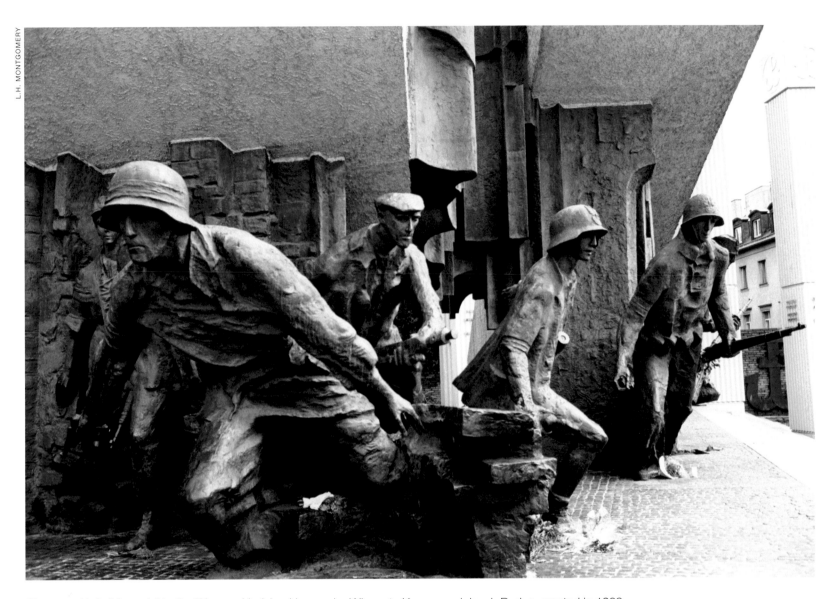

L.H. MONTGOMERY

Above and left: *Memorial to the Warsaw Uprising Heroes*, by Wincenty Kucma and Jacek Budyn, erected in 1989.

THE WARSAW UPRISING, AUGUST 1, 1944

As the Germans advanced, thousands of freedom fighters crawled though the underground sewers. Some went mad, confined in the stench and dark, others got disoriented and lost, still others committed suicide, some escaped to tell the story.

After 63 days and nights of resisting, the people of Warsaw, abandoned by their allies, and left to the Nazis, either surrendered or killed themselves. Their courageous struggle over, the brave battle for Warsaw lost, one of the great capitals of Europe disappeared block by block by block. At the end of the day, the grandest city of Poland, the home of Chopin and opera, was a smoking field of dead Jews and exhausted Nazis. The Soviets, in silence and denial, had given birth to the first chapter of the Cold War.

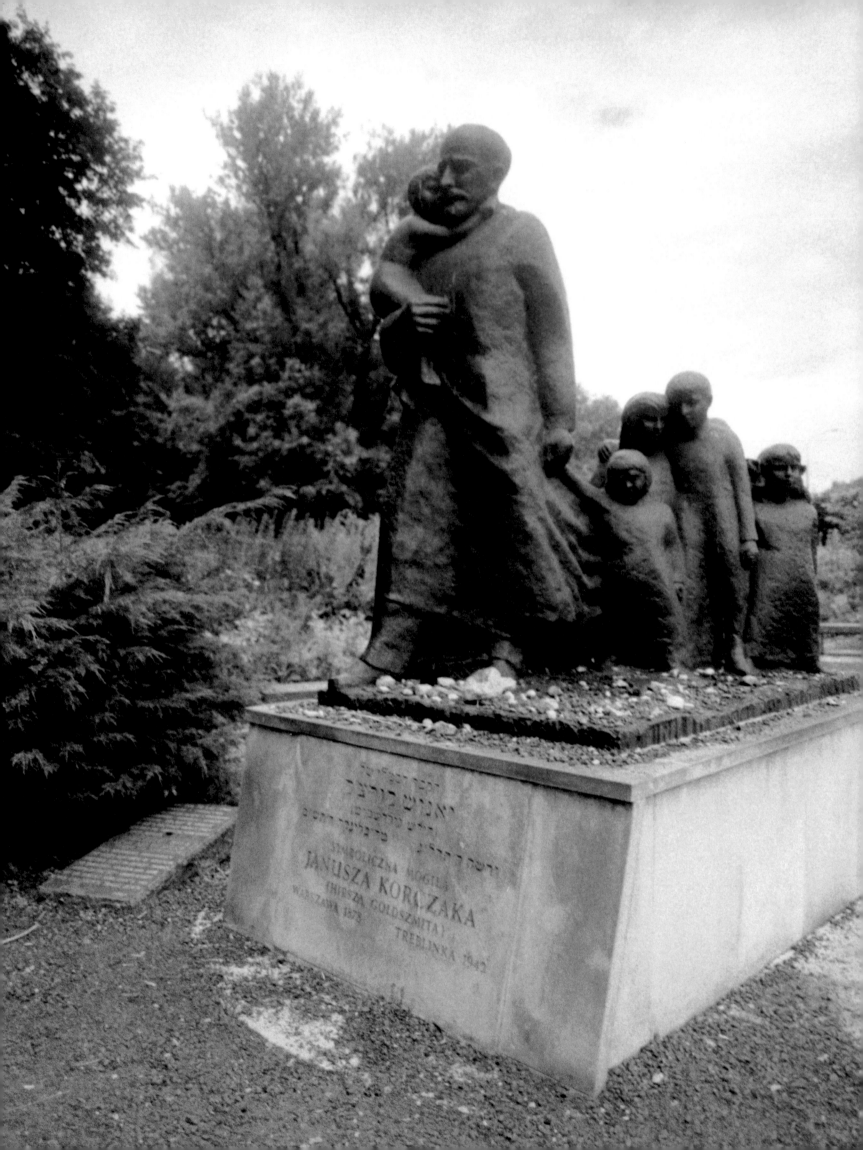

"One day, around 5 August when I had taken a brief rest from work and was walking down Gesia Street, I happened to see Janusz Korczak and his orphans leaving the ghetto. The evacuation of the Jewish orphanage run by Janusz Korczak had been ordered for that morning. The children were to have been taken away alone. He had the chance to save himself and it was only with difficulty that he persuaded the Germans to take him too. He had spent long years of his life with children and now, on this last journey, he would not leave them alone. He wanted to ease things for them. He told the orphans they were going out into the country, so they ought to be cheerful. At last they would be able to exchange the horrible, suffocating city walls for meadows of flowers, streams where they could bathe, woods full of berries and mushrooms. He told them to wear their best clothes, and so they came out into the yard, two by two, nicely dressed and in a happy mood. The little column was led by an SS man who loved children, as Germans do, even those he was about to see on their way into the next world. He took a special liking to a boy of twelve, a violinist, who held his violin under his arm. The SS man told him to go the head of the procession of children and play...and so they set off.

When I met them in Gesia Street, the smiling children were singing in chorus, the little violinist was playing for them and Korczak carrying two of the smallest infants, who were beaming, as he was telling them some amusing story. I am sure that even in the gas chamber [at Treblinka], as the Zyklon-B gas was stifling their childish throats and striking terror instead of hope into the orphan's hearts, the Old Doctor must have whispered with one last effort, "It's all right, children, it will be all right," so that at least he could spare his little charges the fear of passing from life to death...

—Wladyslaw Szpilman, *The Pianist*

The Warsaw ghetto orphanage had 192 children that went to the death camp at Treblinka in the summer of 1943. The founder of the orphanage, Henryk Goldschmit, a Jew, used a Gentile pseudonym, Janusz Korczak. Under his Gentile name, he was offered the chance to be excused by an SS officer. He refused and led his little colony of orphans to the railway station.

Left: Memorial to Janusz Korczak in the Powazki Cemetery in Warsaw.

AUSCHWITZ-BIRKENAU

Auschwitz has become the world's symbol of the Jewish Holocaust, but Auschwitz was the site of death of only 20% of the 6 million Jewish victims of Nazi genocide.

> *...This is why for us today it is not merely a question of fighting against Nazism, or for Poland, or for the Czechs, or for our civilization, but to fight in order to survive. Those who have left their farms, their shops, their factories, fight in order not to become mere fertilizer for German prosperity. They have gone out to gain the right to live and to live in peace.*
>
> —Antoine de Saint-Exupery,
> *Wartime Writings – 1939-1944*

While flying a World War II spy mission for the Allies, in 1944, Antoine Saint-Exupery's plane disappeared over the village of Mougins, falling into the Mediterranean. Only a year before, he had written his most famous book, "The Little Prince."

L.H. MONTGOMERY

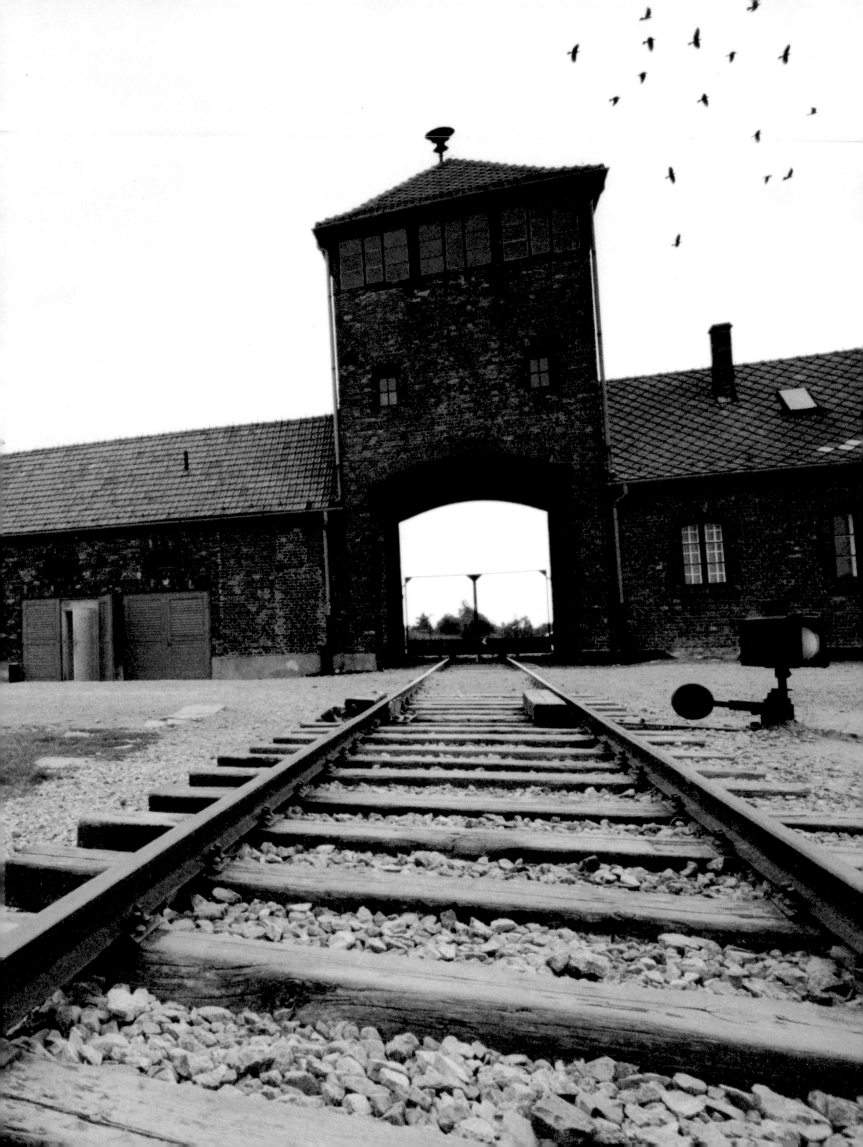

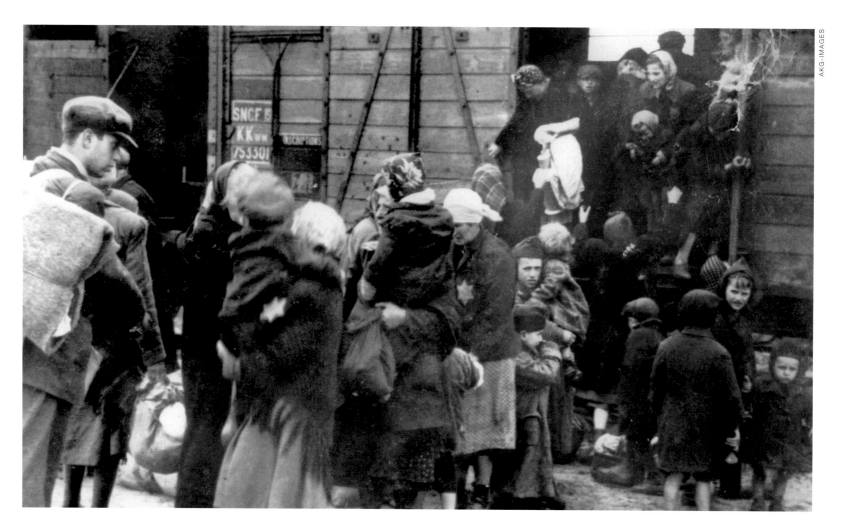

Deportation of women and children in a railroad cattle car.

…By the time we made our way to the train the first trucks were already full. People were standing in them pressed close to each other. SS men were still pushing with their rifle butts, although there were loud cries from inside and complaints about the lack of air.

The smell of chlorine made breathing difficult, even some distance from the trucks. What went on in there if the floors had to be so heavily chlorinated? We had gone about halfway down the train when I heard someone shout, "Here! Here! Szpilman."

A hand grabbed me by the collar and I was flung back and out of the police cordon. Who dared do such a thing? I didn't want to be parted from my family. I wanted to stay with them…My view was now of the closed ranks of the policeman's backs. I threw myself against them, but they did not give way. Peering past the policeman's heads I could see Mother and Regina helped by Halina and Henryk, clambering into the trucks, while Father was looking around for me.

"Papa!" I shouted.

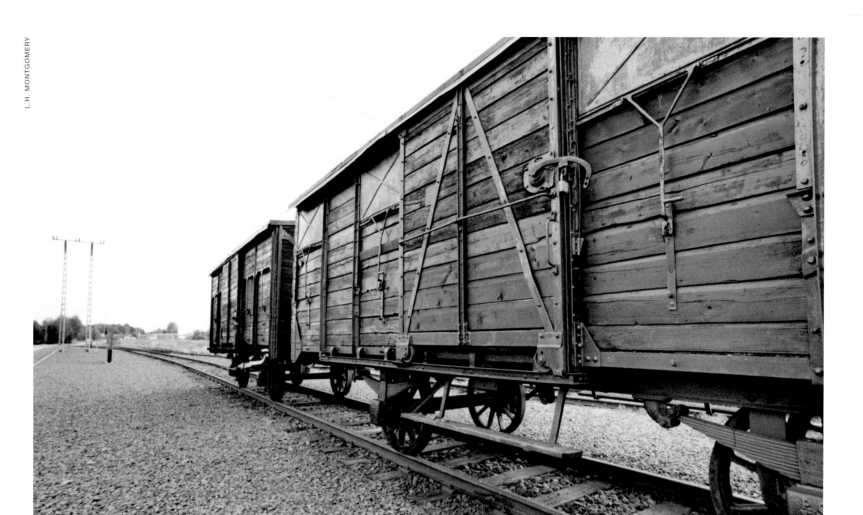

L.H. MONTGOMERY

Cattle cars used to deport Jews to concentration camps.

He saw me, took a couple of steps my way, but then hesitated and stopped. He was pale and his lips trembled nervously. He tried to smile, helplessly, painfully, raised his hand and waved goodbye, as if I were setting out into life and he was already greeting me from beyond the grave. Then he turned and went towards the trucks. I flung myself at the policeman's shoulders again with all my might.

"Papa! Henryk! Halina!"

I shouted like someone possessed, terrified to think that now, at the last moment, I might not get to them and we would be parted forever. One of the policeman turned and looked angrily at me.

"What the hell do you think you're doing? Go on save yourself."

The doors of the trucks had been closed, and the train was starting off, slowly and laboriously. I turned away and staggered down the empty street, weeping out loud, pursued by the fading cries of the people shut up in those trucks. It sounded like the twittering of caged birds in deadly peril.

—Wladyslaw Szpilman, *The Pianist*

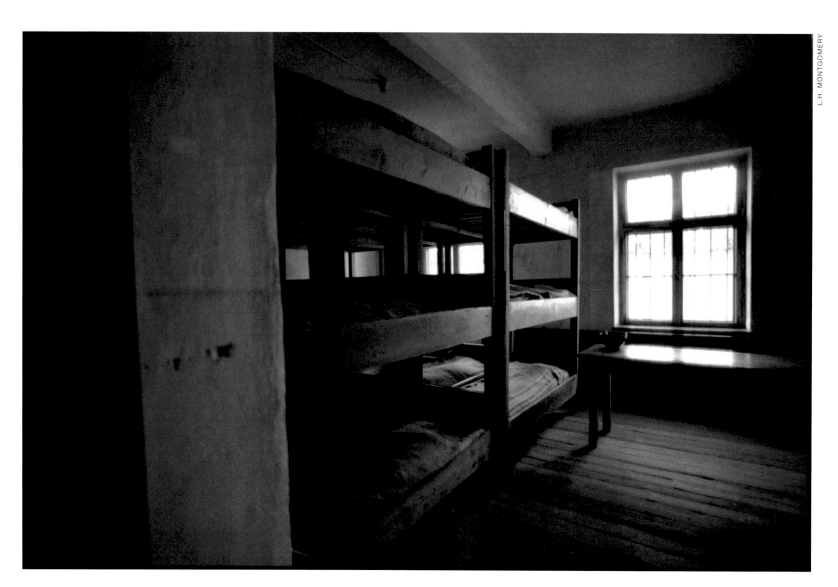

L.H. MONTGOMERY

Barracks at Auschwitz.

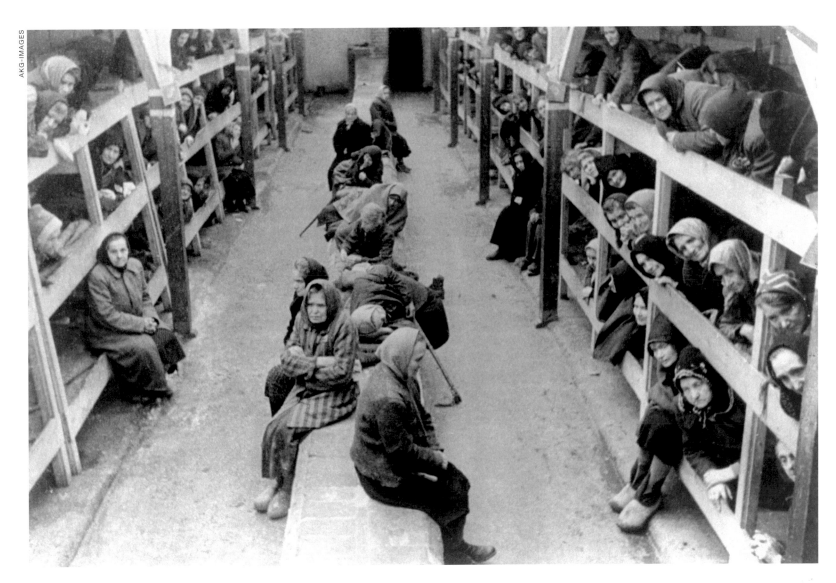

Female prisoners in barracks at Auschwitz.

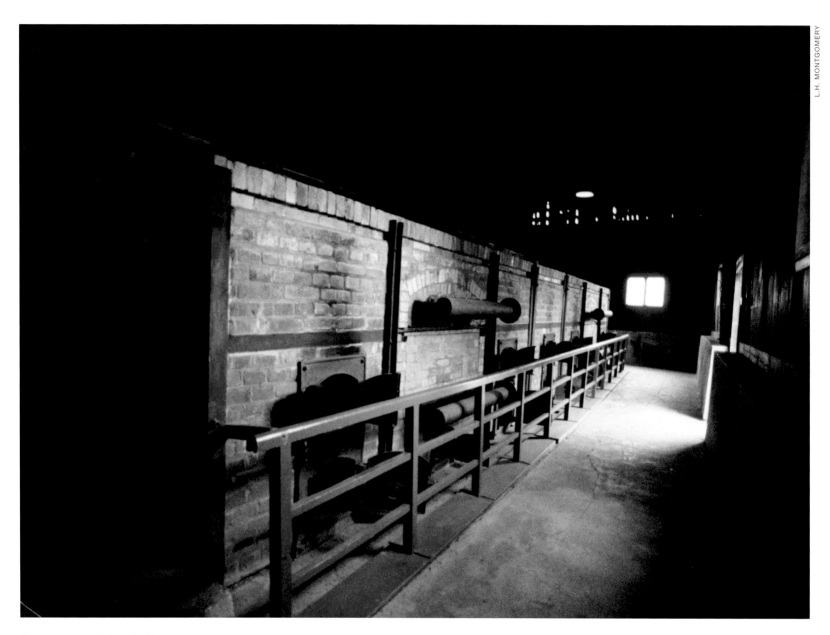

Crematorium at Auschwitz.

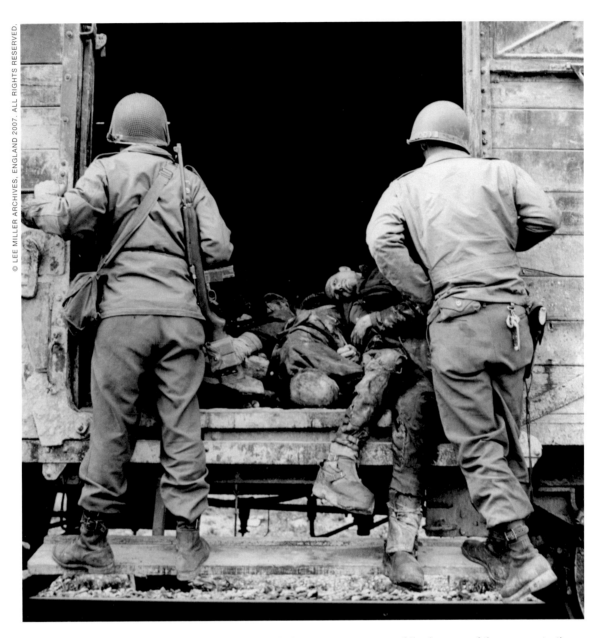

Members of the 42nd Rainbow Division of the 7th Army uncover some of the horrors of the concentration camp at Dachau.

Cable from Lee Miller, *Vogue* photographer, sent to *Vogue* magazine, May 8, 1945:

> *I implore you to believe this is true... No question that German civilians knew what went on.*
> *Railway siding into Dachau camp runs past villas, with trains of dead and semi-dead deportees.*
> *I usually don't take pictures of horrors, but don't think that every town and every area isn't*
> *rich with them. I hope Vogue will feel that it can publish these pictures.*
>
> —Lee Miller

Vogue ran Lee's cable below the headline in extra bold: BELIEVE IT.

TREBLINKA

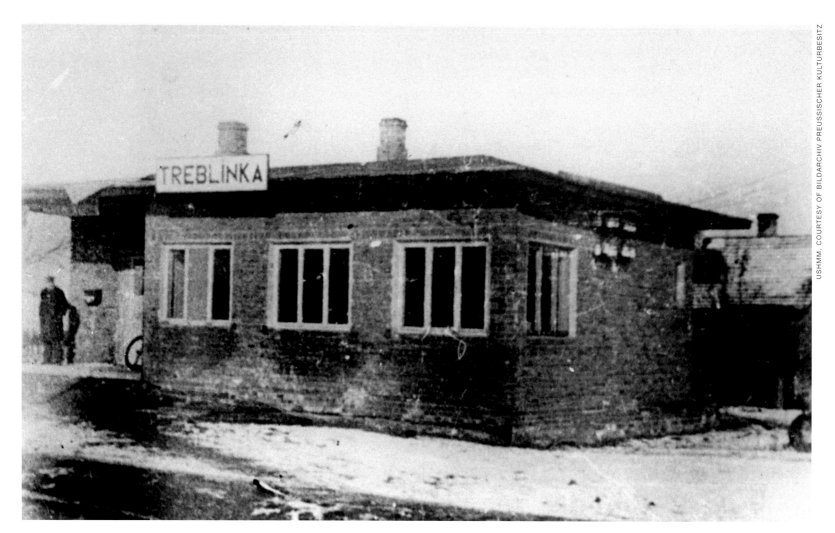

Train station in Treblinka. Treblinka, one of the "Operation Reinhard" camps, was the largest extermination camp of Polish Jews.

Trains from other European countries than Poland arrived at Treblinka in a very different manner...the people in them had never heard of Treblinka and believed to the last minute that they were going there to work...these special trains arrived with no guards, and with the usual staff. There were sleeping cars and restaurant cars in them. Passengers had big trunks, and suitcases, as well as substantial supplies of food. The passenger's children ran out at the stations they passed and asked whether it was still a long way to Ober-Maiden...

It is hard to tell whether it is less terrible to go towards one's own death in a state of terrible suffering, knowing that one was getting closer and closer to one's death, or to be absolutely unaware...

...In order to achieve the final deception for people arriving from Europe, the railroad dead-end siding was made to look like a passenger station. On the platform...stood a station building with a ticket office, baggage room and restaurant hall. There were arrows everywhere indicating To Bialystok, To Baranovich, To Volokovysk, etc. By the time the train arrived, there would be a band playing in the station building, and all the musicians were dressed well. A porter in railway uniform took tickets from the passengers and let them pass on to the square...

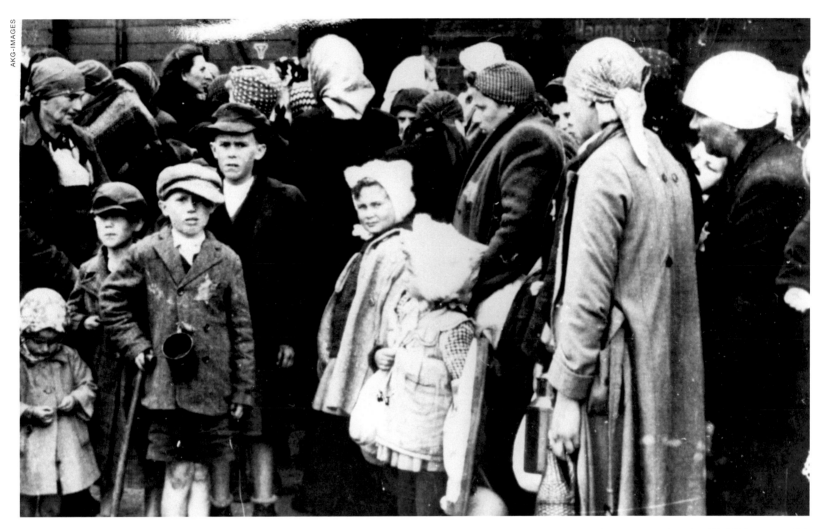

Arrival of Jews at the station platform. It is estimated by the Simon Wiesenthal Center that some 876,000 people were murdered at Treblinka: 874,000 Jews; 2,000 Gypsies.

And why, right where the platform ends...is there no more railway and only yellow grass growing behind a three metre high wire fence?...and the new guards grin in such a strange way...what is there behind this huge six-metre high wall, densely covered with yellow pine branches...and bedding? How did this bedding get here? Who brought it with them? And where are there owners? Why don't they need them any longer? And who are these people with light blue armbands? One remembers all the thoughts that have come into one's head recently, all the fears, the rumours...No, no, this can't be true. And one drives the terrible thoughts away...But finally everyone is in the square. And a terrible feeling of doom, of being completely helpless comes over them...it's impossible to run away or turn back, or fight. The barrels of large-calibre machine guns are looking at them from low wooden towers. Call for help?

But there are SS men and guards all around with sub-machine guns, hand grenades and pistols. They are the power. In their hands are tanks and aircraft, lands, cities, the sky, railways, the law, newspapers, radio. The whole world is silent, suppressed, enslaved by a brown gang of bandits which has seized power. London is silent and New York too. And only somewhere, on a bank of the Volga, many thousands of kilometers away, the Soviet army is roaring...

— Vasily Grossman, *A Writer at War*

USHMM, COURTESY OF THE JACOB RADER MARCUS CENTER OF THE AMERICAN JEWISH ARCHIVES

FRANZ STANGL

Franz Stangl joined the Austrian police force in 1931. By 1938, Stangl was a police superintendent at the Euthanasia Institute near Linz. In 1940, he became Commandant of the Sobibor death camp. In 1942, he was transferred to Treblinka as the Commandant. Stangl, a faithful husband and devoted father, was responsible for the deaths of more than 900,000 Jews in less than a year. At the end of the war, he was interned by the U.S. for being a member of the SS. His involvement in the Final Solution became known in 1947, and Stangl was imprisoned at Linz. In May, 1948, Stangl, with the aid of Bishop Alois Hudal, and other officials at the Vatican, escaped and made his way to Syria, where he was joined by his adored family. In 1951, they moved to Brazil where Stangl found work in a Volkswagen plant. In 1967, he was tracked down by Nazi hunter, Simon Wiesenthal, and arrested in Brazil. He admitted to the killings but argued, "My conscience is clear. I was simply doing my duty…" In 1970, Stangl was sentenced to life in prison. He died of heart failure in 1971.[1]

GITTA SERENY: Would it be true to say that you got used to the liquidation?

He thought for a moment.

FRANZ STANGL: To tell the truth, one did become used to it.
SERENY: In days? Weeks? Months?
STANGL: Months. It was months before I could look one of them in the eye. I repressed it all by trying to create a special place: gardens, new barracks, new kitchens, new everything; barbers, tailors, shoemakers, carpenters. There were hundreds of ways to take one's mind off it; I used them all.
SERENY: Even so, if you felt that strongly, there had to be times, perhaps at night, in the dark, when you couldn't avoid thinking about it?
STANGL: In the end, the only way to deal with it was to drink. I took a large glass of brandy to bed with me each night and I drank.
SERENY: I think you're evading my question.
STANGL: No, I don't mean to; of course, thoughts came. But I forced them away. I made myself concentrate on work, work and again work.
SERENY: Would it be true to say that you finally felt they weren't really human beings?
STANGL: When I was on a trip once, years later in Brazil—my train stopped next to a slaughterhouse. The cattle in the pens, hearing the noise of the train, trotted up to the fence and stared at the train.
They were very close to the window, one crowding the other, looking at me through that fence. I thought then, 'Look at this; this reminds me of Poland; that's just how the people looked, trustingly, just before they went into the tins…'
SERENY: You said tins…what do you mean?

But he went on without hearing or answering me.

STANGL: …I couldn't eat tinned meat after that. Those big eyes…which looked at me…not knowing that in no time they'd all be dead.

He paused. His face was drawn. At this moment he looked old and worn and real.

SERENY: So you didn't feel they were human beings?
STANGL: Cargo…they were cargo.

He raised and dropped his hand in a gesture of despair. Both our voices had dropped. It was one of the few times in those weeks of talks that he made an effort to cloak his despair, and his hopeless grief allowed a moment of sympathy.

—Gitta Sereny, *Into That Darkness*, Random House, 1974

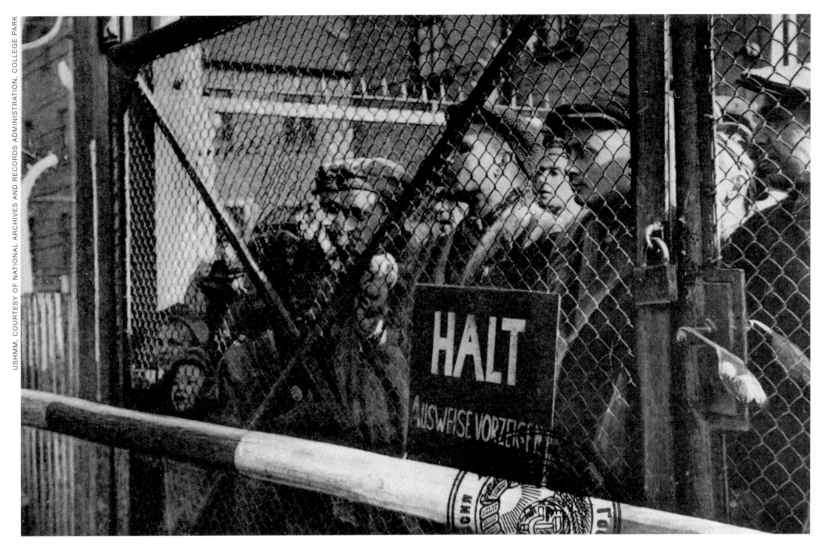

Inmates at the gate to Auschwitz concentration camp. The deportation to the camps within Poland for the Polish Jewry was executed by a train made up of 50 or so freight wagons. Each car was packed with about 80 people. Ventilation was through small vents, high up and wrapped in barbed wire. The use of chlorine as a disinfectant suffocated some of the children and elderly before they ever arrived at the camps.

MAJDANEK

On July 21, 1941, outside of Lublin, the Germans established
one of the first labor camps, Majdanek, to house Soviet POW's
as construction workers. The camp was created to house
25,000-50,000 prisoners to serve the Germanization of the
exquisite town of Lublin. After the Reich attacked Russia, the
camp was to be used both for labor and for extermination.
The deportations of Jews to Majdanek coincided with the
beginning of mass exterminations under "Operation Reinhard"
by SS officer Reinhard Heydrich.

On November 3, 1943 Majdanek was the site of one
of the largest massacres of Jews in World War II. Called
"Erntefest" ("Harvest Festival"), the shocking event was ordered
by Heinrich Himmler.

About 18,000 prisoners were marched without clothes
to the massive fields around the camp and into ditches, dug
days before, near the crematorium. Women and children
were placed in rows together. Men were lined up in different
ditches. To drown out the salvo of machine gun fire, two radio
cars and a loudspeaker played piercing waltz music. The
shootings, underneath the cover of German waltzes, took
approximately nine hours.

From that time on, until the summer of 1944, Majdanek
was used as a place of execution primarily for Poles who had
ties to the Resistance. Just before the Soviet troops reached
Lublin on July 23, 1944, 900 people were shot outside the
crematorium.

Majdanek was the first concentration camp liberated by
the Russians, on July 24, 1944.

L.H. MONTGOMERY

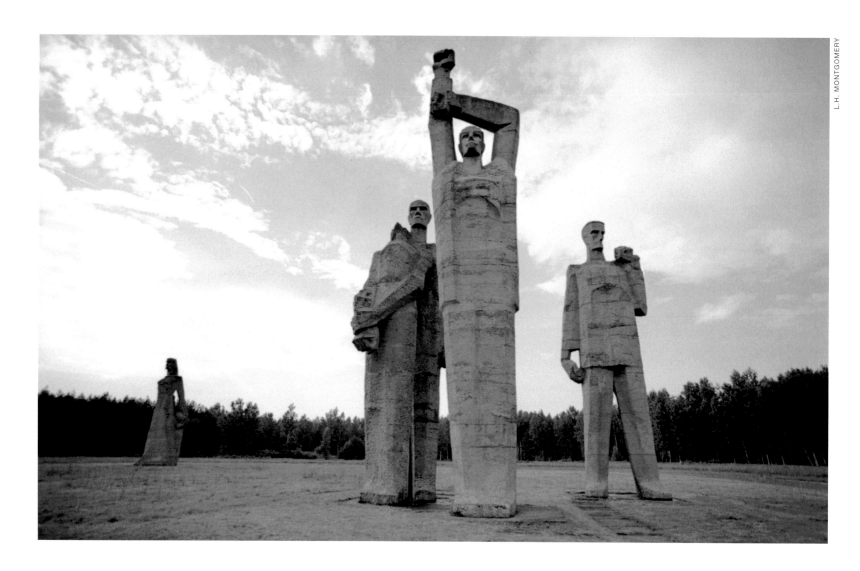

L.H. MONTGOMERY

LATVIA

Salaspiels is known as the "Baltic Auschwitz." Now huge monuments cover the burned ground of the former Nazi work camp, "Kurtenhof," built in 1941, and used for three years during the Nazi occupation of Latvia. The memorial of massive sculptures was erected in 1967 by the Russians to honor the more than 100,000 men, women and children put to death here by the Nazis. The group of sculptures is spoken of as "the unbroken" or "the unchained," referring to the annihilation of the Jews. I was totally alone in this empty, still space…the only sound was that of an hidden, electric metronome that tick tocks night and day, imitating the human heart beat.

—L.H.Montgomery

In 1950, Churchill sadly summarized the tragedy of the Baltic States:

> *"Hitler had cast them away like pawns in 1939. There had been a severe Russian and Communist purge…Presently Hitler came back with a Nazi counter-purge. Finally, in the general victory, the Soviets had control again. Thus the deadly comb raked back and forth, and back again, though Estonia, Latvia and Lithuania. There was no doubt however where the right lay. The Baltic States should be sovereign independent peoples."*

Hindsight suggests that the fate of the Baltic States was sealed once Molotov and Ribbentrop signed their infamous pact.

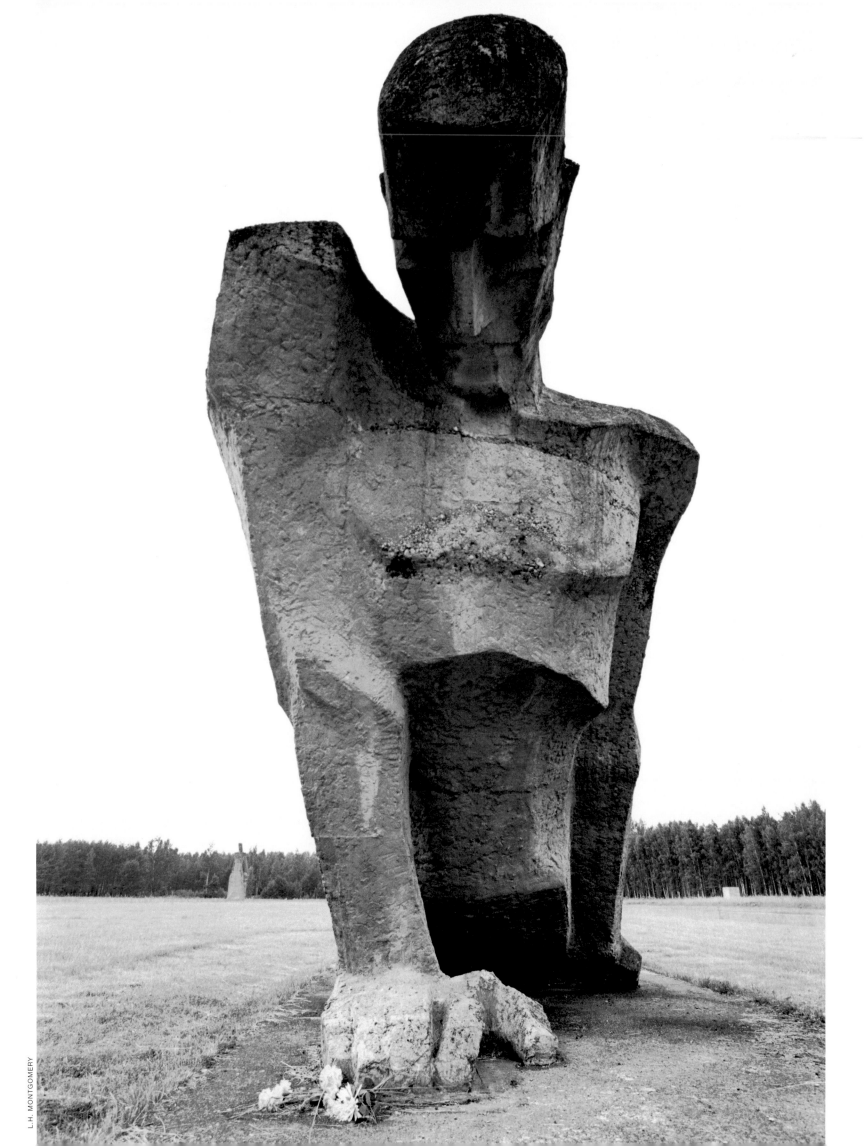

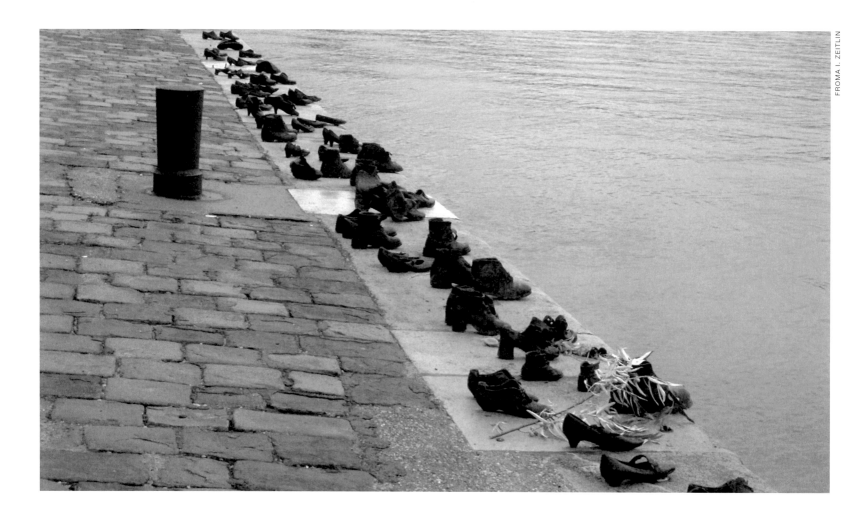

FROMA I. ZEITLIN

HUNGARY

There are 60 pair of shoes cast in iron representing the shoes of some thousands of Jewish victims shot and thrown into the Danube by the Arrow Cross regime of terror.

The catastrophe that befell Jews in Hungary during the Holocaust differs from the other genocidal procedures in Nazi dominated Europe because it came so late and happened almost overnight. The Germans were clearly losing on both fronts and Hungary had the last substantial, surviving community of Jews. After the invasion of Hungary in March, 1944, Adolf Eichmann personally supervised the deportation of Jews from the provinces to ghettos already in frightful condition. Most of the half a million deported Jews were sent to Auschwitz between May and July of 1944. In the winter of 1944, many of the remaining 200,000 Budapest Jews were routed out by the Hungarian Nazis, known as the Arrow Cross, and killed by the banks of the Danube.

Budapest was liberated by the Soviets on January 17, 1945. In the final count only 225,000 Hungarian Jews survived out of 825,000.

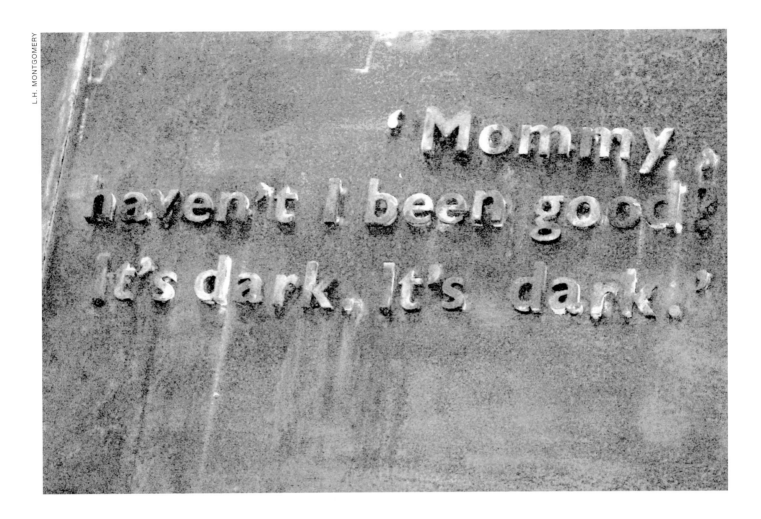

L.H. MONTGOMERY

BELZEC

The Germans built the Belzec death camp in early 1942. It was part of the Nazi-organized system for the "final solution to the Jewish question," that is the slaughter of all the European Jews, including babies and the very old. Created under "Operation Reinhard," the camps included Belzec, Treblinka, and Sobibor. After Belzec was built, the brigade of Jewish construction workers was liquidated to a man.

The internal organization of Belzec was different from that found in other German death camps. It was nothing but a slaughterhouse, containing only the technical equipment required for the mass murder of Jews. The execution procedure in the killing center at Belzec consisted of mass transports of Jews brought in trains, shunted through the Belzec station to a spur inside the camp. There, the people were poisoned with exhaust gas.

From January to July 1943, the center was liquidated and evidence of the crime was destroyed. All corpses were taken from mass graves and burned, and the buildings removed.

Little information comes from prisoners who worked in Belzec. If the total number of escapees from Treblinka and Sobibor was about 200, only five escaped from Belzec.

> Earth do not cover my blood;
> Let there be no resting
> place for my outcry!
> —Job 16:18

Above and overleaf: Belzec memorial

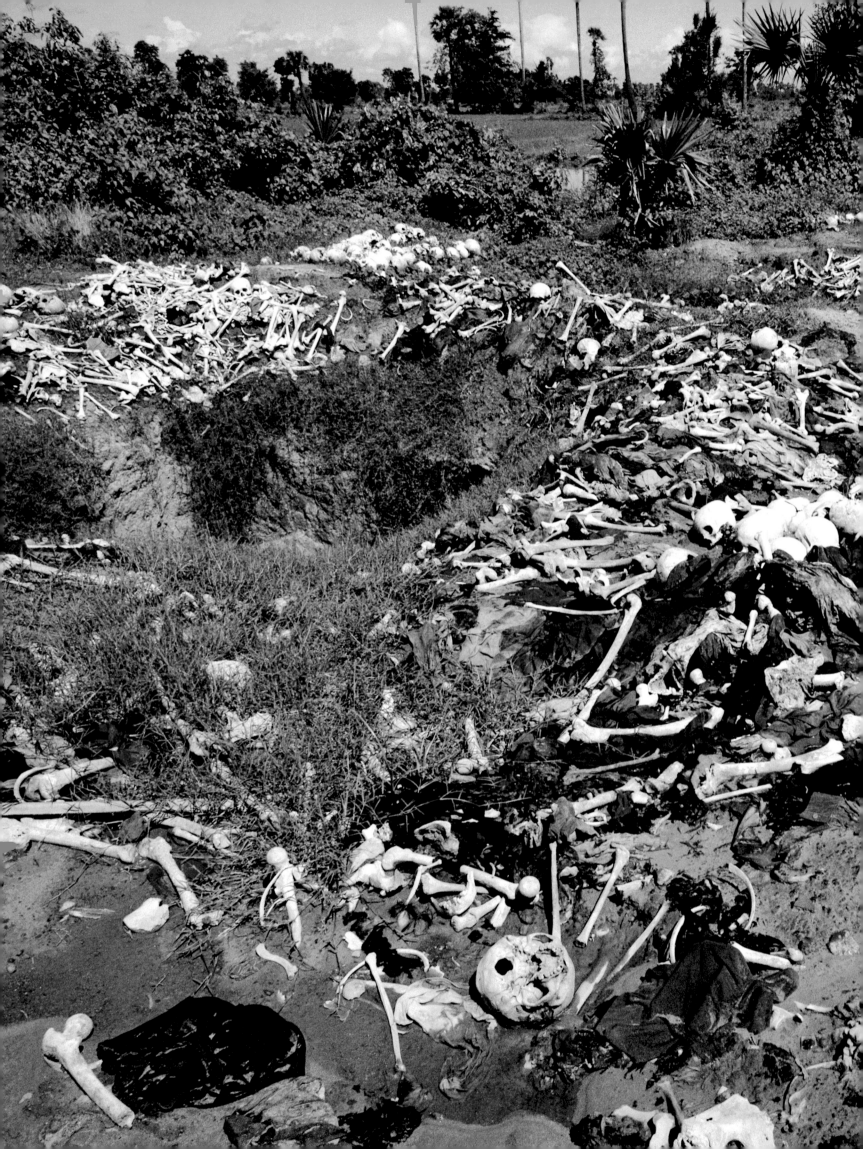

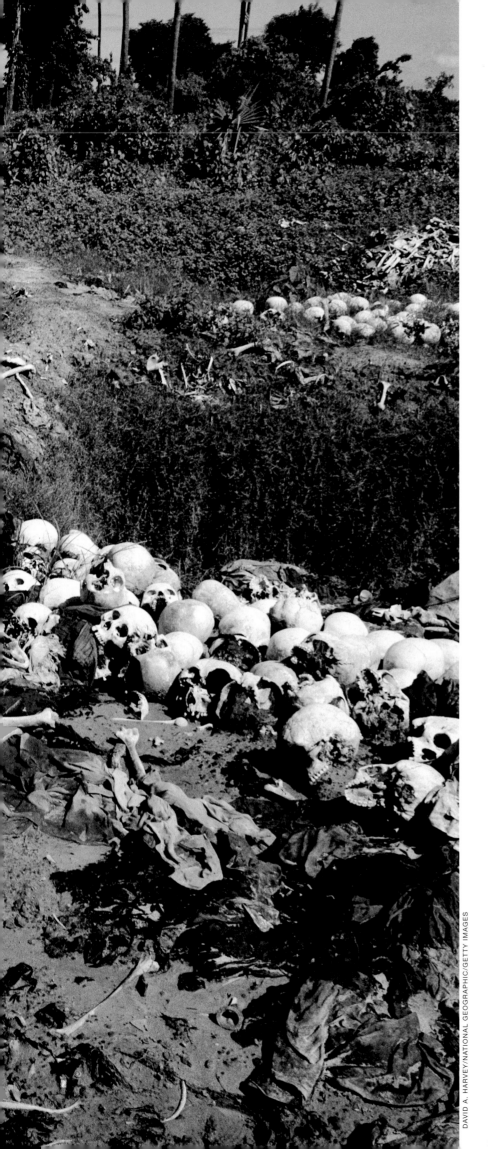

DAVID A. HARVEY/NATIONAL GEOGRAPHIC/GETTY IMAGES

CAMBODIA

"The killing of perhaps two million people in
Cambodia was an example of human cruelty
perpetrated to fulfill a vision of a better world.
God made the Jews wander in the wilderness for
forty years so that only a new generation, with
souls uncontaminated by slavery in Egypt,
would reach the promised land. The Cambodian
communist leaders did not have the patience of
God. They set out to create a radically new
society immediately. Anyone bound to the old
ways by their former status or present behavior
was to die, to make this better world possible. In
the resulting climate of violence and suspicion,
many of the communists themselves were killed."

—Ervin Staub, *The Roots of Evil: The Origins of Genocide
and Other Group Violence*

Remains of genocide victims scattered along the mass
graves in the killing fields of Cambodia.

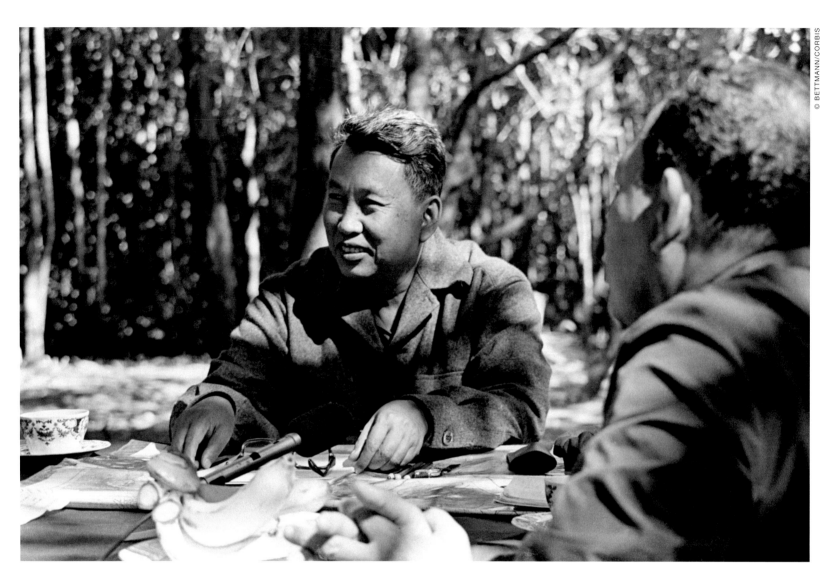

Born Saloth Sar on May 19, 1925, Pol Pot, was the leader of the Khmer Rouge and the Prime Minister of Cambodia (officially renamed the Democratic Kampuchea during his rule) from 1975 to 1979. As a young man he attended schools in Paris, including the Sorbonne, where he became a member of the French Communist Party. While in power, Pol Pot imposed an extreme version of agrarian communism in which all city dwellers were relocated to the countryside to work in collective farms as forced labor. The Khmer Rouge killed about 1.7 million Cambodians (approximately one-fourth of the entire population). Pol Pot fled into the jungles of northwest Cambodia after Vietnamese communists "liberated" the country in 1979, leading to the collapse of the Khmer Rouge government and a ten year civil war. He was never brought to justice. He died in 1998.

Once in power, the Khmer Rouge set about destroying their own people in an auto-genocide...

Ambassador James Rosenthal

For Americans and others in the world, the war in Southeast Asia—"the Vietnam War" —ended in April, 1975. This long and bloody conflict came to a close with communist victories throughout Indochina, and a welcome, if still difficult and uneasy, peace finally came to Cambodia's neighbors, Vietnam and Laos. But for the Cambodian people, whose country had been drawn into that conflict, "peace" brought much greater horror and suffering. For them, their worst nightmare was only just beginning.

The communists in Vietnam and Laos imposed severe dictatorships on their people. But they paled in comparison to that of their comrades next door in Cambodia, where the victorious Khmer Rouge carried out one of the most savage and brutal regimes of the 20th century. They began by abruptly emptying the cities, forcing the entire urban population, including families with small children and the old and sick, into the countryside without food, water, medicine, or shelter. Thousands died in the process, either murdered when they objected to the evacuation, or from starvation, illness, or exhaustion along the way. Members of the defeated government, including soldiers and civil servants and much of the educated class, were summarily executed. The rest of the population was driven into virtual slave camps in the countryside, where they were forced to farm for the state under the harshest conditions imaginable.

The Khmer Rouge regime was driven by perhaps the most extreme radical ideology ever put into practice in modern times. It was Marxist/Leninist in origin, but in theory, and certainly in practice, it went beyond even the excesses of Stalinism and Maoism. Its leader, Pol Pot, and many of his colleagues, had met at the university in Paris, where they easily fell into the communist party prevalent in Paris at the time. The Khmer Rouge called for the complete elimination of the existing society and its replacement by a thoroughly new and "pure" agrarian one. Cities and towns were seen as hostile and unnecessary. The urban and educated were considered irredeemably tainted, fit only for ruthless reformation or physical extermination. The new economy was based almost entirely on rudimentary agriculture and forced labor. The Khmer regime, guided by an essentially faceless party, had total, arbitrary power over every facet of the people's existence— where, how, and whether they lived, how they were fed and housed, even whether or not they could have families.

The regime lasted for nearly four years, during which time an estimated 1.7 million Cambodians—from one-fourth to one-third of the entire population—were killed by the Khmer Rouge or died from the severe privation imposed upon them. Proportionally, it was the largest death toll suffered by a country at the

hands of its government in perhaps centuries. It was "auto-genocide"—ruthless, mass killing directed by a regime not against foreign or outside elements or minorities, but against its own people. It was also systematic, in that it focused most heavily on the country's educated and skilled people. The damage continues to be felt long after the regime has disappeared, due to the deep traumatization and near-decimation of a whole generation of Cambodians most needed now to rebuild their shattered country.

The Khmer Rouge government was ousted in 1979, when their former allies, the Vietnamese communists, invaded Cambodia and set up their own puppet regime headed by ex-Khmer Rouge leaders who had defected earlier. Cambodians initially welcomed the relief from their murderous tormenters, even when such relief came from their traditional enemies, the Vietnamese. But Cambodia's ordeal was far from over. The Khmer Rouge retreated to the countryside and led a bloody civil war against the Vietnamese occupiers that lasted another several years and brought further devastation. The Vietnamese departed in 1989 after a harsh occupation of their own, leaving behind a country still badly torn by civil strife and saddled with an inept and dictatorial government.

The international community knew little of the horrors of Khmer Rouge rule in the early years of the regime. The country was sealed off almost completely from outside contact, and world attention shifted elsewhere. Those who did have some knowledge—the Thais and especially the Chinese who backed the Khmer Rouge—had little interest in bringing attention to it. Later, as more information came out from refugees and other sources, awareness of the Khmer Rouge holocaust—and international condemnation of it—greatly increased. But it was too late. The worst damage had already been done by the time of the Vietnamese invasion, which ended the most brutal aspects of Khmer Rouge rule.

The UN intervened in the early 1990s to restore a semblance of peace and stability and to organize elections for a more broadly-based and effective government. Armed conflict is no longer a great threat, and more normal conditions have returned to the country and to Cambodian society. But political turmoil has continued sporadically even after the UN-sponsored and subsequent elections. To this day, the country still suffers misrule under a corrupt and dictatorial government led by one of the same Khmer Rouge defectors installed by the Vietnamese occupiers in 1979.

The Khmer Rouge leadership has never been punished or called to account for its murderous rule and crimes against humanity. Though long out of power, several top leaders remain at liberty and live normal lives near the Thai border. The Khmer Rouge regime's notorious leader, Pol Pot, was never taken into custody, and died a natural death in 1998.

The current Cambodian government, spurred by the international community and the UN, has agreed to form a tribunal to try Khmer Rouge leaders for their crimes. But cooperation with the UN has been grudging at best, and there is still no assurance that trials of those most responsible will ever take place. Perhaps the regime fears renewed civil strife. Perhaps it is afraid of what might be uncovered about its own dubious past and links to the Khmer Rouge. Perhaps it reflects a true desire of the Cambodian people to put things behind them and not have to relive the huge suffering and trauma they endured some thirty years ago under Khmer Rouge rule.

———

James D. Rosenthal is the former United States Ambassador to Guinea. He also served at the U.S. Embassy in Saigon and at the Paris Peace Talks on Vietnam. He was Director of Vietnam, Laos, and Cambodia Affairs at the Indochine Desk of the State Department.

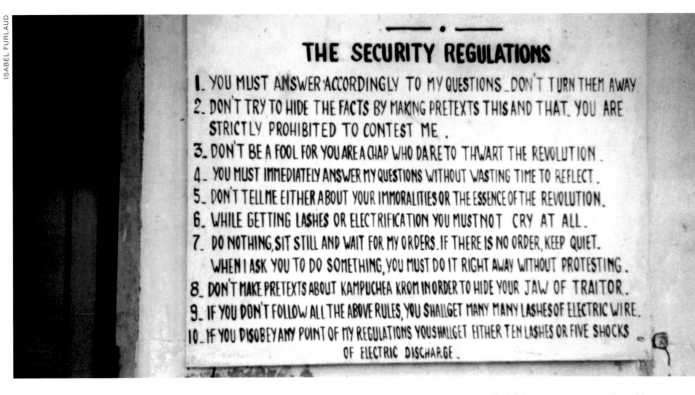

ISABEL FURLAUD

Rules posted at the notorious Tuol Sleng prison, where more than 17,000 men, women and children were tortured and later slaughtered in the killing fields during the Khmer Rouge regime. Tuol Sleng prison, a former high school, derived its name from the word *Poison Hill*.

CAMBODIA TIMELINE

800-1300 A.D.
The Kingdom of Angkor in Cambodia is at its height, as it presides over the construction of the most astonishing architectural achievements of that time. Only about 100 temples remain today, a mere shadow of the fabulous religious capital it once was.

1864
France adds Cambodia to its other colonies in Indo-China, making Laos, Vietnam, and Cambodia the French protectorate called Indochine.

1941
Prince Norodom Sihanouk becomes king. Cambodia is occupied by Japan during World War II.

1945
Japanese occupation ends.

1946
France re-imposes its protectorate. Communist guerrillas begin an armed campaign against the French.

1953
Under King Norodom Sihanouk, Cambodia wins its independence from France. In Vietnam, The French are defeated at Dien Bien Phu following the Geneva Agreements. It is the end of French Indochina.

1965-66
The United States sends in ground troops to protect South Vietnam from communist invasion. The Khmer communist movement founded in 1951 sends a delegation to Peking and becomes known as the Kampuchean Communist Party (KCP). Sihanouk breaks off relations with the U.S. and allows North Vietnamese guerrillas to set up bases in Cambodia.

1968
American troops in South Vietnam number 550,000. America begins secret bombing campaign against North Vietnamese hideouts in Cambodia. During the next four years, American B-52 bombers, using napalm and cluster-bombs, sadly kill hundreds of Cambodians in their effort to destroy suspected North Vietnamese supply lines.

1969
A coup d'état on March 18 in Phnom Penh. General Lon Nol (U.S. supporter) seizes power and proclaims the Khmer Republic. Both American and South Vietnamese troops infiltrate Cambodia. The Vietcong invade the territory and occupy the site of Angkor.

1973
Signing of the Paris Agreements and withdrawal of American troops.

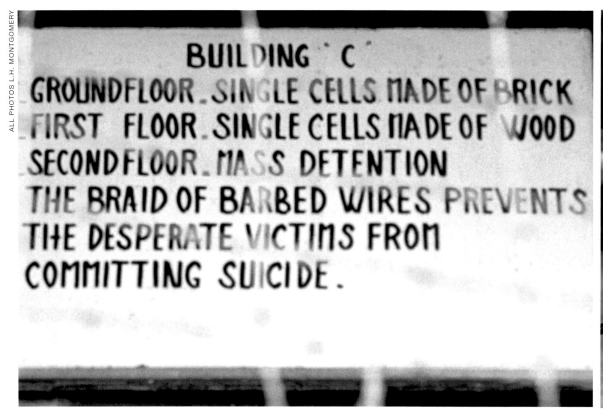

BUILDING "C"
GROUNDFLOOR. SINGLE CELLS MADE OF BRICK
FIRST FLOOR. SINGLE CELLS MADE OF WOOD
SECONDFLOOR. MASS DETENTION
THE BRAID OF BARBED WIRES PREVENTS
THE DESPERATE VICTIMS FROM
COMMITTING SUICIDE.

The prison was enclosed with corrugated iron sheets and dense electrified barbed wire to prevent escapes. Of the approximately 17,000 people who entered Tuol Sleng, only six survived. Many were interrogated and tortured under suspicion of treason or for being spies, before being executed.

1974
The start of the Khmer Rouge offensive against Phnom Penh in December.

1975
On April 17, Lon Nol is overthrown by the Khmer Rouge and the capital falls. The opening of the Tuol Sleng torture prison at Phnom Penh.

1976
Sihanouk resigns. Pol Pot is the new Prime Minister and renames the country Democratic Kampuchea. Pol Pot was educated in French schools including the Sorbonne. With the country firmly in Khmer Rouge control, all urban dwellers are forcibly evacuated to the countryside to become agricultural workers. Money becomes worthless; basic freedoms are curtailed; religion is outlawed. The Khmer Rouge coin the phrase "Year Zero" to

mark the beginning of a new Cambodia, now called Kampuchea. Hundreds of thousands of the educated middle-class are tortured and executed. Many others starve or die from disease. Children are taken from their parents and placed in forced labor camps. All leading Buddhist monks are killed and most of the temples are destroyed. One can be shot simply for knowing a foreign language, or wearing glasses. The Khmer slogan is, "To spare you is no profit, to destroy you is no loss." During the next three years, an estimated 1.7 million Cambodians—about one-fourth of the country's population—die from torture, execution and starvation.

1977
Kampuchea's economy is now supported entirely by China.

1978
Following a series of Khmer incursions into Vietnamese territory, Vietnamese divisions occupy the provinces to the east of the Mekong River.

1979–80
Vietnamese take Phnom Penh on January 7, 1979. Famine causes the Khmer Rouge fighting units to disband. They withdraw their headquarters to Thailand. The remainder of their armed forces retreat to the forest along the Thai border. International allegiances are largely dictated by the Cold War, as the West ensures that the Khmer Rouge (rather than the new Vietnam-backed communist government) retain Cambodia's seat in the United Nations. Khmer Rouge guerillas who reach Thailand receive food and aid from U.S. relief agencies.

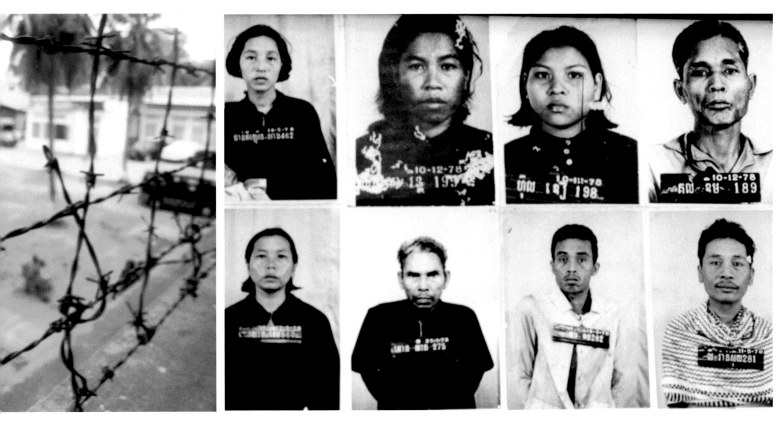

The number of workers in the complex totaled about 1,720, including units of male and female children 10-15 years of age. The groups of buildings that made up Tuol Sleng have been converted into a "museum of genocide."

1985
Vietnamese troops capture several Khmer Rouge positions on the Thai frontier.

1989
Formal withdrawal of Vietnamese expeditionary force.

1991
International Peace Agreement is signed in Paris in 1991. Numerous defections among the Khmer Rouge ranks after elections organized by the United Nations. Relative stability returns to Cambodia, although with the middle class and the educated virtually eradicated, the country continues to have severe difficulties.

1995
Mass graves are uncovered, revealing the horrifying extent of the genocide.

1998
Khmer Rouge leader, Pol Pot, dies a natural death which brings about the collapse of the Khmer Rouge movement. Efforts to convene a criminal tribunal languish. Several former Khmer Rouge leaders join the Cambodian army. By this time, many other former Khmer Rouge guerillas have defected to the new government, or made immunity deals.

1999
Prime Minister Hun Sen, who has agreed to put the main leaders of the Khmer Rouge on trial, opposes UN plan for the court to be composed mainly of foreign judges. He also opposes setting up a "truth commission."

2007
More than 30 years after the mass killings and a decade of wrangling between Cambodia and the United Nations, formal proceedings begin against surviving leaders of the brutal Khmer Rouge regime. Theirs is a race against mortality. Only one prisoner, Kaing Khek Lev (nicknamed Dutch), the commander of the torture chamber at Tuol Sleng, is in custody. Dutch has become a Fundamentalist Christian. An interview suggests that he may be as enthusiastic *now* about repentance as he was *then* about the slaughter.

AUGUST 2007
For a tiny country, which for over two decades was crippled by the Vietnam war and ravished by genocide to be now able to post debt ratings on Standard and Poors is an heroic feat. A biodiesel plant is underway, hotel realtors are moving in, and off the coast there is the promise of oil. Korea has offered to share its miracle of growth with Cambodia.

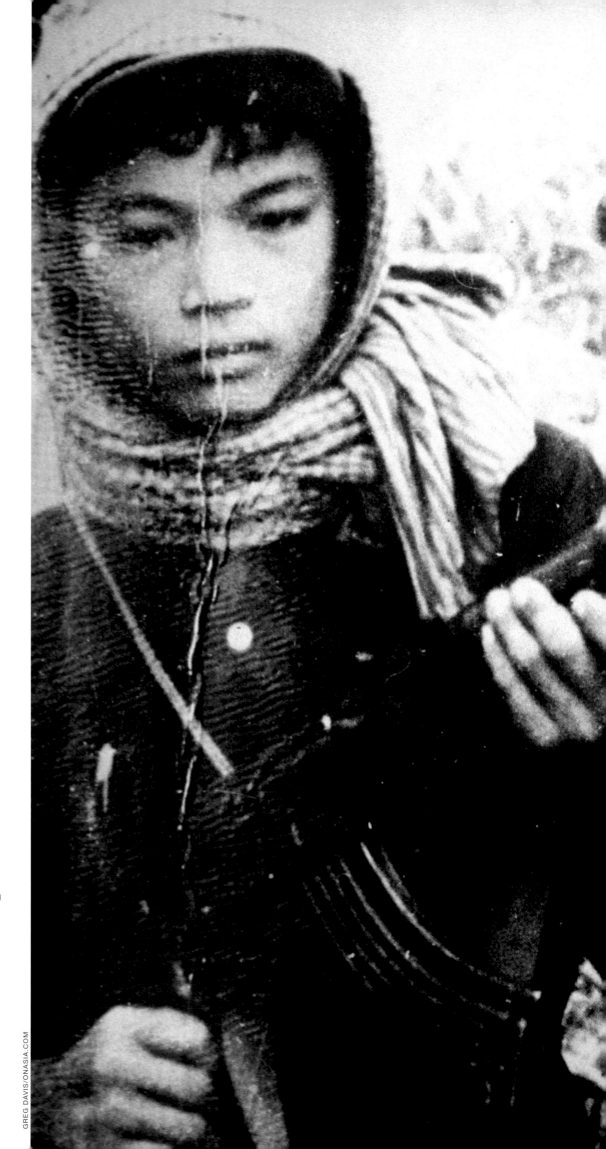

Two Khmer Rouge teenage soldiers. These young guards were trained and used by the Khmer Rouge. Most of them had started out as normal teenagers before becoming increasingly evil. They turned out to be exceptionally cruel and disrespectful towards the prisoners and their elders.

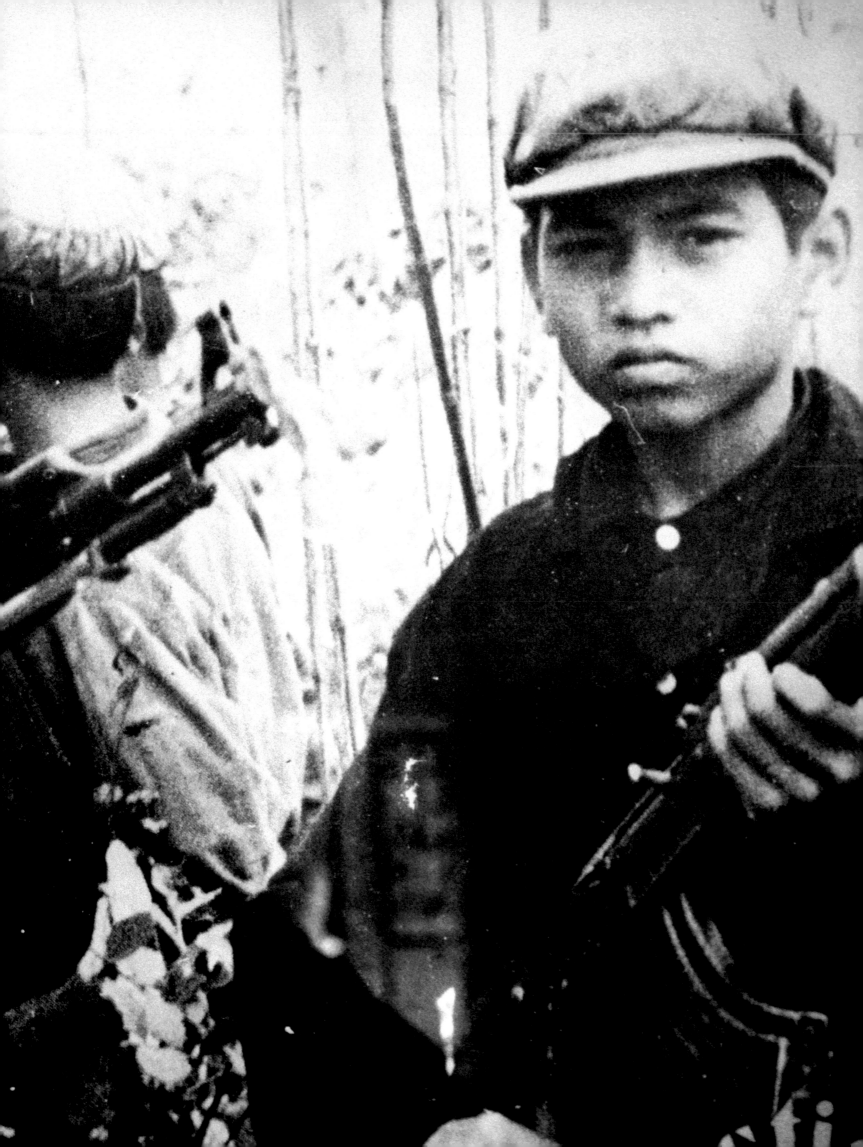

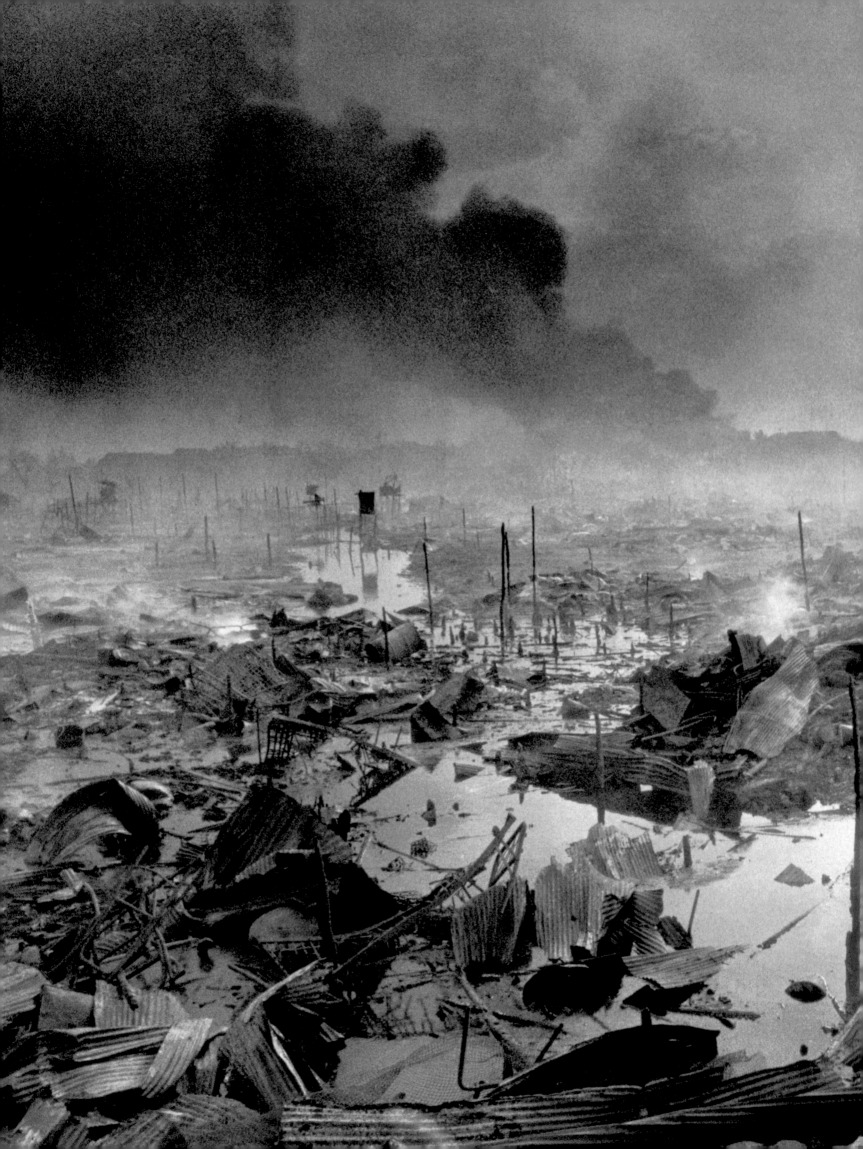

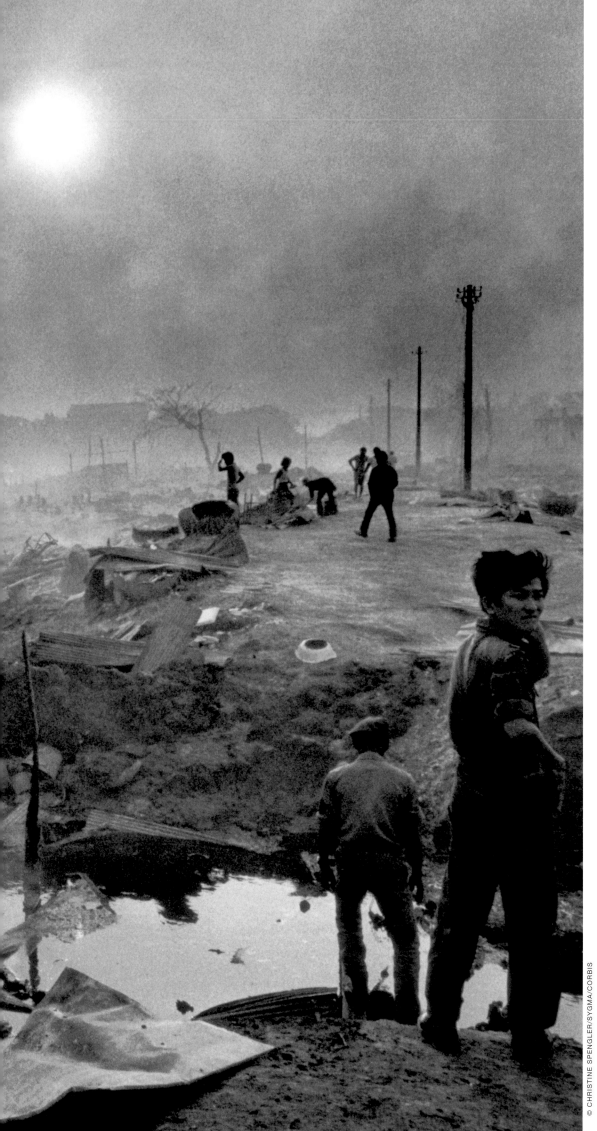

Survivors sifting through rubble after a Khmer Rouge bombing of Phnom Penh, the Cambodian capital. Under the Pol Pot regime, the Khmer Rouge laid siege to the city, attacking the two million refugees who gathered there.

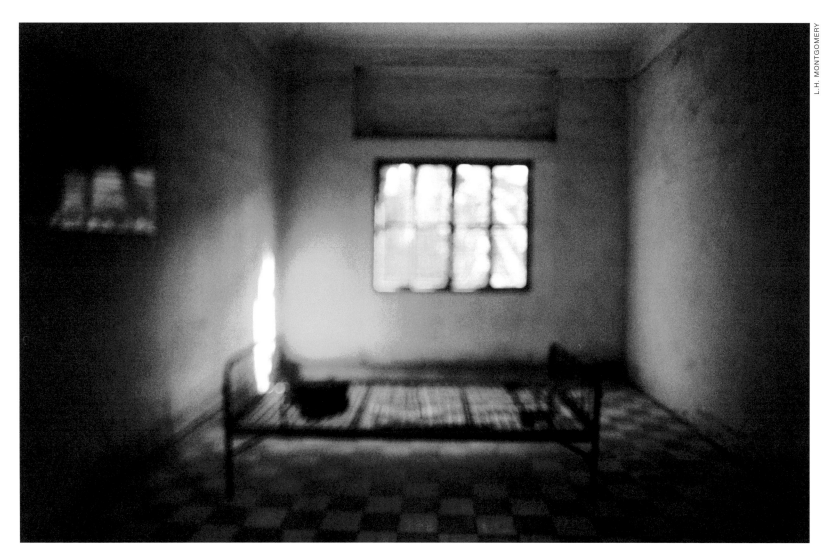

L.H. MONTGOMERY

Interrogations took place on the ground floor of Tuol Sleng prison in this room—furnished with only an iron bed frame on which the victim was placed. On the bare metal bed can still be seen shreds of material, including tarnished handcuffs, covered in thick dust, just as they were left by the guards on the afternoon of January 7, 1979, when they fled with the arrival of the Vietnamese.

So the gate does not open on to the agonized cries of the tortured in Tuol Sleng prison, but on to absurdity and despair…what matters is the weight of the life that gave rise to them, reappearing suddenly out of the silence of things…this soldier lying there beneath the stone, is the son or the brother or the uncle of someone you know, the lover of the woman you came across, blown to bits by the side of the road, wearing the new sarong she so carefully chose at the market this morning…

— Francois Bizot, *The Gate*

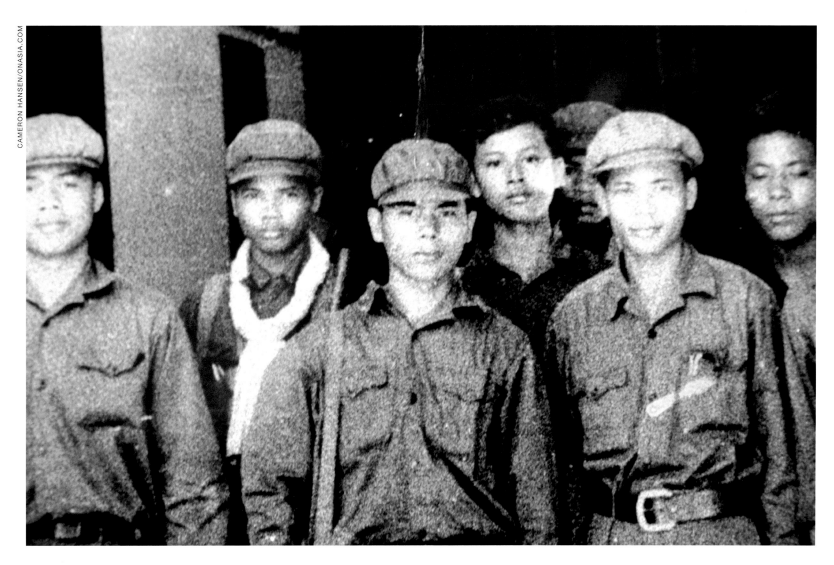

CAMERON HANSEN/ONASIA.COM

A group portrait of guards at Tuol Sleng prison. Yu fui (center) joined the Khmer Rouge army when he was 18.

I started to work in S-21 (a section of Tuol Sleng Prison) in 1977. All the time I was in S-21 I was afraid I would be killed next. Once I asked my boss if I could leave but he refused my request. Now people accuse me of being a murderer. But I would not have worked in S-21 if I had a choice. I have been having mental problems since that time. Sometimes I can't sleep for days. An NGO has sent a 'trauma doctor' to see me. They said my mind is sick because I killed so many people.

—Yu fui

Overleaf: Young boys peering into the window of the genocide memorial in the middle of the killing fields, 20 kilometers outside of Phnom Penh.

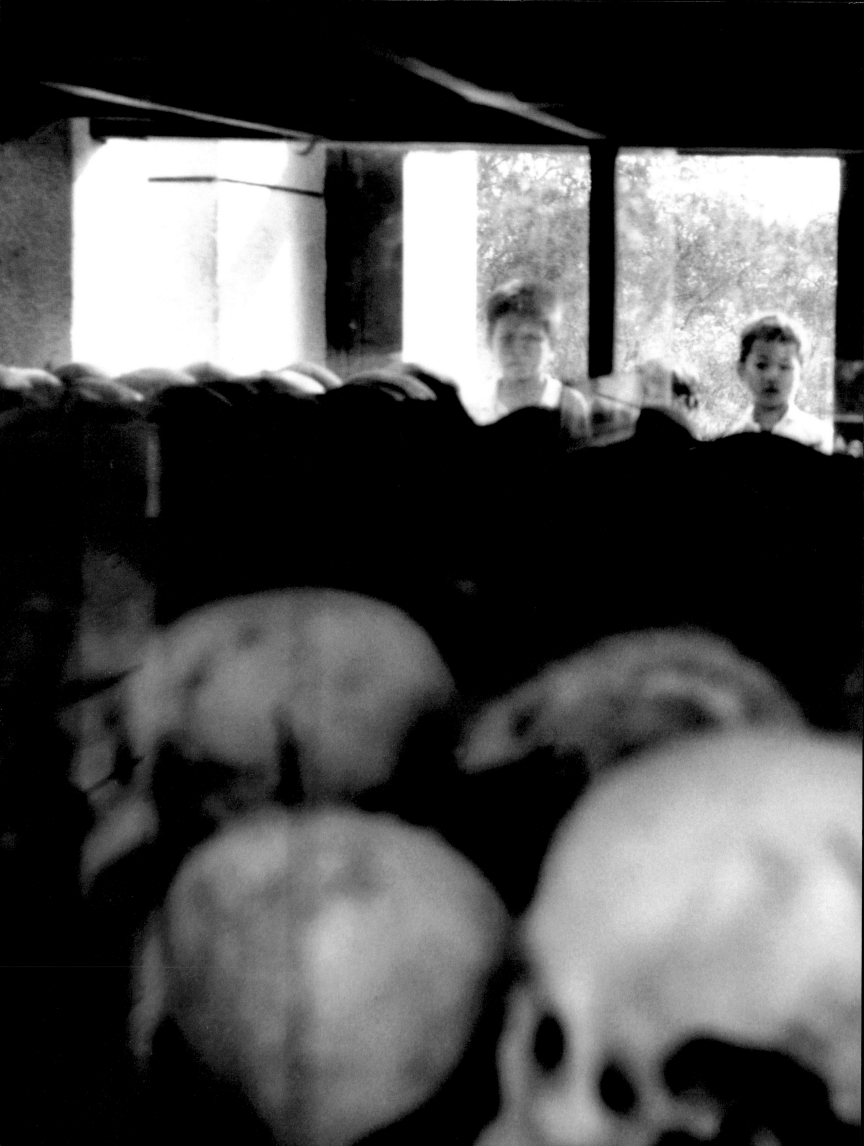

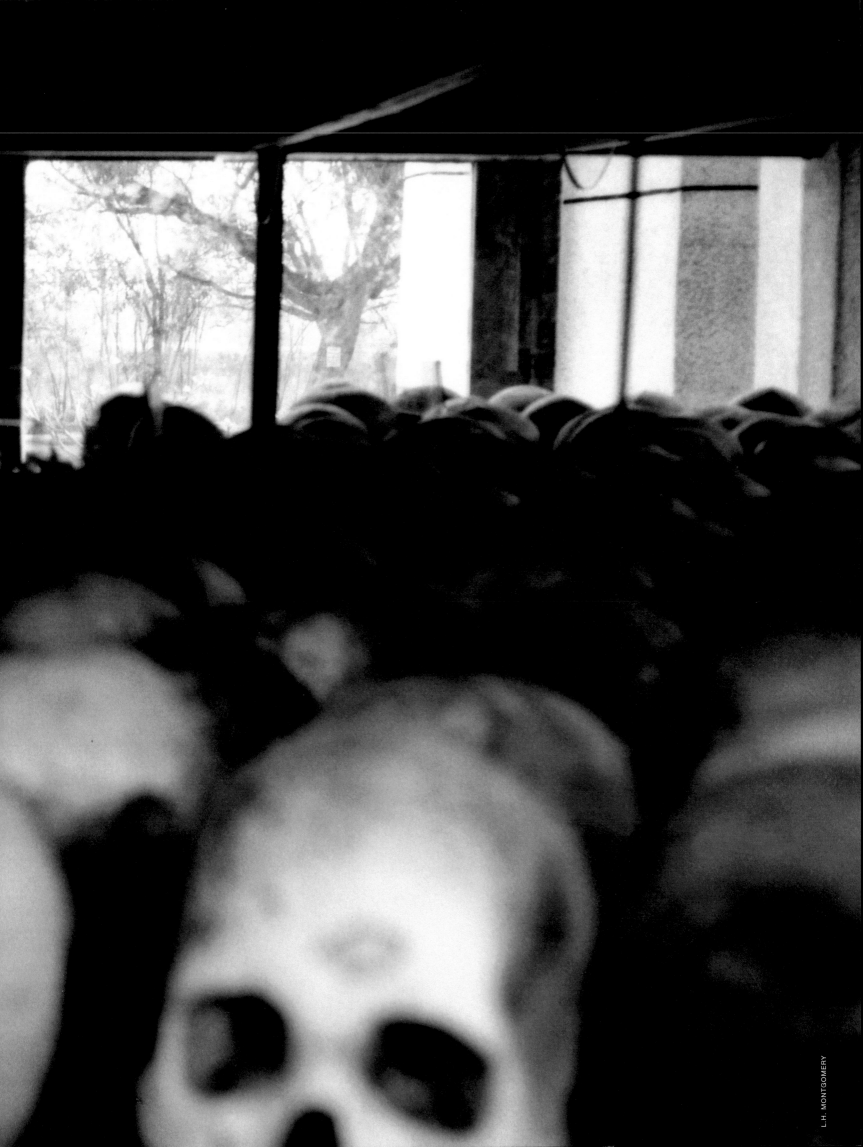

A boy standing by a cage of skulls at Wat Sophakmongkol, a gruesome legacy of the 13-year civil war and brutal Khmer Rouge genocide.

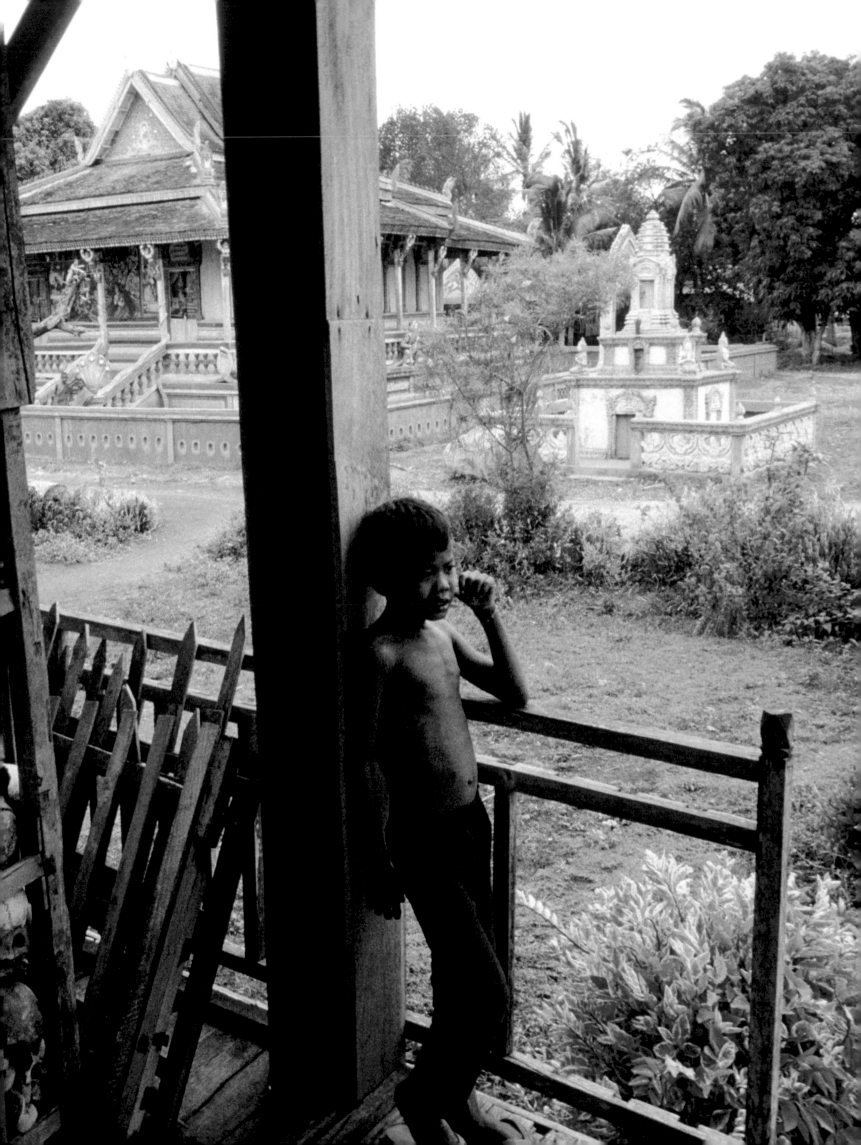

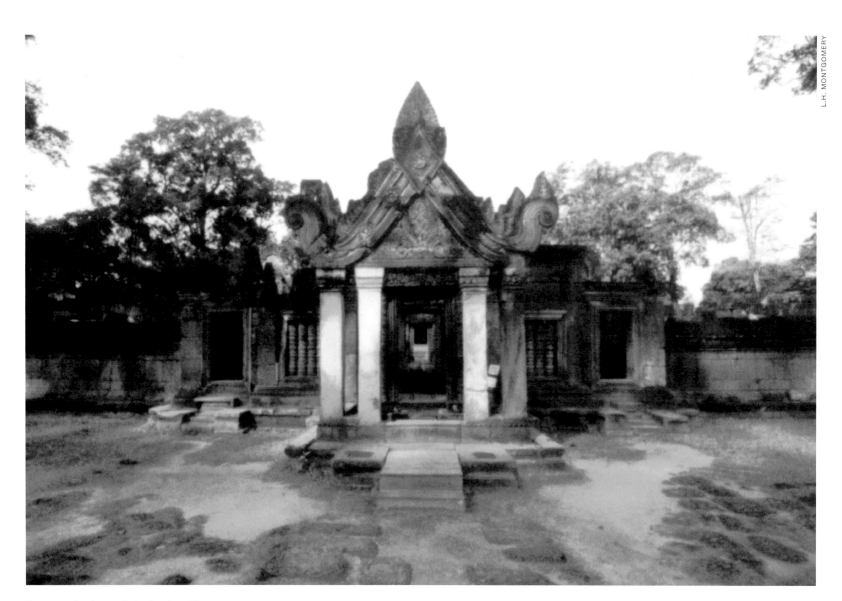

L.H. MONTGOMERY

Banteay Srei temple in Angkor Thom.

For years I had yearned to go to Cambodia, but each time a trip was planned it was cancelled by another Khmer Rouge-incited incident. Finally, in February of 1998 the Siem Reap Province was enjoying a period of peace, Pol Pot was ill and dying. John Sanday, an executive with the World Monuments Fund, invited a few people to visit the secluded temples of Banteay Srei in the jungle area of Angkor Thom. It is difficult to describe the beauty as we arrived through the jungle path and saw the temples, rarely seen since 1975. The carvings date back to 963-973 A.D. and are for the most part intact.

MASAO ENDO/ONASIA.COM

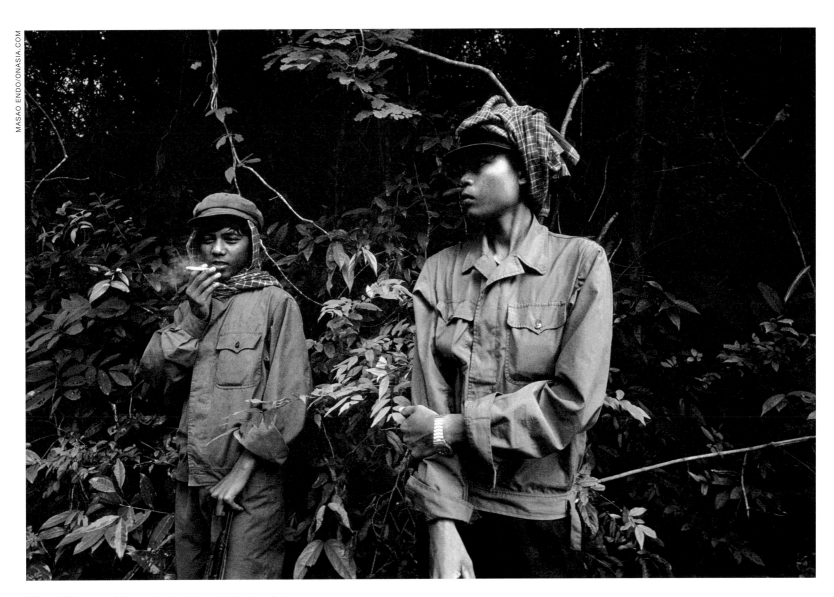

Khmer Rouge soldiers at a back road checkpoint.

As I walked over to photograph one of the smaller temples, the jungle foliage suddenly parted to expose four or five Khmer Rouge soldiers in their distinctive black/green uniforms with red and white checkered scarves around their waists. I remember two machetes. Stunned, I lowered my camera and began walking backwards. The Khmer Rouge held their position. When I reached John he took my camera and told me to run. I ran. Back in the car, I asked the driver to wait with the motor on. A few minutes later John arrived and handed me my camera. The Khmer Rouge had dismissed them without incident, but had ordered us to leave the temple area immediately. That night at dinner John presented me a Khmer Rouge checkered scarf. It is still in tissue, folded inside a closed drawer. A wrapped memory.

—L.H. Montgomery

When I arrived in Siem in 1965, Cambodia was dwelling rather peacefully alongside [a] Vietnam that had been plunged into war…In neighbouring China, the Cultural Revolution was brewing. All Europe was full of encouragement for those who were working to overthrow the old feudal societies and bring about a better world. The intelligentsia of every country denounced American involvement in Vietnam…I realized that my only gods were in fact American: Saul Steinberg and Charlie Parker. So when I came to Indochina, I had little reason to share the hostility towards the United States shown by most of the French community…When the Americans arrived in Cambodia, I saw them as allies in my impossible quest…Yet today, I do not know what I reproach them for more, their intervention or their withdrawal…

…In 1975, bolstered by international opinion, the revolutionaries defeated an enemy in a state of complete physical and moral collapse…From that moment on, more blood than ever was shed. After the horrors of the Vietnam War had overflowed on its soil, this unhappy country endured pre-revolutionary terror. Once in power, the Khmer Rouge set about destroying the population, systematically eliminating whole classes of society, starting with the peasants. Those who were moved from their villages and herded into the forced labor camps were decimated by hunger, disease and torture.

The genocide ended only in 1979, after four long years…Vietnam(ese) troops put an end to it by invading Cambodia and 'liberating' the country a second time, not from American imperialism but from the cruelty and incompetence of their Khmer Rouge 'brothers'…Man who—when, exceptionally, he becomes his true self—can bring about excellence, yet also bring about the worst —a slayer of monsters, and forever a monster himself…

—Francois Bizot, *The Gate*

Right: Interior of temple in Angkor Thom.

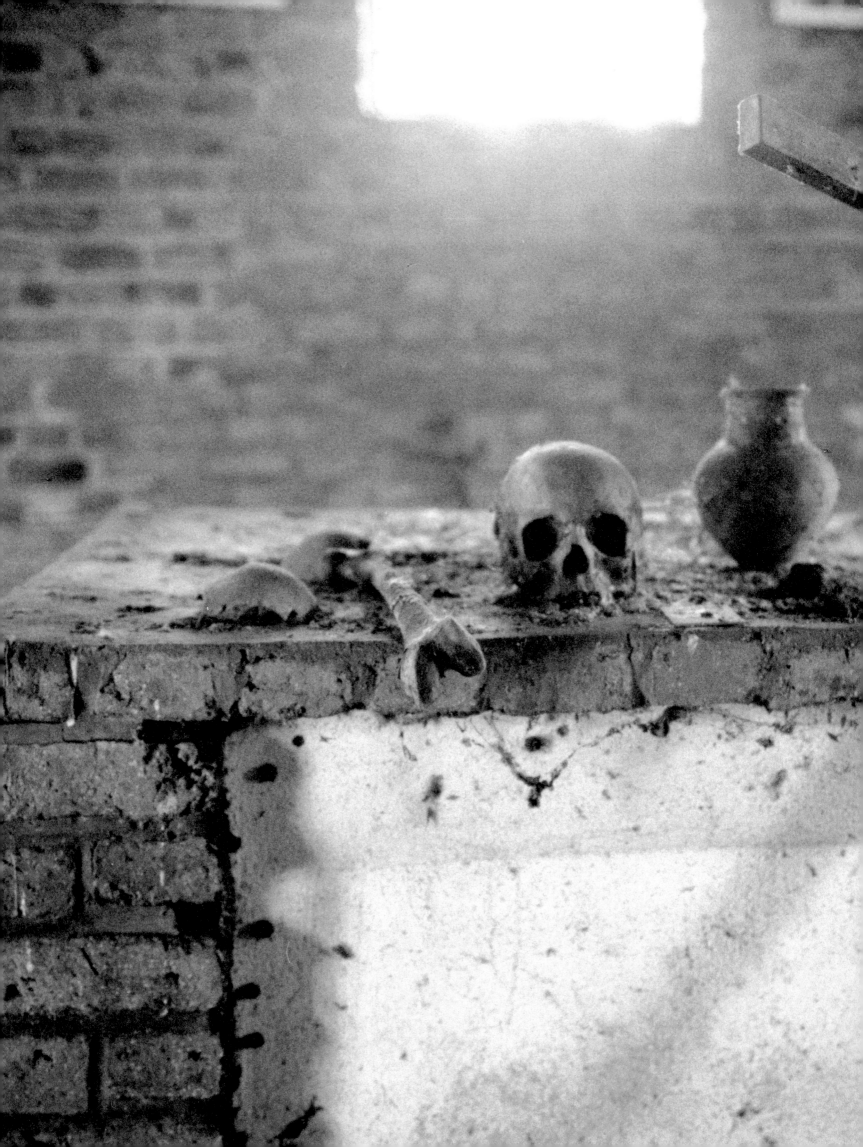

L.H. MONTGOMERY

RWANDA

*The sounds came so thickly they produced a kind of
claustrophobia. All the sounds could be silenced by a loudly
crackling branch or a shout, but only for a second. They
would quickly start again, moving in on the ear like an
approaching train. The only movements were the hundreds
of butterflies fluttering silently close to the ground...even
a bright moon rarely threw light on the roadway. To do so
it had to be directly over the channel through the trees and
usually the clouds obscured it...the darkness was primeval.*

—Blair Fuller, *A Far Place*

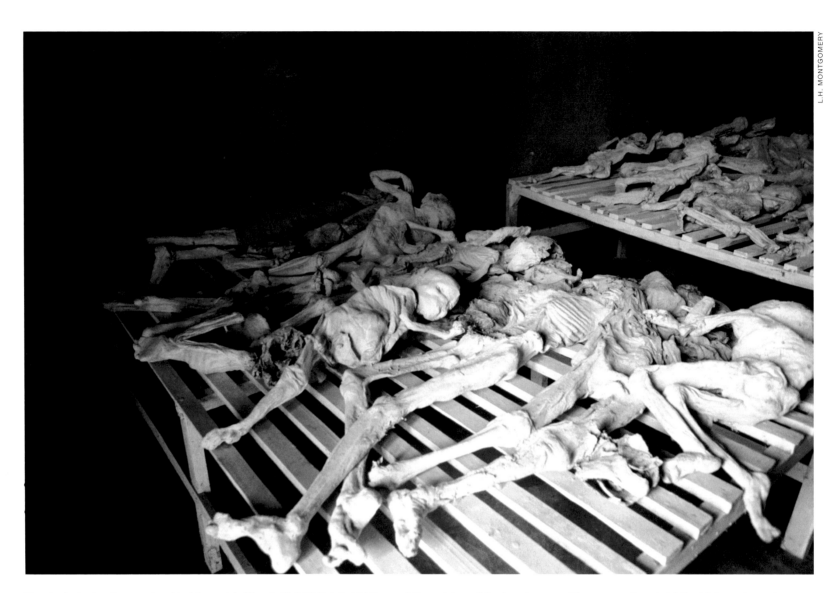

The technical college school in Murambi. About 40,000 Tutsis hid there at the advice of the local mayor. The mayor then told the Hutus where they were. Armed only with machetes it took the Hutus four days to kill that many people.

I said a silent prayer that this was as close to genocide as I would ever come

Terry George

Co-Producer, Writer and Director, "Hotel Rwanda"

Rwanda is called the Land of a Thousand Hills. This is an understatement. On a crystal clear morning, I stood on a hill at a place called Murambi, in Southern Rwanda. From where I stood I could see a hundred hills, some shimmered blue in the distance, others so green and lush I felt I might reach out and touch them. All were cultivated from valley to peak with banana groves, maize, cassava. Every inch of their rich soil worked to feed the mouths of the most densely populated country in Africa. Behind me on the peak of the hill was a drab two-story 1970s building—a technical college. I'd seen this kind of building throughout my youth. The design spoke to me of boredom, stuffy classrooms, days of drudgery. What I found in Murambi's technical college changed my life in a way that no classroom was ever designed to do.

In April 1994, as Hutu extremists began slaughtering their minority Tutsi neighbors across Rwanda, the Hutu mayor of the Murambi region promised his Tutsi neighbors protection if they gathered at the technical college. Some forty thousand of them rushed there for shelter. The mayor arrived accompanied by the extremist Interhamwe militia. Over the course of the next four days they herded the terrified Tutsi into the classrooms and slaughtered them.

The bodies of the dead were thrown into pits and covered with lime. Somehow the lime preserved those bodies.

Today scores of those bodies are laid out on tables in the rooms were they died. They are frozen in the last desperate moments of their agony, hands pleading, heads cradled by arms, skulls cracked open by merciless machetes. There is a children's room where tiny skeletons bear the same silent testimony to the horror. In one of the cruelest ironies the lime has turned the skins of the victims alabaster white, a skin tone that would no doubt have saved their lives.

A solitary tall man looks after that sacred place. He is one of only four survivors of the massacre. He has a hole the size of a nickel in his forehead where the execution bullet entered and failed. He led me to the lobby where there is a condolence book. As I signed it my sunglasses failed to hide the tears running down my cheeks.

I said a silent prayer that this was as close to genocide as I would ever come. But God, and man, have not answered that prayer and now I must steel myself to go to the desert of Sudan where the bodies are still warm and the babies cry in tents made of cheap plastic.

And now, instead of a condolence book, I read the hypocritical promises and sickening excuses of a world that does not care—Again!

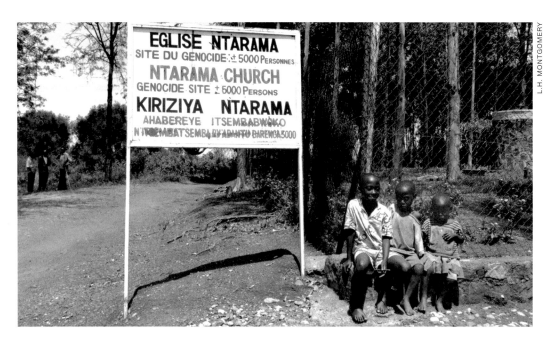

Children outside the Ntarama church in Kigali, Rwanda, site of a massacre of 5,000 Rwandans.

"We are no longer Hutus, we are no longer Tutsis. We are Rwandans..."

—Eric Kayirang

My first detailed recollection of the horrors that occurred in Rwanda was on a lovely summer evening of 1997 in Bedford, New York. George Hritz, a board member of the International Refugee Committee (IRC), his wife and their houseguest, Joshua Kaplan, came for dinner. Joshua was a young lawyer who had just returned from Sierra Leone and had evacuated the IRC office from the genocide currently occurring there. They referred to Philip Gourevitch's recent book, the winner of the National Book award, *We wish to inform you that tomorrow we will be killed with our families:… Stories from Rwanda.*

Joshua reiterated that after five years, Rwanda's estimates were now over a million plus killed in eight weeks. Yet, the fog of genocide still hung over Rwanda and its atrocities. As General Roméo Dallaire was to write later, the South African elections and the American figure skater, Tonya Harding's criminal troubles were

keeping the madness in Rwanda off the front page. Unknown to me then, I was to meet Philip Gourevitch, and that became the starting point for this book.

Most of the genocides of the 20th century unfolded over years, since it generally takes a long time to kill off an entire people. In Rwanda, it took only about 100 days for one ethnic group to murder nearly a million members of another. The victims were the tall Tutsis, who had formed the dominant class under Belgian colonial rule, and the perpetrators were the Hutus, who since independence in 1962 had essentially ruled Rwanda.

In great haste, Hutu Power agitators started calling for Hutus everywhere to rise up and kill any and all Tutsis. The killings were carried out without any technology, simply with machetes and clubs. Urged on by a constant stream of propaganda broadcast by state-run radio, people killed their neighbors, friends and even relatives. People who spoke the same language,

were the same color, and bore the same burdens of a struggling, emerging population. "Do your work. Cut down the tall trees," urged the radio, and countless ordinary citizens did. They lived in a land of a thousand verdant hills, whose lush greenery turned blood red overnight. Respected Hutu community leaders and even clergymen participated in and facilitated the genocide, and when people in this devoutly Christian country sought refuge in churches, they found none. In fact, some of the worst massacres occurred in churches:

A letter written by seven Tutsi pastors at the Seventh Day Adventist church at Mugonero read:

"Our Dear Leader, Pastor Elizaphan Ntakirutimana,

How are you! We wish you to be strong in all these problems we are facing. We wish to inform you that we have heard that tomorrow we will be killed with our families. We therefore request you to intervene on our behalf and talk to the Mayor. We believe that with the help of God who entrusted you with the leadership of this flock, which is going to be destroyed, your intervention will be highly appreciated, the same way as the Jews were saved by Esther... We give honor to you."

They were all killed.

While these events were going on, the tiny UN peacekeeping force—already in the country to enforce the terms of a ceasefire with Tutsi rebels—found itself unable to stop the killing. The UN commander, General Roméo Dallaire, sent ten of his best soldiers to guard the new president of Rwanda, but the Hutu extremists took them captive and murdered them. In response to this event, the Americans and Europeans evacuated their citizens from Rwanda, leaving the Rwandans behind to die.

The UN steadfastly refused to acknowledge the killings as genocide, instead interpreting them as part of a civil conflict, and the Security Council voted not to intervene. Almost all UN troops were withdrawn from the country. At this point, the genocide went into high gear, since the Hutus no longer feared opposition.

In that, however, they were wrong. There was opposition, but not from the outside world. The killing finally came to an end when Tutsi militias from across the border in Uganda and Tanzania, the Rwandan Patriotic Front (RPF), invaded their homeland and put a stop to the genocide once and for all.

—L.H. Montgomery

RWANDA TIMELINE

APRIL 6, 1994
Rwandan President Juvénal Habyarimana and Burundian President Cyprien Ntaryamira are killed when Habyarimana's plane is shot down near Kigali airport. The Rwandan president was about to implement the Arusha peace accords. The killings begin that night.

The Rwandan armed forces (FAR) and Hutu militia set up roadblocks and go from house to house killing Tutsis and moderate Hutu politicians. Thousands die on the first day. Some UN camps shelter civilians but most of the UN peacekeepers (UNAMIR –United Nations Assistance Mission in Rwanda) stand by while the slaughter goes on. They are forbidden to intervene as this would breach their "monitoring" mandate.

APRIL 9
France and Belgium send troops to rescue their citizens. American civilians are also airlifted out. No Rwandans are rescued, not even those employed by western governments in their embassies, consulates, etc.

The International Red Cross estimates that tens of thousands of Rwandans have been murdered.

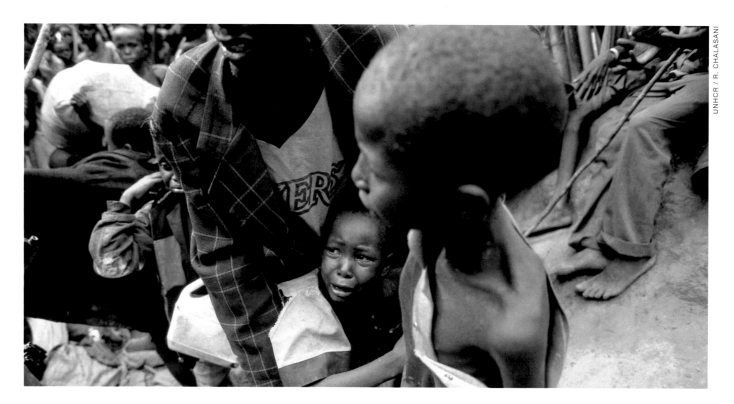

Rwandan refugees in the Kisangani region after an attack on the Biaro camp.

APRIL 11

The number of refugees seeking refuge reaches two thousand. That afternoon, the UN soldiers are ordered to withdraw to the airport. Most of the civilians they abandon are killed.

APRIL 14

The mob tortures and then kills ten Belgian peacekeepers. The United Nations Security Council votes unanimously to withdraw most of the UNAMIR, cutting the force from 2500 to 270.

APRIL 15

A report on those Tutsis seeking refuge in the Saint Famille church, which was bombed, comes in: 120 causalities; 13 dead; 16 evacuated to the Red Cross field hospital and 15 to the King Faisal Hospital.

APRIL 21

International Red Cross estimates tens perhaps hundreds of thousands of Rwandans are now dead.

Paul Rusesabagina, manager of the Hotel Milles Collines, discovers an old fax line that the Hutus had not cut when they cut service from the switchboard. Paul regarded the line as the greatest weapon he had to protect his guests and the Tutsi wives that had been hidden there by their Hutu Power husbands ."We could ring the King of Belgium...I could get through to the Ministry of Foreign Affairs of France immediately. We sent many faxes to Bill Clinton at the White House..."

APRIL 28

The United Nations Security Council passes a resolution condemning the killings but omits the word "genocide." Had the word been used the UN would have legally been obligated to "prevent and punish" the perpetrators.

APRIL 30

Tens of thousands of refugees flee into Tanzania, Burundi, and Zaire.

MAY 2

Kofi Annan testifies before the Senate Foreign Relations committee.
"...When the Belgians left, it was clear that the UN could not implement the mandate they had. It had to be changed or reinforced...if we do not send in a well equipped reinforcement...then I'm not sure they'll be able to bring about law and order that will lead to the end of the massacres...here we are watching people being deprived of the most fundamental of rights, the right to live, and yet we seem a bit helpless... "

MAY 3

Madeline Albright testifies at a Congressional hearing on funding of UN programs:
"But let me tell you on the Rwanda thing, it is my sense that to a great extent the Security Council and the UN missed the boat. We are now dealing with a situation way beyond anything that anybody expected..."

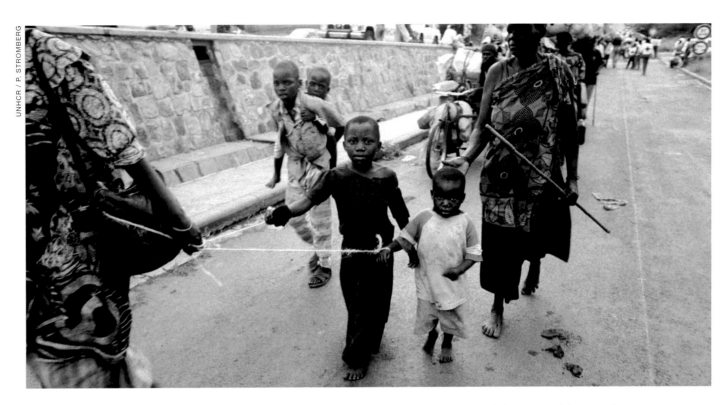

UNHCR / P. STROMBERG

The mass return from the Ngara camps, Tanzania. Children were tied together by their relatives to avoid separation.

MAY 5

Anthony Lake, National Security Advisor:
"When I wake up every morning and look at the headlines and the stories and television images of this conflict, I want to work to end every conflict. I want to work to save every child out there...but neither we nor the international community have the resources nor the mandate to do so. So we have to make distinctions...and the reality is that we cannot often solve other people's problems; we can never build their nations for them..."

MAY 13

The UN Security Council prepares to vote on restoring UNAMIR'S strength in Rwanda.

As the slaughter of the Tutsis continues, the UN finally agrees to send 5,500 troops to Rwanda. The Security Council resolution says "acts of genocide may have been committed." However, the deployment of the mainly African UN forces is delayed

because of arguments over who will pay the bill and provide the equipment.

MID-MAY

The International Red Cross estimates 500,000 Rwandans have been killed.

MAY 25

At a State Department briefing, spokesperson Christine Shelley is asked, "How many acts of genocide does it take to make genocide?"
Response: "That's just not a question that I'm in a position to answer."

Secretary of State Warren Christopher:
"If there is any particular magic in calling it a genocide, I have no hesitancy in saying that."

JUNE 22

The Tutsi RPF forces capture Kigali, capital of Rwanda. The Hutu government flees to Zaire, followed by a tide of refugees. The

French end their mission and are replaced by Ethiopian UN troops. The RPF sets up an interim government in Kigali.

JANUARY 26, 2004

UN Secretary General Kofi Annan addresses the "Preventing Genocide" Conference in Stockholm—the first genocide conference in more than fifty years:
"The events of the 1990s, in the former Yugoslavia and in Rwanda, are especially shameful. The International community clearly had the capacity to prevent these events. But it lacked the will...in Rwanda in 1994, and at Srebrenica in 1995, we had peacekeeping troops on the ground at the very place and time where genocidal acts were being committed. Instead of reinforcing our troops, we withdrew them."

Some of the sourcing for the above material comes from the PBS/Frontline 1999 report "The Triumph of Evil," which is published on its web site.

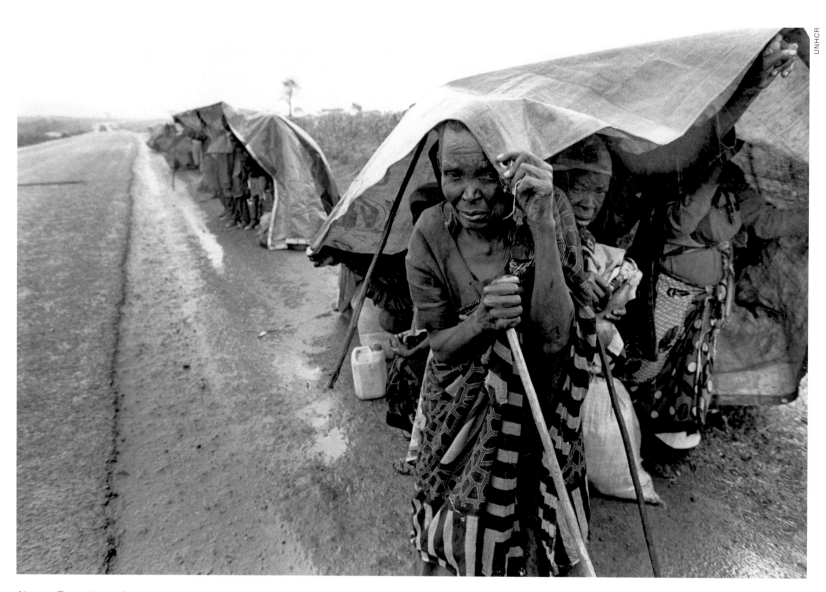

UNHCR

Above: Rwandan refugees.

Right: Repatriation: Rwandan refugees from Tanzania crossing the border at Ngara-Rusumo, December 1996.

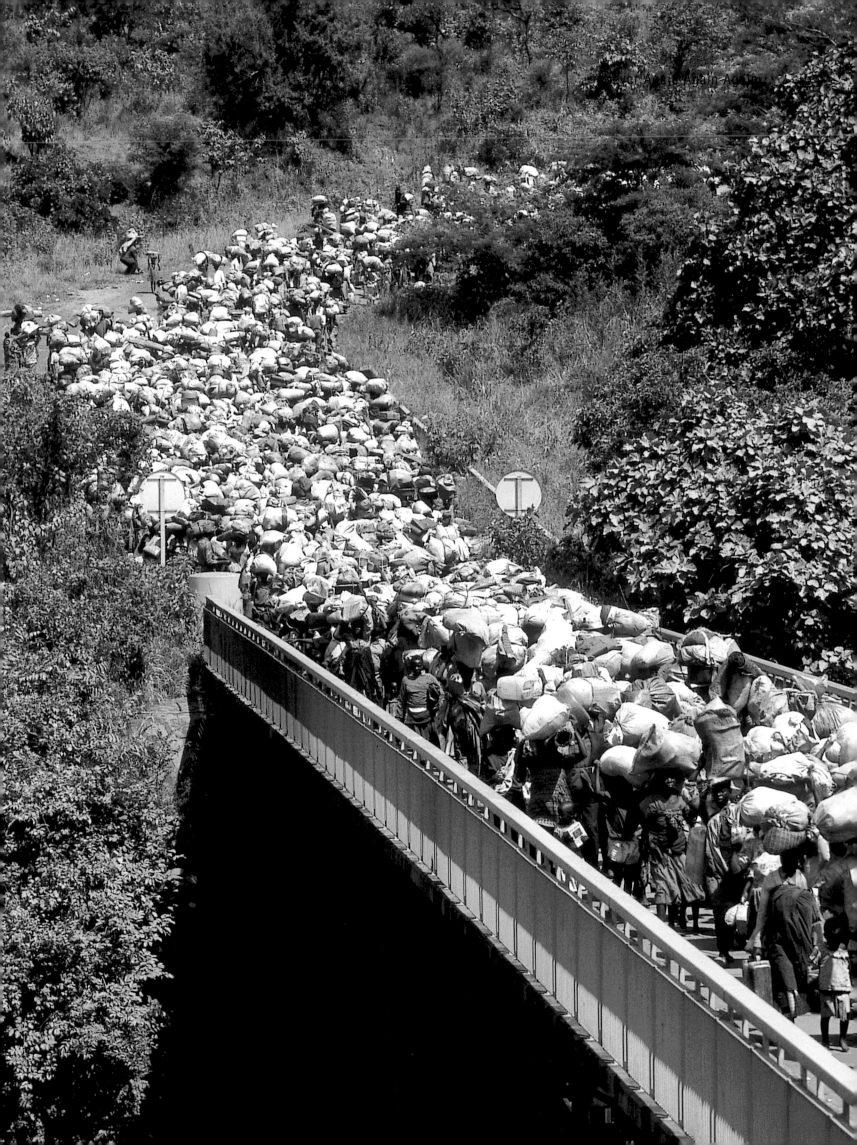

L.H. MONTGOMERY

Suburbs of Kigali. A fortunate few were buried by family members who survived the massacres.

My driver, Eric Kayiranga, 33 years old, was assigned to me by the IRC office in Kigali. His father was killed in the genocide. He fled to Zaire with his mother and younger sisters, They were some of the first to return home. We managed, in incorrect French and English, to communicate.

We arrived at the church at Ntarama. A man and a woman stood at the door of the church. It seems they each had lost their spouses in the church massacre and felt an obligation to guard and to show the church. Nothing, nothing could prepare one for opening the door and entering the dark center of that wooden church. As the slab of sunlight widened, I reeled back against the wall.

I remember hitting my head back up against the door while coughing from the smell and shaking from the sight of skulls and skeletons grasping for life before they lost it. As the door opened wider, I heard Eric gasp, and I remember being shocked that he had not been here before. Yet, the scene looked like it happened just before we arrived. A panorama of hell. I tried to focus my camera but my hands were trembling. I put the ASA at 1000. I saw only a lighter blur than before. I did not want to focus on what I was seeing. I kept blinking my eyes as I dared to look. I could look only through the lens as it passed without focus over the piles of skulls and bones—

L.H. MONTGOMERY

Orphaned Tutsi children.

I stopped on a prayer book with a rosary, the pages singed from fire; I blinked and moved my camera over a skeleton with a little baby skeleton between the legs. I lowered the lens and there was a lady's purse on a silver chain...feminine and fragile in tattered old French needlepoint...like my grandmother's. Eric bolted out of the door...I knew he was going to be sick.

I kept pushing back waves of nausea. It was hopeless between my stream of tears and trembling hands. I followed Eric. He went into the trees.

I waited beside the car and watched little boys play with sticks in the driveway. They were laughing. I tried to focus on them. I managed to take their picture and they crowded around me, posing with wide smiles. Eric later told me they were orphans from the Tutsi women who had been raped by the Hutu men. Many of the mothers had AIDS and had abandoned these children. We drove in silence. I finally said, 'I don't think I can do this.' Eric nodded. We drove further in silence. I asked, 'You are Tutsi, aren't you?' Eric did not answer me at first. Later, he explained that I needed to understand that they could never forgive, could never reconcile, if they continued to speak of one another as Tutsis or Hutus. They were and are again Rwandans.

—L.H. Montgomery

Overleaf: Singed prayer book and rosary, Ntarama Church.

Before we arrived back into Kigali, we passed a prison camp. On the side of the road were these big men dressed in shocking pink uniforms, unshackled, guarded by two soldiers with rifles. 'Who are they?' 'Prisoners' said Eric. 'What prisoners?… prisoners of the genocide?' Eric, 'Yes. They are waiting to go to trial.' 'But it's been ten years.' I asked him to stop. I got out and found I could easily take their pictures. They turned their heads and pulled their shirts over their eyes. Outrage felt good. It wiped away my deep sadness and sparked disgust. I kept taking their pictures and they kept hiding their faces.

That night I had dinner with the IRC team and some NGOs from England. Back at the Milles Collines there were reporters and writers from all over the world for the 10th anniversary of this atrocity. Joining them, I felt safe for the first time.

—L.H. Montgomery

These prisoners remain today without trial or sentencing for their crimes.

L.H. MONTGOMERY

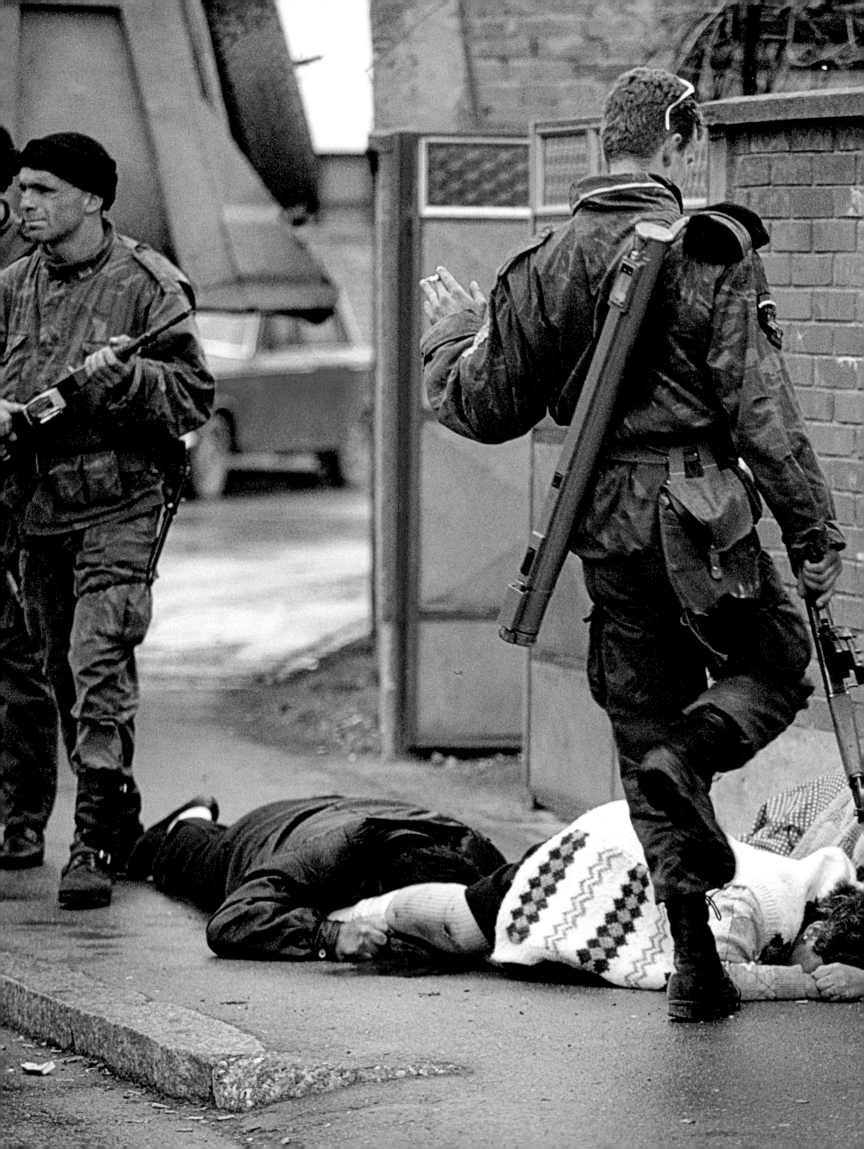

BOSNIA AND HERZEGOVINA

A Serb militiaman kicking a dying Muslim woman.

VII / RON HAVIV

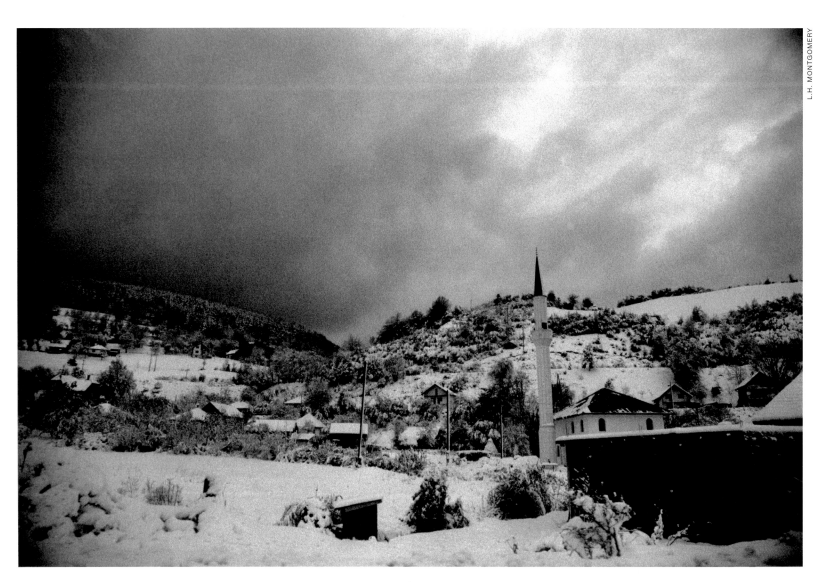

The empty village of Srebrenica after the hush of genocide. It has been said that one can hear the widows weep at night.

The hush that descends after lips have finished uttering a prayer for the dead...

Chuck Sudetic

Reporter for The New York Times *from 1990 to 1995 on the collapse of Yugoslavia and the transition from communism in other Balkan countries.*

Genocide leaves a telltale sound. It is the hush of absence, something like the hush that envelops an abandoned town or the hush that descends after lips have finished uttering a prayer for the dead. I have heard this sound in different settings, from the Zap River valley in northern Iraq to the Drina valley in eastern Bosnia. In May, 1993, in Srebrenica, an eastern Bosnian mining town, I heard this sound in a deserted schoolyard. A detonating Serb mortar round had torn the pavement, and flying shrapnel had splattered against the school's stucco walls. When the round landed, the schoolyard was teeming with young people watching a soccer competition. The explosion ripped the air. There were screams and cries for help. Blood pooled on the concrete, and body parts were hanging from fences. For me, there was only the gouged concrete, the absence, the hush.

A few weeks after the mortar round landed in this schoolyard, the United Nations Security Council passed a resolution declaring that Srebrenica, then home to about 40,000 Slavic Muslims, most of them refugees whom Serb forces had already ethnically cleansed from nearby villages, was a "safe area" free from armed attack or any other hostile act. In defiance of this resolution, units of the Bosnian Serb Army, acting under the instructions of Radovan Karadzic and Ratko Mladic, mounted a five-day offensive and captured the town on July 11, 1995. The United Nations, including the member nations of its Security Council, stood by and did nothing. Fearing for their lives, about 15,000 Muslim men and boys, only a third of them armed, fled Srebrenica that night in an attempt to transit hostile Serb territory on foot and reach friendly lines.

The other 25,000 Muslims, the vast majority of them wives and mothers, children, and elderly, sought protection in an open field beside a United Nations military base in Srebrenica itself. Serb soldiers surrounded them on the afternoon of July 12. Serb commanders summoned the same soldiers who had killed Muslim civilians during ethnic-cleansing operations earlier in the Bosnian war. They downed shots of brandy and belched out victory songs with crude lyrics. They meandered through the crowd. They pulled out a few Muslim men and slaughtered them behind a cluster of houses. They slit the throats of Muslim boys who had gone to fetch water for their families. They snatched young women and raped them within sight of the helpless throng and the United Nations soldiers. They soon began separating all the men and boys deemed fit to carry a gun. They packed the women, the elderly, and the children onto buses that dumped them in no man's land to walk to Muslim-controlled territory. Then, with knives and guns, they executed about 2,000 of the men and boys along with some 5,500 other Muslim men and boys captured earlier while trying to walk to safety.

A few survived, including a seven-year-old boy who, hysterical and crying for his dead father, walked out of a killing field covered with shit from bowels blown apart by bullets. The survivors I have spoken with said that, before the death squads opened fire, many of the victims uttered words from the Holy Koran. *"Bismi-llahi ar-rahmani ar-rahami...,"* their prayers began. "In the name of God, the most Gracious, the most Merciful...."

After the voices and the guns had gone silent, after the killers had driven off, the hush of absence hovered over the bodies.

During the year 2000, a corps commander of the Bosnian Serb Army was on trial before the United Nations war crimes tribunal in The Hague. General Radislav Krstic was facing genocide charges in connection with the Srebrenica massacre. One of the prosecution's expert witnesses was a Bosnian psychologist named Teufika Ibrahimefendic. She had worked with Muslim women from Srebrenica since July 13, 1995, when the first buses transporting the women, children, and elderly arrived outside a military airport near the city of Tuzla. Some women were lucky. Their men managed to cross the front line and reach them. Other women were not. These women, Ibrahimefendic testified, were desperate. As time passed and it became clearer that their men had been killed, these women insisted on remaining there, in tents, to wait, to hope. They were confused. They were forced, many for the first time in their lives, to think and act for themselves. Before the war, the men had been the heads of the Muslim households. The men had been the providers and the protectors. They had taken the major decisions. Many of the men had gotten high school diplomas or had received higher, technical education. The women had remained housewives and mothers, working the land and caring for the livestock. Most had finished only four grades of primary school, married before the age of twenty, and started having children.

The war crimes tribunal in The Hague, citing the Genocide Convention adopted on December 9, 1948, defined genocide to be something more than just numbers and percentages. In the Krstic case, the prosecution argued that the events at Srebrenica fit the definition of genocide. Causing the deaths of at least 7,500 Bosnian Muslim men amounted to the destruction of a group that had, before the town fell, numbered approximately 38,000 to 42,000.

This death toll, the prosecution argued, also constituted more than just a significant number and a substantial part of the group. The Bosnian Serb Army forces at Srebrenica were fully aware that, by killing the military-aged men, they would rock the group's social and cultural foundations. By killing the leaders and defenders of the group and deporting the remainder of it, General Krstic had assured that the Muslim community of Srebrenica would neither return to Srebrenica nor reconstitute itself anywhere else.

Krstic's defense attorneys asserted that the massacre at Srebrenica did not meet the legal definition of genocide, because the massacre was not committed with the intent to destroy the group. First, the defense argued, 7,500 Bosnian Muslims did not amount to a significant part of Bosnia's 1.4 million Muslim population; nor did the 7,500 dead even amount to a substantial portion of the 40,000 or so Muslims at Srebrenica. The defense also argued that if the Bosnian Serb Army had actually intended to destroy Srebrenica's Muslim community, it would have killed all the women and children already in its grasp and would not have invested the time and manpower to search out and eliminate the men trying to move overland to friendly lines. The defense maintained that the effect of the killing of the 7,500 men and boys on those people from Srebrenica who survived, while terrible, did not contribute to determining the true intent of the killing.

On August 2, 2001, the Tribunal's trial judges ruled that the Bosnian Serb Army had committed genocide at Srebrenica. The judges cited the testimony of the prosecution's expert witness, the psychologist, Ms. Ibrahimefendic, in finding that the women of Srebrenica were forced to live for years in collective and makeshift housing with a dramatically reduced standard of living. They had been forced to become the heads of their households and with significant difficulty, conducted family business in the world outside the home. Bosnian Muslim women must have a clear marital status, either widowed, divorced, or married; but, the judges

found, the women of Srebrenica whose husbands were still missing did not fit within any of these categories. On a psychological level, these women were unable to move forward to recovery without knowing with certainty what had happened to their fathers, husbands, and sons. Likewise, the adolescent survivors of Srebrenica faced a gauntlet of problems as they grew into adulthood. Few were employed, and returning to Srebrenica was not even a topic of interest. Younger children who survived had developed difficulties concentrating and were suffering nightmares and flashbacks. The absence of male role models was another factor that would inevitably hold significant implications for Srebrenica's children.

The Tribunal concluded that by killing so many of the men and boys of Srebrenica, the Bosnian Serb Army forces sought to eliminate Srebrenica's Muslim community. Finally, it was decided that there was a strong indication of intent to destroy the killings revealed by the Serbs efforts to conceal the bodies. After originally burying the Muslim dead in mass graves, the Serbs dug up and reburied the bodies in even more-remote locations, thereby preventing burial in accordance with religious and ethnic customs. Also, by killing the military-aged men, the Tribunal ruled, the Bosnian Serb forces effectively destroyed the community of the Muslims in Srebrenica and eliminated all likelihood that it could ever re-establish itself on that territory. Three years later, in 2004, an appeals court affirmed this judgment.

Each July 11, Muslim mourners return in buses and cars to Srebrenica. They come to bury the dead whose remains have been exhumed from mass graves and identified during the intervening year. They come to gaze at the United Nations base where the woman and their families had gathered seeking protection. They walk through the town. They pause before the elementary school where the mortar round ripped into the concrete, the young people screamed, body parts flew, and blood pooled on the pavement. Women gaze at the places where they bid farewell to their husbands, fathers, and sons. They stand beside the graves. They listen as a voice over a loudspeaker reads a roster of the dead. They pray as imams recite passages from the Holy Koran.

Each July 11, Muslim mourners return in buses and cars to Srebrenica. They come to bury the dead whose remains have been exhumed from mass graves and identified during the intervening year.

Once they have completed their prayers, once they have said goodbye to the mounds of fresh earth covering the dead, once the last buses and cars have carried the last of the mourners away, what remains in Srebrenica— beside the mundane sounds of the Serb newcomers and the minuscule number of Muslims who have returned— is the unmistakable hush of absence —the telltale sound of genocide.

Chuck Sudetic's first book, Blood and Vengeance, *a chronicle of the experiences of two Bosnian families during the century of turmoil ending with the Srebrenica massacre, became a* New York Times Notable Book *and was named a "Book of the Year" by* The Economist, *the* Washington Post, *and* Publisher's Weekly. *He has co-authored the forthcoming memoirs of Carla Del Ponte, Chief Prosecutor of the International Criminal Tribunal for the former Yugoslavia, and worked at the Tribunal from 2001 to 2005. His articles have appeared in* The Economist, Atlantic Monthly, Rolling Stone, Mother Jones, Das Magazin *(Zurich), and other periodicals. He is now a senior writer for the Open Society Institute (Soros Foundation) and is completing a book about the Adriatic town of Dubrovnik, where he resides.*

BOSNIAN TIMELINE

The history during and after World War II in Yugoslavia is a compilation of many wars, one on top of the other, much like a layer cake. To begin with, there was the initial war carried out by Hitler and Mussolini which began with Yugoslavia being served up in portions to Germany, Italy, Hungary and Bulgaria.

1937

Stalin has the Secretary-General of the Communist Party in Yugoslavia (CPY), Milan Gorkic, murdered.

Josef Tito returns to his homeland, Yugoslavia, from the Soviet Union after Stalin names him to replace the former Secretary-General of the still outlawed CPY.

APRIL 6, 1941

German, Italian and Hungarian forces arrive in Sarajevo and destroy the synagogue in the old town. The Luftwaffe bombs Belgrade and other major Yugoslav cities. With the help of the local communities all synagogues are razed to rubble.

APRIL 17, 1941

Within eleven days of resistance fighting, Yugoslavia signs an armistice with Germany in Belgrade. The independent state of Croatia is established as a Nazi puppet-state. Germany takes the slice that is Bosnia and Herzegovina as well as some from Serbia and Slovenia. Bulgaria, Hungary and Italy get smaller servings.

JUNE 22, 1941

Tito's Partisans become the first anti-fascist unit in Europe. This group of Partisans is successful in liberating Nazi territories and it provokes the Germans into retaliation that results in mass murders of Yugoslav citizens. For each German soldier killed, one hundred innocent Yugoslavians are killed and for each wounded German soldier, fifty civilian lives are taken. Tito's Partisans face competition from Serbian Chetniks, supported by the British. By the end of June, with the help

of local communities, the majority of Jews are rounded up and taken to concentration camps. Out of the 14,000 Jews in Bosnia, it is estimated that 12,000 are killed by the end of World War II.

1943

The Yugoslav Partisans stand up to the Axis attacks. At the Tehran Conference, Roosevelt, Churchill and Stalin officially recognize Tito's Partisans.

1945

Tito signs an agreement with the USSR allowing temporary entry of Soviet troops into Yugoslav territory. Tito becomes the Prime Minister and Minister of Foreign Affairs and forms the JNA, the fifth strongest army in Europe.

1941–1945

In all of Yugoslavia, at least a million Yugoslavs are killed by Yugoslavs.

1948

Tito unites his country. He defies Stalin's leadership, and manages to survive several assassination attempts from Stalin —the only satellite leader to do so with success.

"No one is questioned 'who is a Serb, who is a Croat, who is a Muslim (Bosniak)', we were all one people, that's how it was back then and I still think that it is that way today." —Josef Broz Tito

1953–1980

Tito becomes president of Yugoslavia and brings internal peace and reconciliation to Yugoslavia after World War II. He runs a "New Class" of communism where

Western luxury is introduced—from expensive cars to first class homes with vintage wines and Godiva chocolates. This new class of communism creates a fake wealth in Yugoslavia where some live like British royalty while the State pays for everything. Tito becomes the most traveled and accepted eastern European leader ever and whereas he helps to heal the wounds of war, power is more important to him than reconciliation at home. Since power often lacks wisdom, Tito imposes a very heavy price on Yugoslavia. As Tito ages, Yugoslavia's economy begins to unravel from cumulative debt. After his death in 1980, the seams come apart within the six Republics he had so so seamlessly stitched together. A new generation rises up through the post war hierarchy and maneuvers for power. The disillusionment of ordinary Yugoslavs is almost universal. But elsewhere in Yugoslavia, as the economy collapses, stronger emotions are aroused by the new leader of the Serbian party, Slobodan Milosevic.

1989

On June 28, several hundred thousand Serbs assemble outside Pristina to celebrate the 600th anniversary of the battle of Kosovo. The bones of Prince Lazar, who was killed in the battle, have become the object of a pilgrimage. In the monastery south of Pristina, people wait to pay homage to the Prince's bones. In the stalls outside, icon-like posters of Jesus Christ, Prince Lazar, and Slobodan Milosevic are selling side by side.

1990

In Bosnia, as in most other republics, the communist party disintegrates. Talk of a

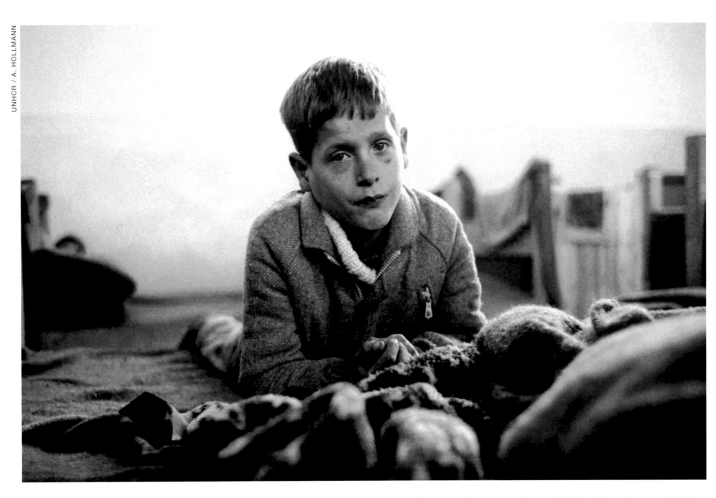

A young boy waiting at the Masinska Skola collective center, a temporary orphanage, hoping relatives will claim him, January 1994.

fundamentalist threat in Bosnia is in any case particularly inappropriate because the Bosnian Muslims are now among the most secularized Muslim populations in the world. The majority do not think of themselves as religious believers and follow some of the practices of Islam as a matter of culture and tradition.

1991

The republics of Slovenia, Croatia, Bosnia-Herzegovina, Montenegro, and Macedonia fall with the collapse of the Soviet Union. The newly established Serbian Republic under President Slobodan Milosevic declares its intention to create a Serbia for Serbs only. In the southern region of Bosnia-Herzegovina, 30 percent of the population is Muslim, a legacy of the old Ottoman occupation.

A policy called "ethnic cleansing" is established which is a euphemism for genocide.

1992

The genocide begins. Once the United States and the European Community recognize Bosnia's independence, Serb forces attack the Bosnian capital of Sarajevo. The Serb militias execute men, women and children in plain sight. Milosevic kills off the more educated Serbs. He sets up killing camps and rape camps to impregnate Muslim women with Serb blood. Many of the atrocities are carried out by young urban Serb gangsters in plain clothes wearing expensive sunglasses.

1993

The Serbian population of Bosnia, under

the leadership of Radovan Karadzic, takes part in the killing with enthusiasm. The UN limits its response to sanctions which have no effect on the violence. The 80 percent Bosnian Muslims in Sarajevo come under daily sniper shelling from posts in the mountains that enclose the city. It is like a smaller Leningrad, a city without water, electricity and food.

1994–1995

U.S. President Bill Clinton takes a stand and NATO demands a cease-fire in the former Olympic city of Sarajevo, host of the 1984 Winter Games. The beauty that was Sarajevo is now only a pockmarked maze of "sniper alleys." Milosevic hesitates and UN peacekeeping forces move in. Soon the Serbs continue the "ethnic cleansing." When NATO attempts limited

View of Sarajevo from its ruined parliament building, March, 1996.

air strikes, the Serbs retaliate by taking the UN peacekeeping troops hostage. The Croatian armies, just miles away from Sarajevo, make no effort to come to the aid of the besieged city.

JULY 11, 1995

The Bosnian Serbs invade a UN safe area called Srebrenica. General Ratko Mladic demands that the Dutch peacekeepers surrender or face a firing squad. The fall of Srebrenica's safe area is the largest massacre in Europe in fifty years. Under Mladic's orders more than 7,000 men and boys are killed. Today, Ratko Mladic remains a free man living in the area surrounding his village. A United Nations War Crimes Tribunal judge describes the Srebrenica genocide as "scenes from hell written on the darkest pages of human history."

NOVEMBER 1995

By the time of the Dayton Accords, Milosevic, Karadzic and Mladic have killed a quarter of a million countrymen and expelled another two million from their homes during the 1992-1995 wars that pitted Bosnia's Muslims, Catholic Croats and Orthodox Serbs against one another.

MARCH 11, 2006

Slobodan Milosevic is found dead in his prison cell at The Hague ending his four-year long war crimes trial without a sentencing.

MARCH 18, 2006

More than 50,000 Serbs rally in the public square in Belgrade to attend the wake for Slobodan Milosevic. His coffin rests in front of the former Yugoslavian Parliament. Older Serbs chant a mantra of prayer, "Slobo! Slobo!" A much smaller group of younger Serbs gather to wish him good riddance with "boos!" Still another defiant group cries out, "We will never give up Mladic!"

SEPTEMBER 2007

Ratko Mladic has not been captured nor brought to trial for the slaughter at Srebenica.

WHEN HOPE DIES, ONE ONLY HAS HOPE TO FIND REMAINS OF THEIR DEAREST...

I am Camila Omanovic. I was born in Srebrenica, on April 15, 1953.

Life in Srebrenica, which had nearly 5,000 inhabitants, was nice those days. Our downtown, as all old Bosnian downtowns, had its soul. No matter what it was, marriage or funeral, we shared all together. Nobody even thought about someone's religion. We were occupied by what dress to wear, what haircut to make, who likes who, who is in love…

In one word, life was more than good. Nobody had too much, or too little.

Three years before the war in Sarajevo, I started work in the battery factory built by the communist government in the town of Potacari. While working there I had many Serbian colleagues. The Serbs claimed how they were persistently endangered. How could they be endangered when we worked and travelled together day by day on the same bus? Later, with time you do see how the whole thing was planned. The scenario was written a long time ago. At the beginning of the war, the Serbs in Srebrenica were armed to the teeth.

The fighting started on April 7, 1992. The Serbs started to shell our town. Afraid, many Muslim families left Srebrenica. Ahmet, my husband, asked me to take the children and leave when it was still possible. Since we got married, we had never separated. Why separate now? Serb forces occupied our town. Nobody could even imagine that neighbors and friends would be turned overnight into monsters, capable to commit unprecedented brutalities. What normal being could kill a mother with child in her arms?

Our forces succeeded to free our territory. The Serbs left Srebenica. We were still completely surrounded by them without electricity, water, or food. But we were happy because there was no more killing, raping, or anything

that happened while they occupied our town. Then thousands of refugees from other villages start coming to Srebrenica. Our town then had around 60,000 people on five square kilometers. Each garage, each basement, each shop was full. All this meant hunger. At the same time, the Serbs stopped humanitarian convoys to reach the town. We were still exposed to Serbian snipers from artillery located outside and around us.. People were dying daily from hunger and illnesses. The UN decided to drop food from planes. The Serbs started shelling us. Each shell found its target.

Fearing the fall of Srebrenica, the United Nations commander in Bosnia, French General Phillipe Morillon, snuck into Srebrenica in March of 1993 and declared, "You are now under the protection of the United Nations. I will never abandon you." The UN flag was raised over our Srebrenica.

Nobody dreamed that we would again fall into Serbian hands. But the disabling of UN Dutch troops monitoring the protected zone was the beginning of the biggest evil. Evil that could have been stopped, but at that time the world gave up its hands from us…We were only a small island in the sea of territory controlled by Bosnian Serbs. The easiest way was to erase that small island… So the Serbs re-entered Srebrenica…

First, they disarmed the Dutch battalion and took about 30 of them as hostages. The town defenders were armed only with light weapons, as all the heavy weapons were taken from us when the United Nations proclaimed Srebrenica a protected zone.

On the morning of July 11, 1995 the sky above Srebrenica was on fire. We were the last who were leaving. Many men decided to go through the forest and find the way out of the fire siege, because nobody had any illusions that the

Overleaf: Camila Omanovic at her husband's grave.

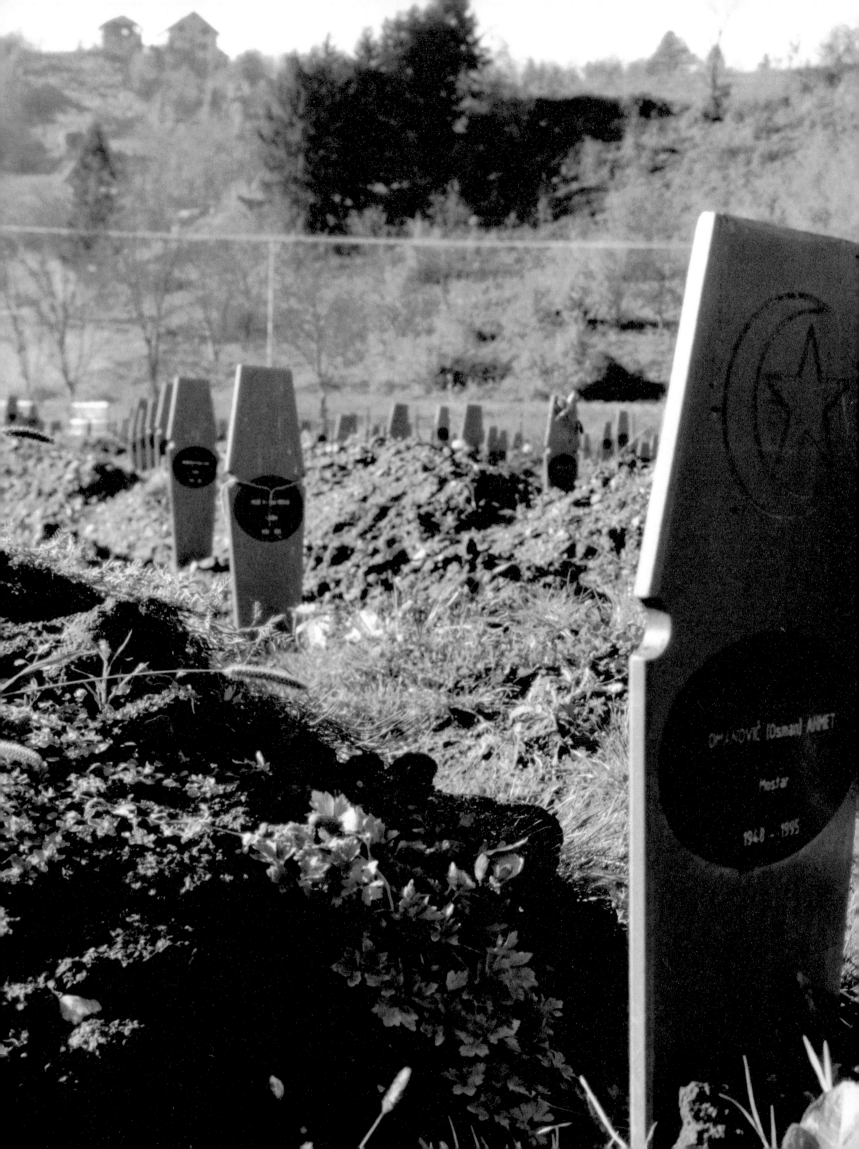

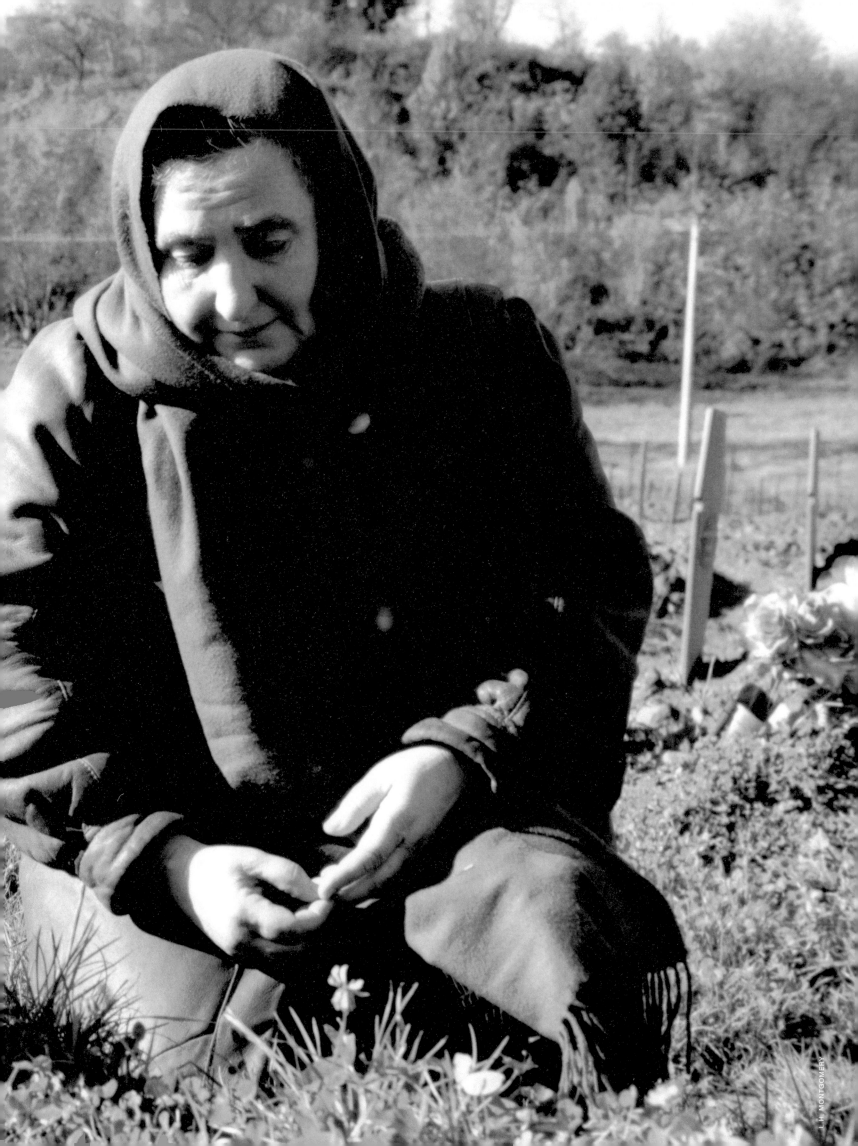

L.H. MONTGOMERY

men could survive if Chetniks got them alive. My husband, Ahmet, was among those men. It was better to get killed in escape attempt than to be tortured to death. On the other side, the women, the elderly, and the children, continued on toward Potocari. On the way, nobody stopped to remove the corpses.

I was pushing the baby carriage loaded with baby things, while my 17-year old daughter was carrying her baby. We reached Potocari. My children sat with me under a broken roof in the destroyed factory.

Chetniks were shooting above us all the time. Srebrenica had fallen!

Slowly we were understanding we were in a real concentration camp waiting for sunrise in Potocari. At sunrise some neighbors came for me and said: "Let's go together to the UNPRO-FOR base and ask if they can help us. "

There they told us that the Serb general, one of the most wanted war criminals today, Ratko Mladic (Head of the Serb Forces in Bosnia) would negotiate with us in the Hotel "Fontana." Ratko Mladic was in the middle of the crowd. He offered coffee to us. He behaved very nice. A TV camera focused on his every

move. I told him I came as a mother on behalf of many mothers. He is telling me that I shouldn't worry. He looks right into the TV camera and makes big smile and then looks right at me.

He is offering me to bring my children to Fontana, promising that not a hair from their heads will be touched. Next, he is asking for the list with names of people for evacuation from Srebrenica. He asks for the elderly, the women and children. I ask him, if transport for us is organised, to send buses instead of trucks. Mladic was all that time behaving as a big actor in some show. Looking into the cameras, Mladic said to us, "Allah can't help you now. Mladic can." We went back to Potocari to wait.

The minister of the Bosnian government, Hasan Muratovic, said that we should be patient as in a few hours French and British troops will come to take care of our safety. Those soldiers never came! But the Chetniks did. They dressed up themselves as Dutch peacekeepers. They started to take away men in big groups, who never came back, taking young girls away, killing, raping, slaughtering, horror… for the first time, I lost my spirit. Dozens of Serb soldiers were moving near us. I heard their dirty comments

about my daughter, how she was young and pretty. Many young girls, as well as my daughter, were raped that night…God knows what else…It was incredible moonlight that night…We could hear only screaming of the people tortured in the white car battery slaughterhouse. They started to use nerve poisons. I cut my daughter's hair and dressed her in traditional outfit in order to make her less attractive.

Morning came and the trucks for the transportation arrived. Serb soldiers, standing at each bus and truck entrance, were separating men from women. Each man older than 13 was taken aside. Just a few survived those mass executions that happened later. We climbed on one truck, but I found out that the truck was for "marked ones." "Marked" meant to be taken from truck and killed. I started to scream in English: "Help!" I decided to jump off and run for help. I reached the head of Medecins Sans Frontieres, Christine Schmidt, and with a translator's help I told her what would happen with the truck where my children were. She got in a car and drove after the convoy of trucks. She reached them and saved the lives of many. Others in the buses and trucks never reached Tuzla. The Chetniks

were stopping buses and trucks, as they wanted. Women were offering gold, but they didn't want it. They wanted money or simply just to make bad things, because they could do whatever they wanted. If you want to find out what kind of man is someone, give him power, and you will find out!

Only the Dutch soldiers and staff of Medecins Sans Frontieres stayed in Potocari… Groups of men who succeeded to go through the Chetnik's siege were arriving. I listened to each of their stories, hoping to find out anything about Ahmet. And you never stop to hope…

His remains were found last year. He is buried in Potocari. His corpse was without a head, without hands… His shirt was still there, a sock, his shoes and a wedding band, all of which I was given during the identification procedure. Would he be alive, in case he stayed with me in Potocari? Hope dies last. And when hope dies, one only has hope to find remains of their dearest, to make a decent funeral, to have the possibility to visit their graves.

Interview given to Lane Montgomery, translated by Bosnian journalist, Elmir Tozo.

L.H. MONTGOMERY

Above: The car battery factory, where Camila once worked, used by Serbs during the slaughter at Srebrenica.

Left: View from a window inside the car battery factory where the Serbs took the people.

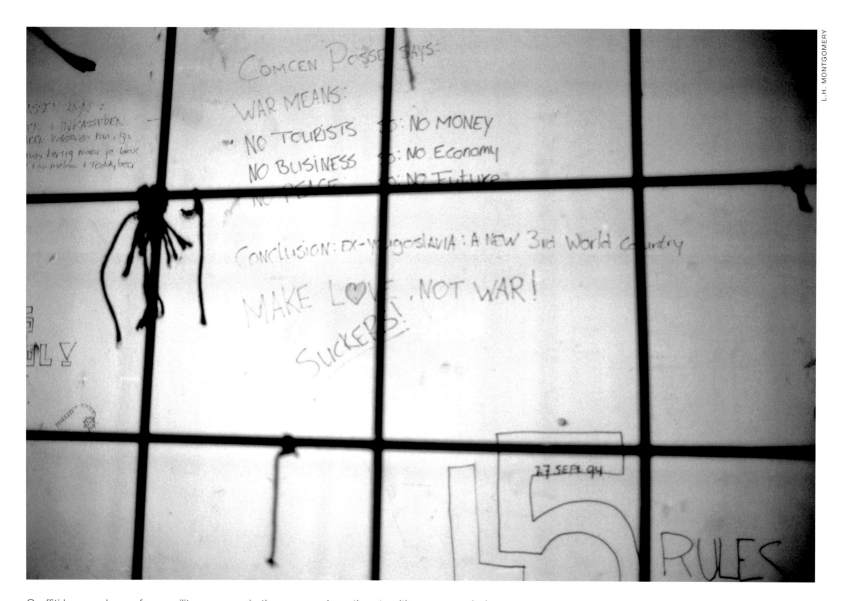

Graffiti by members of paramilitary groups in the rooms where the atrocities were carried out.

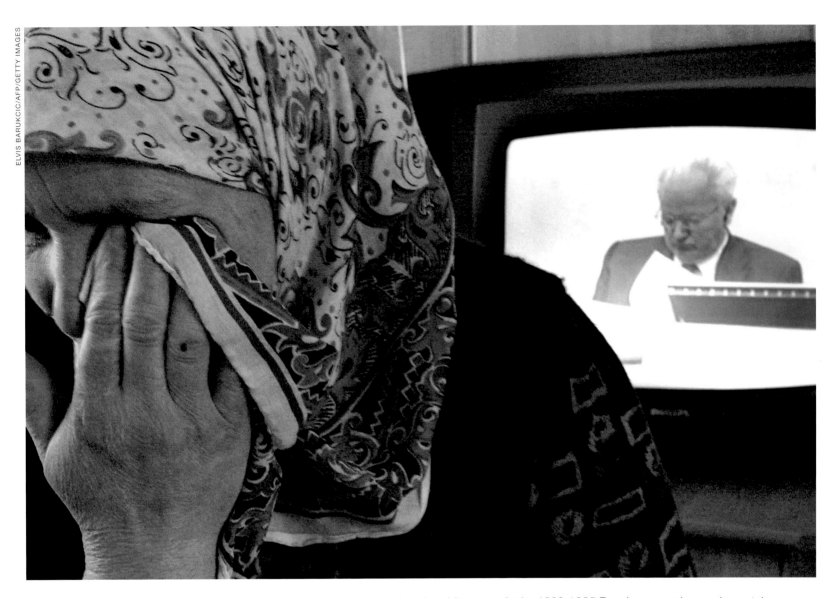

Vasvija Mehic (47), a Bosnian Muslim from Srebrenica who lost her husband and four sons in the 1992-1995 Bosnian war, cries as she watches former Serbian President Slobodan Milosevics' trial at The Hague tribunal in Sarajevo, February 14, 2004.

Overleaf: Children of Sarjevo in sniper alley

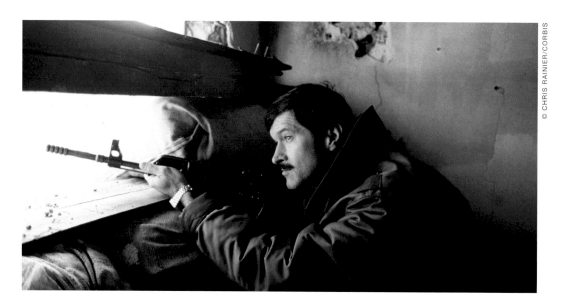

A Bosnian Muslim sniper aims at a target in Sarajevo during the Yugoslavian Civil War.

SARAJEVO—THE BEAUTY OF THE ONCE OLYMPIC CITY—NOW A POCKMARKED ALLEY OF EVIL AND DEATH

Sarajevo, during my time there, was a sniper's paradise, a five-mile strip of city situated on the floor of a deep valley...It was the perfect mix of elements for a human shooting gallery...Perhaps the most widely told story was about a bunch of snipers called safari hunters. These were poets, businessmen, soccer fans, politicians, or any breed of psychopath from Serbia who made weekend hunting trips to Sarajevo to bag humans...

Out of everyone I had met in Sarajevo, Vlado existed in the bleakest place of all, yet he had this hidden inner core that kept carrying him forward...I thought that if I could just get access to that core myself, maybe I would finally find that golden nugget of wisdom I had been looking for... I knew some things about his past, that he was a successful businessman before the Balkan war. He wore Pierre Cardin suits and drove a Beemer then. He had been a hippie as a teenager in the seventies... When I got to Vlado's that night, he greeted me at the door by putting his arm over my shoulder. "I wait for you to return before I open," he said, holding a half gallon jug of moonshine. "It's pure, perfect."

Once inside, he poured two healthy shots. We clinked glasses and cheered each other.
"Shivoli."

After I was a little liquored up, I asked him a question that I always eventually ask someone from Sarajevo. Did you see the war coming? Vlado told me, "no."

"Really? Come on, everyone tells me that. You NEVER saw it coming?"

"Of course, never," he said. "It was 1992. I live in Europe. Fly to Rome. London. I drive BMW. I ski with family, here nearby, on Olympic mountain. Friends and me see Rolling Stones, in concert. Everyone had good life here. Why war? Only crazy man can see war from that." He finished off his remaining booze. "Of course, crazy man smarter than the rest of us," he said. "He plan for war, while normal man sleep."

The next morning Vlado and I went back to business as usual, hiking up to the nest atop Building B. For an hour or so he chatted with his partner, looked though the notebook, and scanned the Serbs' side of the line. Finally, he moaned...Then turned around and said, "Johnny, come with me."

We walked down the hall to the elevator and sat in some rubble, where he lit a smoke. "So strange," he said. "Nothing there. No sign of Chetnik snipers." I was hungover from the night before, so I just sat there, a lump on rubble. For the next minute we didn't say anything, until he finally broke the silence. "Johnny, you ever see the film *On Golden Pond*?"

"Not really. Why?"

"That was my favorite film," he said. "Favorite film of all time. Purrrfect film. Fonda… what's his name?"

"Henry Fonda."

"Ah, yes." he said. "Henry Fonda. And Katherine Hepburn, the actress. We loved her here in Yugoslavia. Now that was a star, that woman."

"That was your favorite movie?"

"Of course, why not? I saw it many times. Before war, that's how I saw my life."

"Whatdya mean?"

"I mean, me and wife, work hard when we are young, raise family, save money. Then we get older, grow tired, settle in the mountains, near Sarajevo, in beautiful home, on lake, like in movie. Forget the troubled daughter in the film. Not important. What is important is me and wife together, end of our lives, and our daughter come to visit us with her family. That would be something…but anyway, never mind, just dream."

"War's gotta end, right?"

"Of course, war can't last forever. We will grow tired someday. Johnny, sometimes I don't think I will survive. Me and just a few others are left. It is quiet now, but won't always be."

"You really think you won't live?"

"Who cares about me? But what of my daughter, my wife? They are what's important. Even if I do live, so what? The life is gone, forever. Everything from before is gone here."

"I'm sorry," I said.

"I was just normal man. Family. Work. Vacation. Had drink with my best friend on weekend. Too busy, I never thought of politics. Maybe I was just stupid man. But this war, not normal war. It is ugly. Too ugly. And it took from everyone, a part of their heart, no matter." Then he stopped talking and just stared at me, hard. I held his gaze for as long as I could, but finally looked down at the ground.

"You know what normal people don't know?" he asked.

"Don't know about war?"

"No. It is easy to kill," he said. "It is too easy."

"I'm sorry."

"Well, I do not need your sorry…I remember once, over year ago. May, 1992. The first big action for us, our line, biggest of the war. Chetniks attack our sector of the city with everything. Praga, APC, tank, many, many Chetnik soldiers. Too many. We fight hard.

"We kill many more of them. The next day, we are at our positions, waiting for the new attack. Our leader, Juka, has given me body armor taken from dead Chetnik…I am nervous. Very nervous. Cannot see anything. So I make mistake. I put head out of bunker to look and then, bang. Chetnik sniper shoot me…And I feel like I am hit by a Volkswagen. Oh, the pain. It hurt. But plate in vest stop bullet. Broken ribs, but nothing more. I am very, very lucky…I never hurt anything, anyone before. Why hurt anything? But that day, I hate. Feel it in me, like volcano, Vesuvius. And that night watching my wife and daughter in shelter…I make promise to myself in head. I kill that man, that Chetnik sniper. And next morning before I go, I find that Chetnik's bullet, now flat like coin, in pocket of vest and give to my daughter. I don't tell her what it is for, that is my talisman, but she know. Already she getting older. Then I get my rifle and go out.

"I go slowly, quietly building, to building on our side, looking for perfect position to look down on where I think that sniper shoot me from. Hour, maybe two, and there he is. I watch and wait. Later, maybe three hour later, he come out of back of medical building. He is in uniform, normal-looking man, holding sniper rifle. I put rifle on him and pull trigger. He fall down. Not like in movie roll. Just falls, right down. I leave position and go back home…"

Excerpt from Hello to All That: A Memoir of War, Zoloft and Peace *by John Falk. Copyright 2005 by John Falk. Reprinted by Henry Holt and Company.*

Muslim man wounded by sniper fire arriving at a temporary medical care unit in Tuzla.

UNHCR / A. HOLLMANN

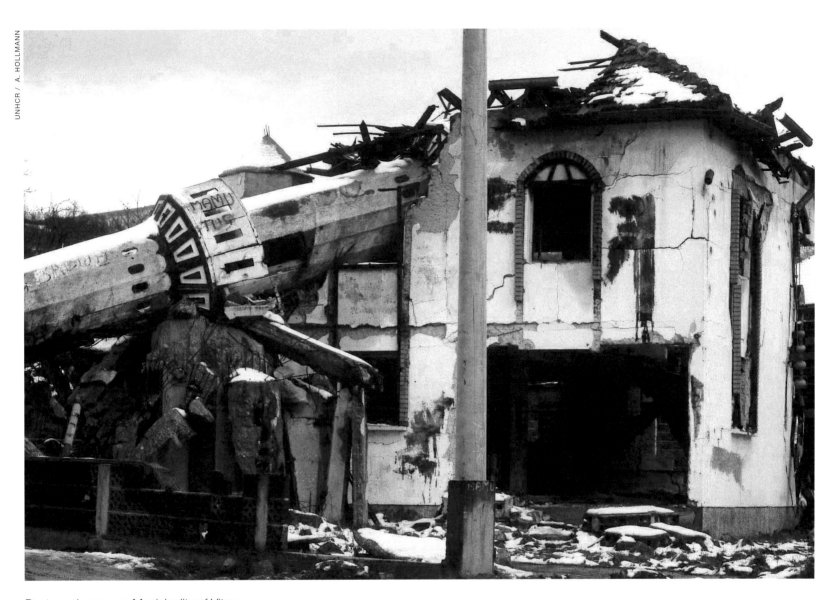

Destroyed mosque, Municipality of Vitez

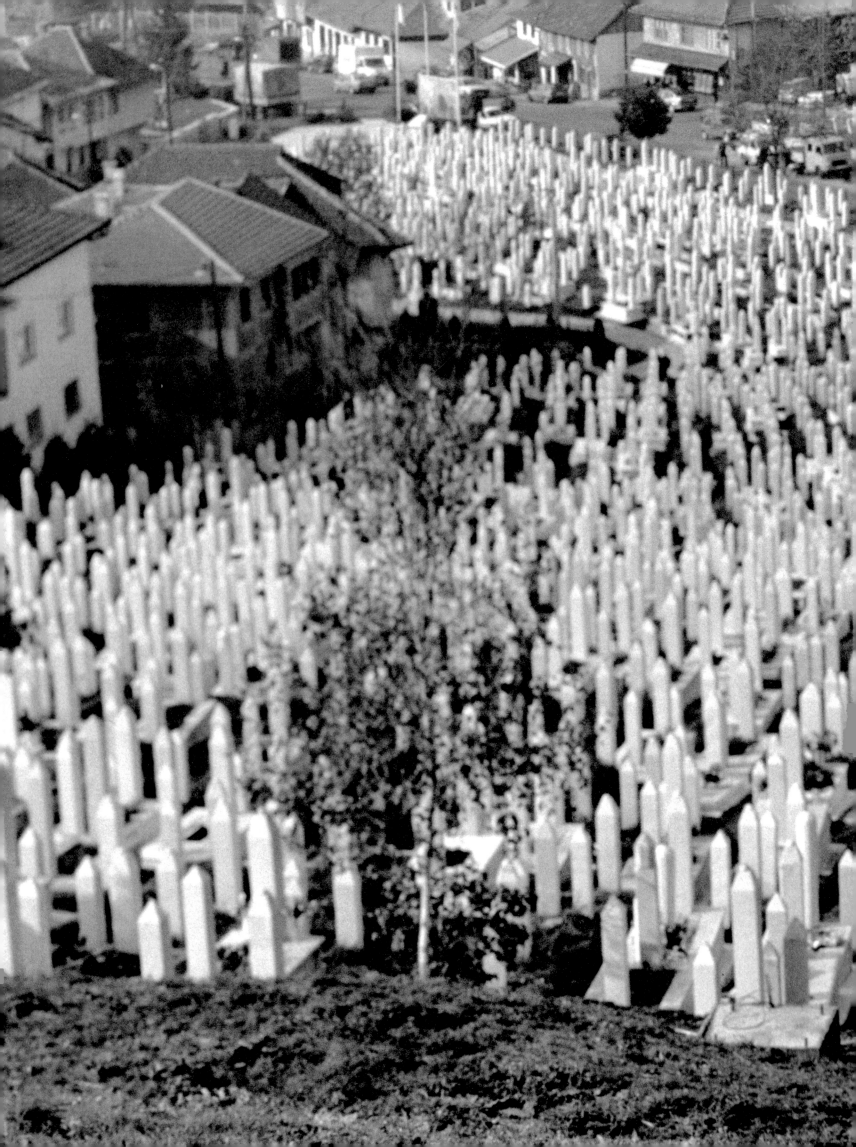

The tombstones of 7,000 to 8,000 Bosnian Muslim civilians killed by Serb snipers and bombing raids now fill the former Olympic soccer stadium in Sarajevo.

L.H. MONTGOMERY

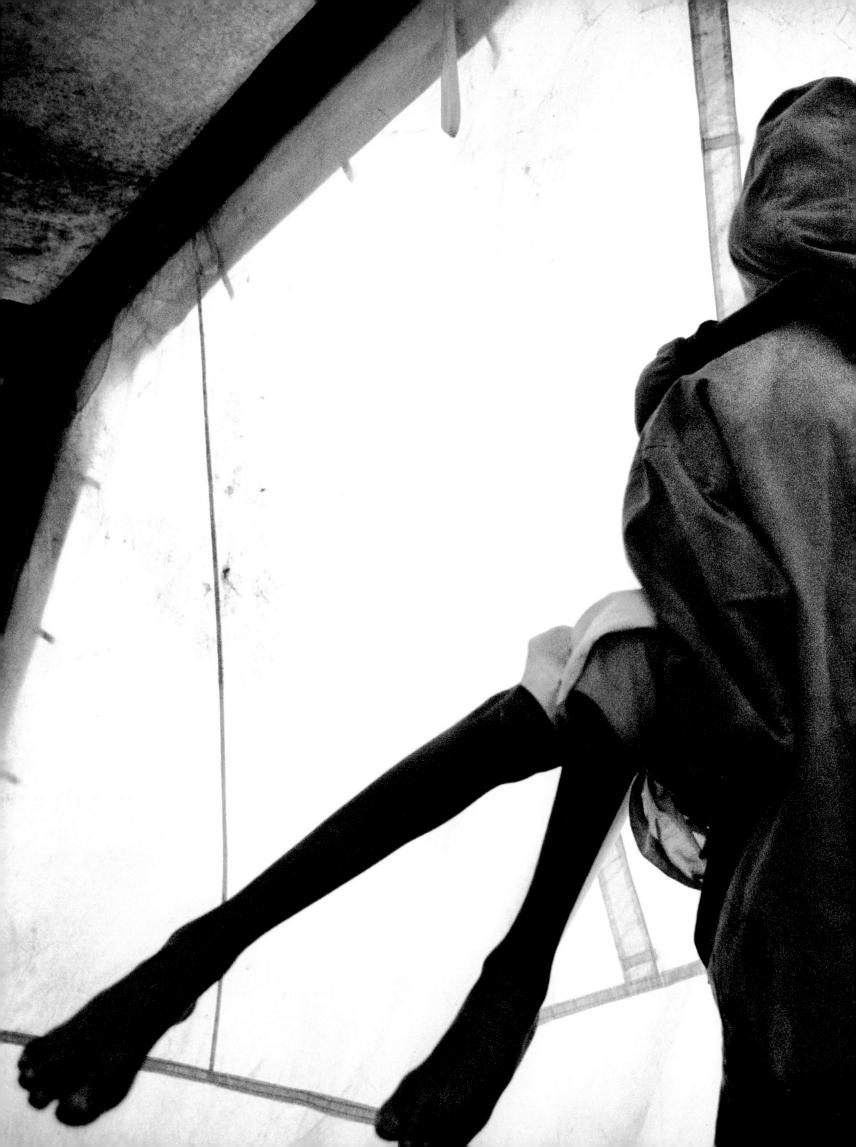

DARFUR

"…But there is something special about genocide. When humans deliberately wipe out others because of their tribe or skin color, when babies succumb not to diarrhea but to bayonets and bonfires, that is not just one more tragedy. It is a monstrosity that demands a response from other humans. We demean our own humanity and that of the victims, when we avert our eyes…"

—Nicholas Kristof, "A Tolerable Genocide," *New York Times*,
 November 27, 2005

A medical tent in Darfur.

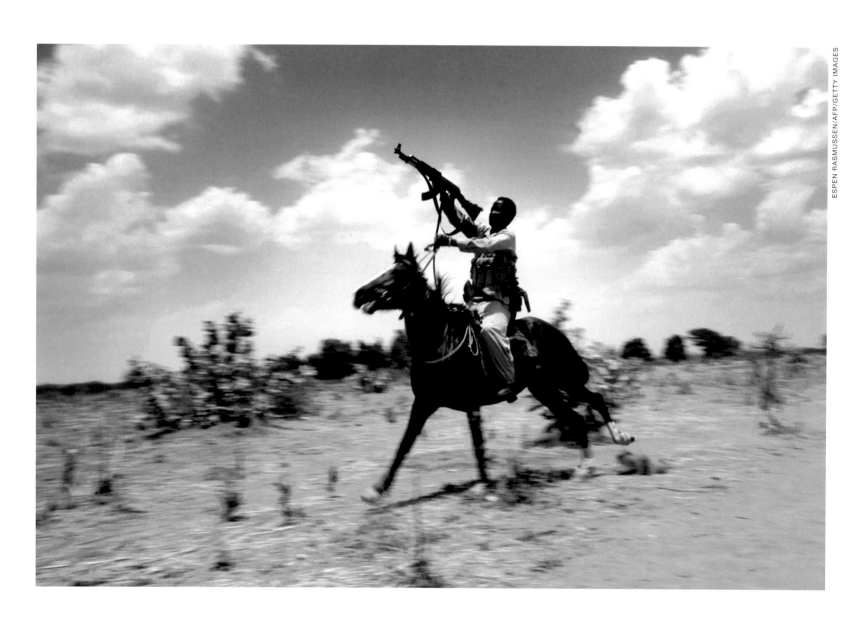

A Sudanese *janjaweed* raids Sudan's western Darfur region near the Chadian border. Much of the violence in Sudan has been attributed to these militias. The word, *janjaweed*, is an Arabic colloquialism meaning "a man with a gun on a horse." They are primarily members of nomadic Arab tribes that have long been at odds with Darfur's settled African farmers. Operating with the covert support of the Sudanese government, the *janjaweed* are largely responsible for the atrocities that have claimed at least 300,000 lives and uprooted some two million people. The *janjaweed* are paid by President Omar al-Bashir's Sudanese government about $80 U.S. per month per man and $120 U.S. if the man owns a horse.

Darfur has been referred to as Rwanda in slow motion...

Ruth Messinger
President of American Jewish World Service

The first genocide of the new century is happening in the Darfur region of western Sudan. It is a difficult task to write about a genocide while it is ongoing. But the story must be told and we need to become better—much better—at learning how to identify such evil when it first occurs and learning how the world can intervene. The genocide in Darfur, now spilled over into Chad, has been ongoing for four plus years. The world is just beginning to pay attention and has so far not acted to stop a systematic campaign of rape, violence and displacement. It is important to try to set down what is happening; to pose the hardest question —why; to speculate on the future of this crisis and discuss possible global responses.

The government of Sudan under Omar al-Bashir has been problematic since the beginning. It waged a civil war against its own people in the north and south that went on for twenty years, Muslim against Christian and animist; this civil war has now ended—the subject of a fragile peace agreement which the Bush administration helped to negotiate.

But before the civil war had ended the attack on Darfur began. The Darfur region is about the size of Texas. It has for many years been home to African tribal farmers living in small villages who shared their land with nomadic herders and grazers, at odds with each other over the decline in water resources. In February, 2003, rebels in the Darfur region, feeling excluded from the peace negotiations between the north and south, attacked an army garrison and killed some soldiers.

The government of Sudan used this one incident to turn against the entire population of Darfur and embark on a genocidal campaign, employing the *janjaweed* militia—herders and grazers—as their agents. In village after village, the pattern of attack has been similar. First, planes fly over the village and bomb it. Then the *janjaweed* militia ride in shouting wildly, yelling ethnic slogans, killing men and children, raping and branding women. They slaughter the livestock and put the dead carcasses in the wells to poison the water supply.

No one has planes other than the government of Sudan. These disguised planes, made to look like UN Relief planes, drop not only ammunition but also old broken refrigerators, car chassis—large objects that flatten housing and kill people. The government has egged on the *janjaweed*, providing them with horses and weapons to attack—Muslim attacking Muslim because one group is Arab-identified and more fundamentalist, the other group is more Africa-identified.

Villagers report the death of relatives and the rape of women in their families. Often people being attacked are killed in front of those closest to them. The numbers are overwhelming. Best estimates are 2,000 villages razed to the ground, over 300,000 killed, and millions living in camps with lack of water and threatened by the militia and the spread of disease.

Darfur has been referred to as "Rwanda in slow motion" and as "genocide by famine." Suddenly, the camps in Chad are no longer safe and there is concern that the government could collapse and a rumor that Sudan is angling to

take over. The African troops on the ground are small and poorly trained and resourced to cover an area the size of Texas. More serious is that they do not even have a mandate to protect the citizens in Darfur but are charged to preserve a cease fire which has never been truly honored.

There is now a small light at the end of this terrible tunnel. The Darfur genocide has become a focus for public scrutiny and political action. More and more advocacy groups are getting involved, pressuring Congress and the White House to action. The U.S. actually declared Darfur a genocide for the very first time that a genocide is ongoing. Now there is verbal acknowledgment from the administration and we are at the moment waiting for action to stop the violence, rape and murder which is flooding the media.

Pressure is being brought by the administration to find a way for NATO to bridge the transition to a UN force to move across the region and stop continued *janjaweed* attacks. There are also active discussions of the establishment of a no-fly zone to prevent Sudan from taking planes into the air over Darfur and to pressure European governments into doing more.

We have our Darfur heroes like Nicholas Kristof who was awarded the Pulitzer Prize for his unrelenting columns on this crisis and a growing and vocal group of Congress members from both sides of the aisle who have—finally—spent time on the ground in Darfur to learn directly the horrors that the people there face every day and night. It may well be Darfur where the world will determine whether we can give real meaning to the term, "Never Again."

DARFUR TIMELINE

"Show an administration a country with an oil well and they will show you a foreign policy"

—Senator Pat Harrison, Mississippi,
Chairman of the Finance Committee in 1945

Darfur was an independent state from the 16th century until 1917, when it was incorporated into modern day Sudan. As an independent state, Darfur enjoyed worldwide recognition, with embassies in the capitals of the major empires of that time. This peaceful co-existence between African and Arab tribes was the source of its stability, prosperity and strength.

However, successive regimes in Khartoum, both civilian and military, introduced policies of marginalization, racial discrimination, exclusion and divisiveness. Darfur has become a source of cheap labor. Exploitation is carried further by the fueling of ethnic and tribal wars by the government in Khartoum, which provides military aid to Sunni Arab militias called *janjaweed*.

1996

Before Osama bin Laden leaves the Sudan for Afghanistan, the Khartoum government offers to deport him. This gesture brings about a closer relationship between the Sudan and the United States that later allows the Bush administration to negotiate peace talks on the North-South civil war in 2003-2004. At the time there is a rumble about atrocities in the Darfur region.

2003

The rumble becomes an erupting volcano as Sudan boldly ramps up air strikes in fly-over attacks on Darfur. Atrocities on the ground eliminate Darfruians.

OIL IS THICKER THAN BLOOD

China buys about half of the oil extracted from the Sudan. While China enriches Africa, she also uses her veto on the United

Nations Security Council to protect Sudan for their miserable record on human rights.

The United Nations calls for roughly 23 million dollars to help the suffering in Darfur.

The government-allied *janjaweed* militias burn villages, murder and rape their Sunni African brethren causing more refugees to flee.

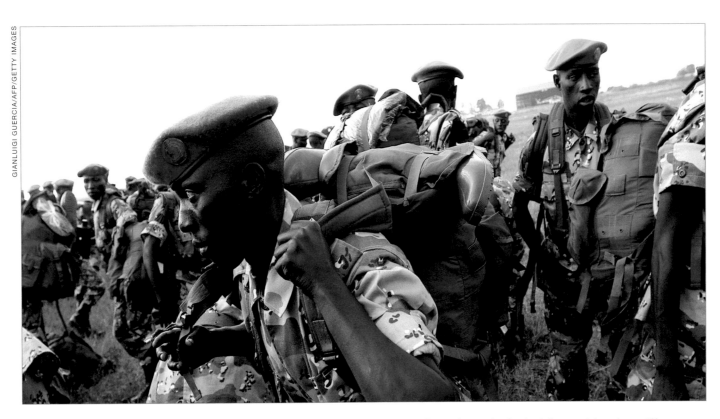

Of the African Union forces trying to prevent more killing in Darfur, 2,500 are Rwandans who look at the world and say, "If you don't save the Darfurians, don't say 'never again' to us. We won't believe you."

2004

Under-Secretary-General for Humanitarian Affairs Jan Egeland tells the Security Council of an ongoing "scorched-earth" campaign by *janjaweed* militias against Darfur's black African population.

Human Rights Watch obtains copies of Sudanese government documents that describe an official policy of support for the *janjaweed* militia. Aid agencies estimate the death toll at 50,000. More than a million Darfurians flee their homes.

Colin Powell, (then U.S. Secretary of State) declares Darfur a genocide followed by the same declaration from President George W. Bush.

2005

UN Security Council imposes sanctions and hands the matter over to the International Criminal Court (ICC)

The *janjaweed* drive an estimated 2 million from their homes with 200,000 fleeing into Chad. The civilian deaths from killing and starvation are 180,000 or more.

The African Union, with the support of the UN, has only about 6,000 AU soldiers to monitor a country the size of France. The security situation declines further, despite the African Union force as the attacks carried out by the *janjaweed* increase. Khartoum fails to disarm or control the *janjaweed*.

2006

The UN Security Council asks Kofi Annan to "initiate contingency planning" and to produce options in consultation with the AU and UN peacekeeping operations. Talk of NATO reinforcements is mentioned.

MAY

A peace agreement is struck in the Nigerian capital, Abjula. But two rebel groups refuse to sign. The agreement still affords a political breach making it possible for the UN to send armed peacekeepers into Darfur to support the AU forces.

JULY

Sudanese President Omar al-Bashir says UN troops will enter Sudan "over my dead body."

AUGUST

The Sudanese government rejects a UN resolution authorizing a peacekeeping force in Darfur on the grounds that it would be a violation of Sudanese sovereignty. The plan was to enlarge the current force of 7,000 to 20,000.

Darfur refugees cross the desert on foot to find safety in another village.

SEPTEMBER

The *janjaweed* change their target from the starving Darfurians to the aid workers from *Medecins Sans Frontieres* (Doctors Without Borders). Six are raped and sexually abused. This attack on human rights workers who are risking their lives by trying to keep the refugees of Darfur alive, establishes impunity of a darker nature.

NOVEMBER

As 200 people are killed by attacks on villages just inside the Chadian border, the government in Chad accuses Sudan of "exporting the genocide." Chad declares a state of emergency and is backed by a UN warning against the incursion. Sudan says it will welcome a hybrid UN-AU force as long as the UN force is not in command.

Hopes of a deal between the UN, AU and Darfur are put in jeopardy when the AU accuses Sudan of launching a new ground and air offensive in Darfur. AU claims there have been heavy casualties. Chad proposes an anti-Sudan alliance with the Central African Republic (CAR). Both nations accuse Sudan of backing rebels fighting against the CAR government.

DECEMBER

The United States proposes a no-fly zone over Darfur to prevent attacks against civilians. The State Department proposes other UN sanctioned options including a naval blockade or air strikes. Meanwhile, the UN Human Rights Council agrees to send a team of experts to Darfur to investigate allegations of abuse.

2007
JANUARY

Chinese President Hu Jintao announces that he is urging Omar al-Bashir to work with the UN to end the genocide. China's UN Ambassador also works to secure Sudanese participation in an international accord to replace the exhausted African Union peacekeeping force in Darfur with a larger UN force.

Chad's UN representative says his agency's resources are insufficient to meet what he calls "overwhelming" humanitarian needs.

President Omar al-Bashir agrees to a peace process that includes a 60-day cessation of hostilities. The officials in Sudan say they do not object if the UN sends peacekeepers to Chad provided none enter Sudan.

FEBRUARY

The U.S. wants China to use its leverage with Sudan to ensure that Khartoum fully accepts a hybrid African Union and UN peacekeeping force. However, China's Foreign Affairs Minister Zhai Jun says, "we should first respect Sudan's sovereignty and territorial integrity."

Two years after the UN Security Council refers the Darfur situation to the International Criminal Court (ICC), the ICC names those suspected of war crimes.

MARCH

The 35-page UN report charges the Khartoum government with direct involvement in planning and carrying out war crimes and crimes against humanity in Darfur. The team, led by Nobel Peace Prize Laureate Jody Williams, says "killing of civilians remains widespread…Rape and sexual violence are widespread and systematic. Torture continues."

In an interview with NBC, Sudan's President Omar al-Bashir denies that his government has any involvement in the violence in Darfur. He goes on to say while some villages have been burned and some women raped and some people have died, reports of violence from the region are either false or exaggerated.

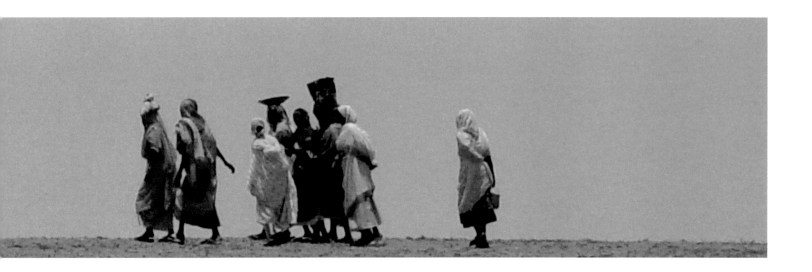

APRIL

Sudan is caught painting its planes white and stenciling "UN" on their wings. These planes are deliberately disguised to appear as saviors to the people of Darfur when they are actually only camouflaged weapons of mass destruction.

China's Foreign Minister urges Sudan to be more flexible on the deployment of UN troops but indicates China will not support tougher measures against Khartoum.

China's relationship with Sudan has prompted human rights activists to call for a boycott of the Summer Olympics scheduled to be held in Beijing in 2008.

Our relief plane landed in Nyala, Darfur in April, 2007, bringing in 12 tons of donated medical supplies for the refugees left behind in Darfur. As we were unloading, across the tarmac from us were Chinese Migs and Russian Hind assault helicopters, loading up arms to attack the women, children and elderly left behind in Darfur. It was clearly one of the most perverse ironies I have witnessed in more than 20 years of relief work around the world.
—Drew Hannah, Co–Founder, Bridge Foundation

MAY

From Khartoum, the response from the Sudanese Minister of Justice to the International Criminal Court is that his nation does not recognize the ICC's jurisdiction. Though the ICC represents 104 countries, it is independent from the United Nations. Whereas it has a mandate to investigate genocide, it has no police to arrest suspects. It is largely dependent on the country it is investigating. In this case, Sudan is both the perpetrator and the defender.

President George W. Bush calls for new sanctions:
"Far too long the people of Darfur have suffered at the hands of a government that is complicit in the bombing, murder and rape of innocent civilians. My administration has called these actions by their rightful name. Genocide."

SEPTEMBER

In the Nyala region of southern Darfur, the notorious *janjaweed* militia is now massacring its own people for the spoils of war in Darfur. This new Arab versus Arab looting and killing is scattering Arab tribes into the same displacement camps they just drove the African Darfurians out of. UN officials believe that various militias are struggling for power and

territory before the too long-awaited hybrid UN-AU force arrives in October. Some aid workers say that Darfur is beginning to resemble Somalia. Danger zones are now everywhere in Darfur. "There is absolutely no law and order in this place," says Annette Rehrl, a spokeswoman for the UNHCR. The main killings seem to be between the northern Mahria and Terjem tribes, once brothers, now attacking each other with the overflow of guns in Darfur. Humanitarian assistance to the region is more difficult and dangerous.

SEPTEMBER 30, 2007

A base camp for the African Union peacekeepers, 100 miles north of Nyala, is attacked by rebel forces. Ten are killed. The violence that surrounds this camp has turned away all humanitarian aid and forced the African Union soldiers to vacate the area. African Union soldiers have never been forced to forsake a camp before. The refugee camps of Darfur lay unprotected again; the rampage is in full force again; the people of Darfur remain waiting for help again…

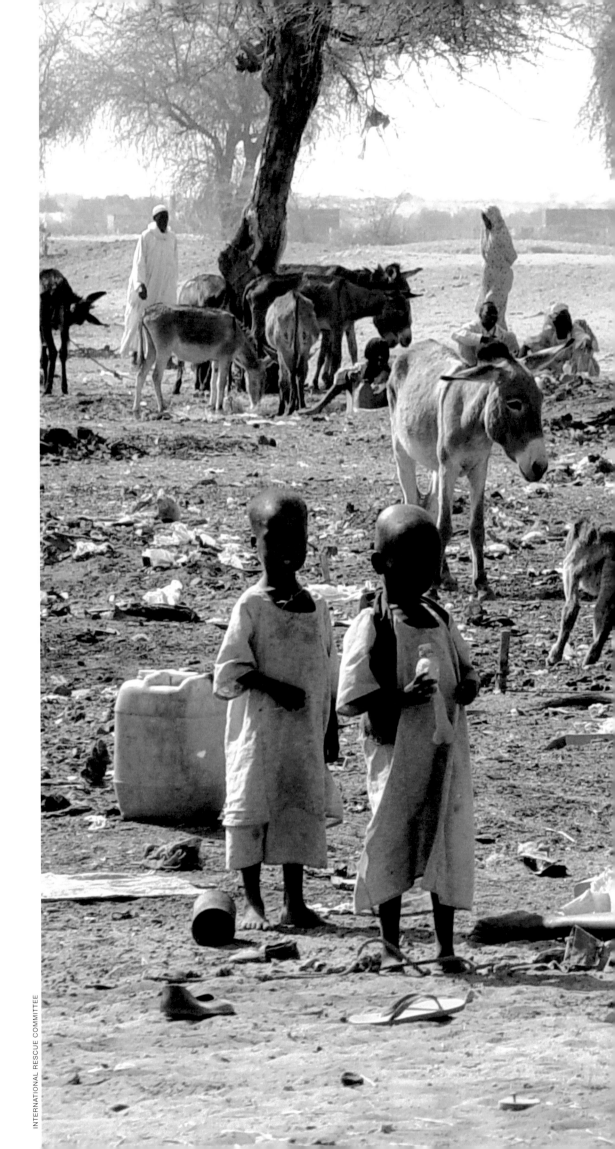

Refugees arriving in Al Mashtal camp,
north Darfur.

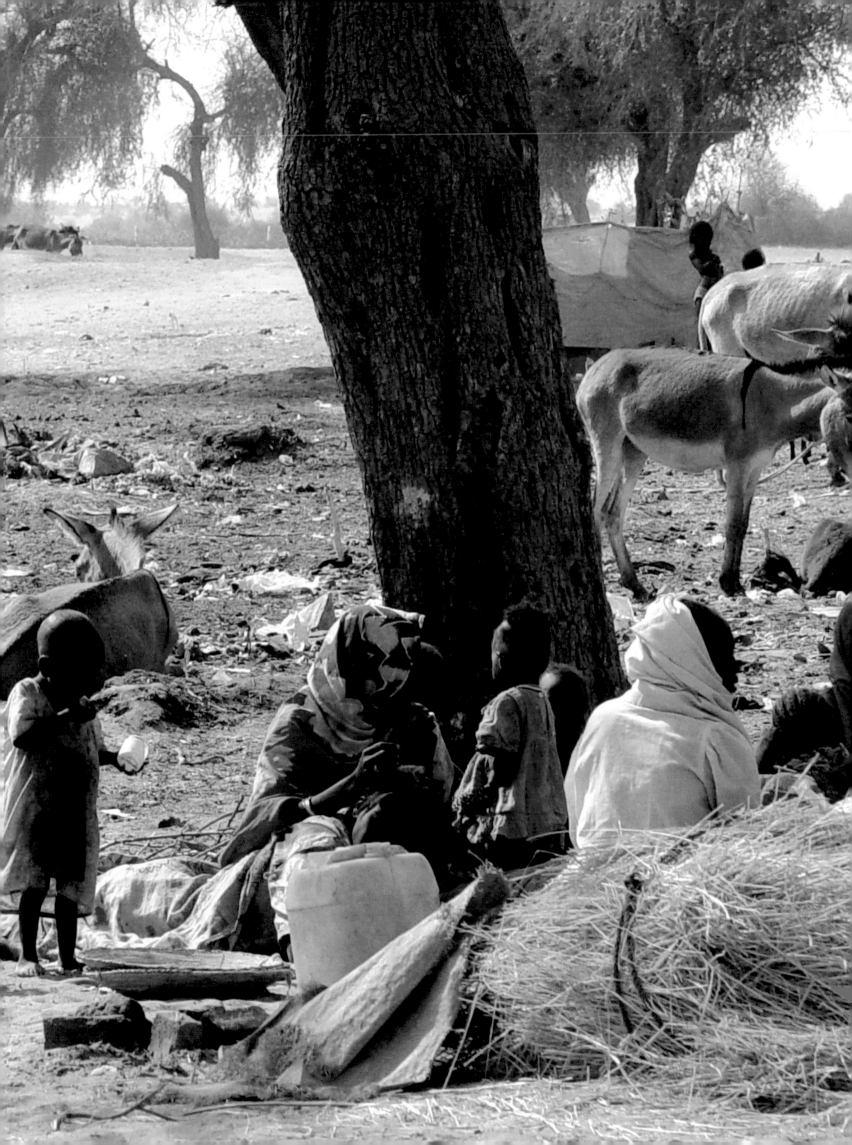

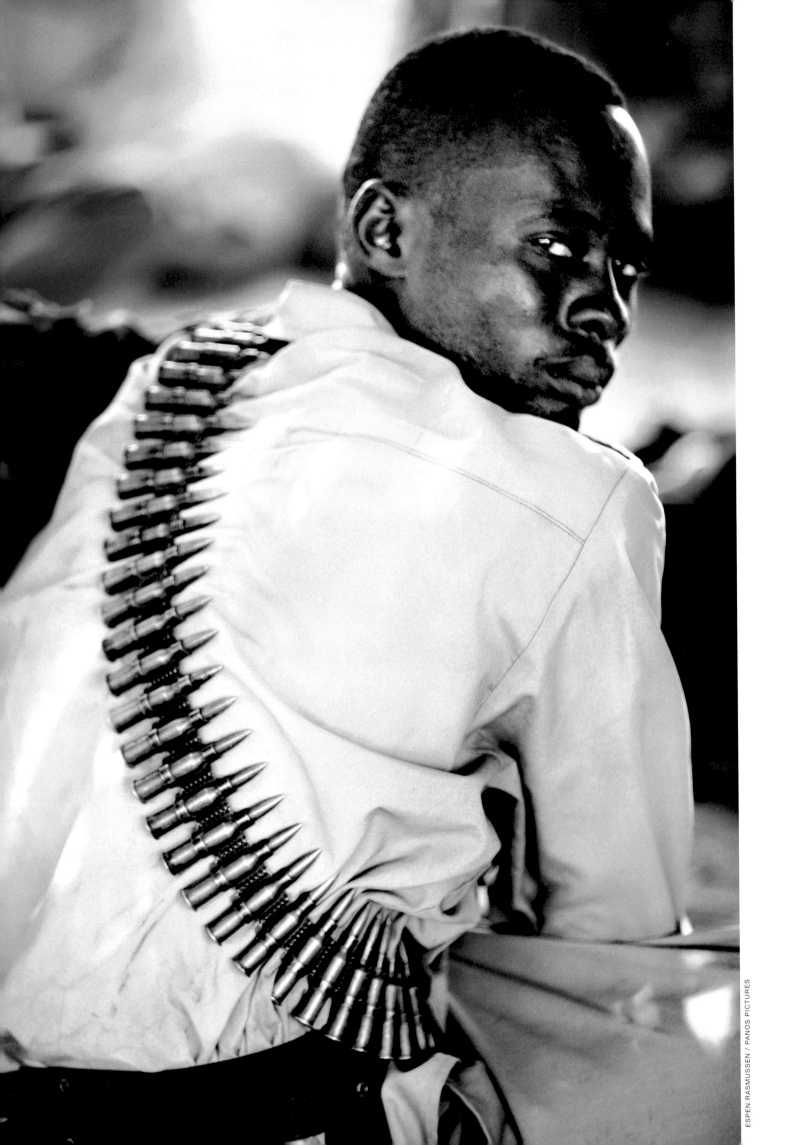

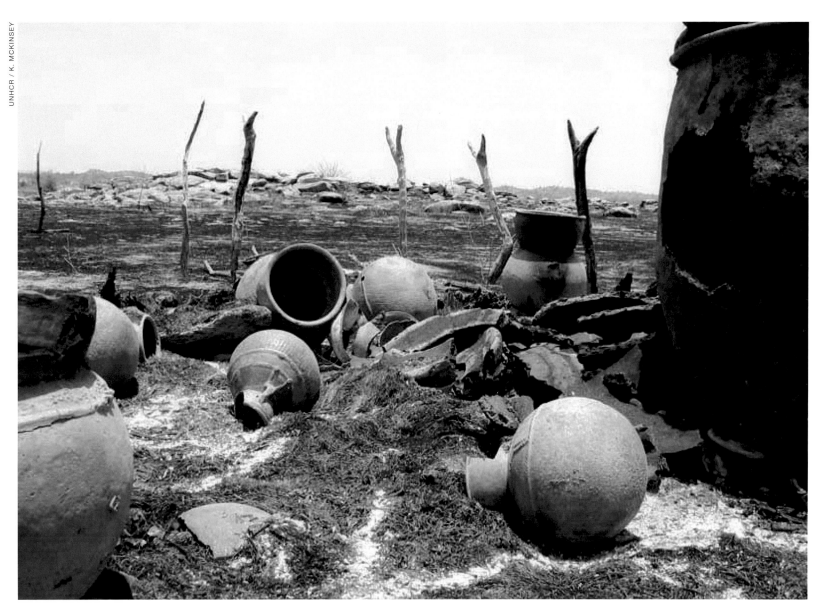

Above: Remains of the abandoned village of Seraf in west Darfur, which was looted and burned by the *janjaweed*.

Left: A *janjaweed* militiaman attending a meeting with border police and Chadian military close to the border with Sudan. The *janjaweed* have been terrorizing the native population of Darfur since 2003, and have also carried out raids across the border into Chad.

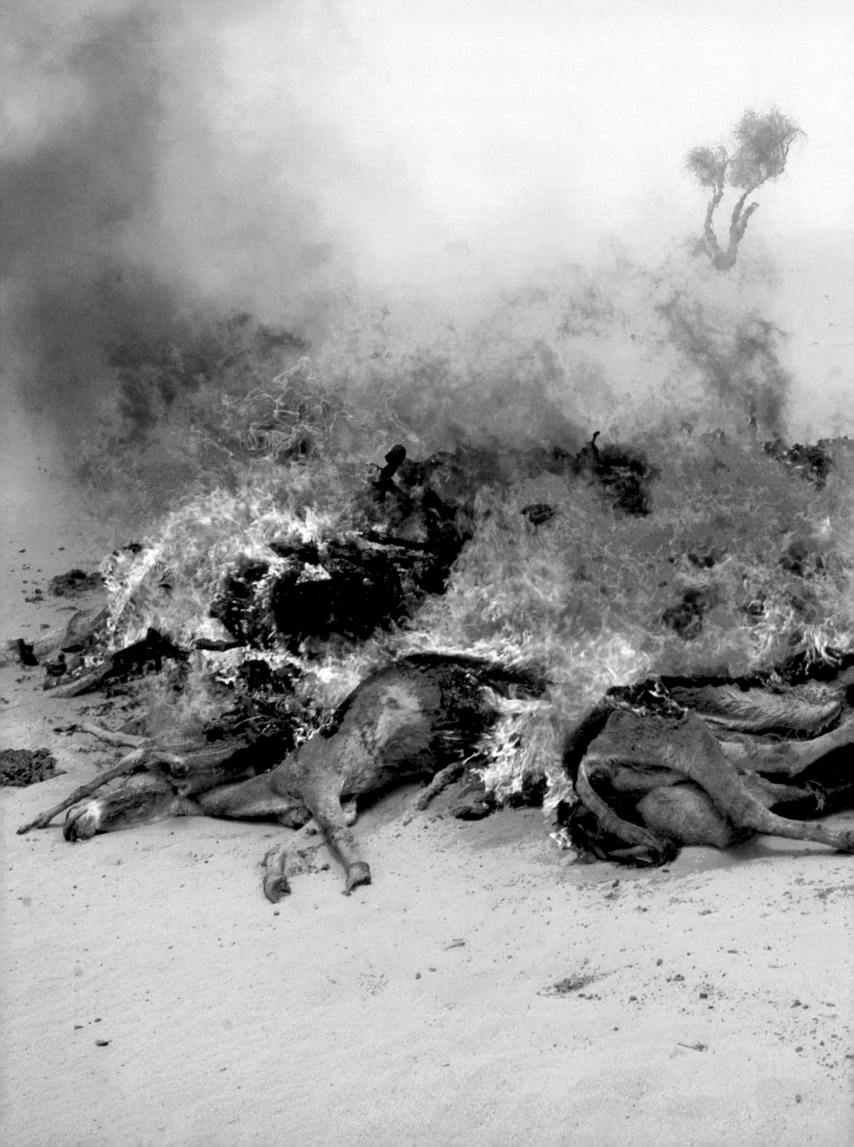

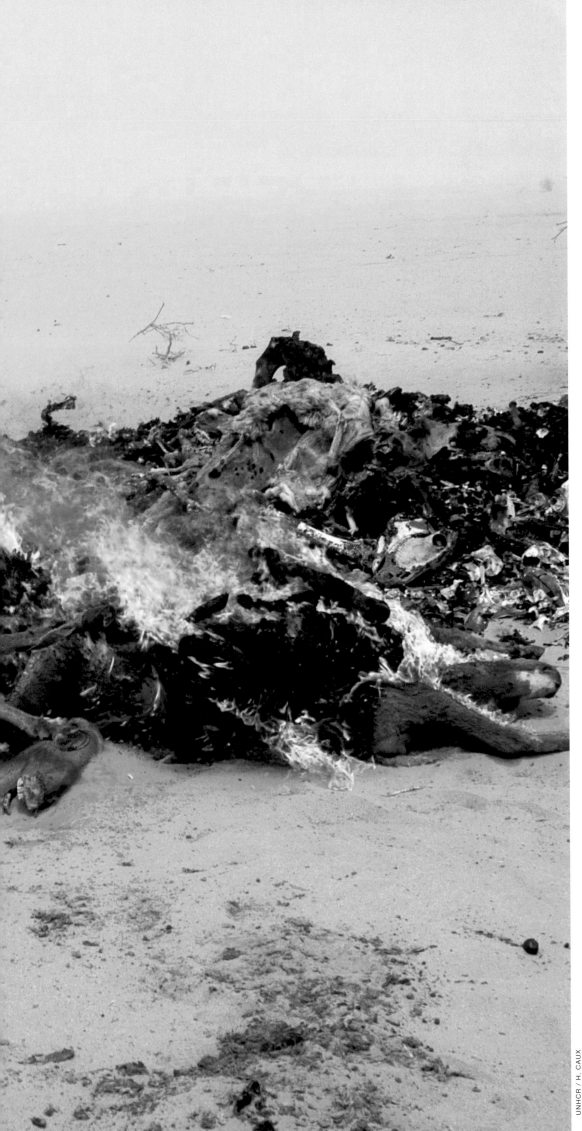

After a journey of several days from Darfur to Chad carrying heavy loads of belongings and refugees on their backs, these donkeys died from exhaustion and lack of food.

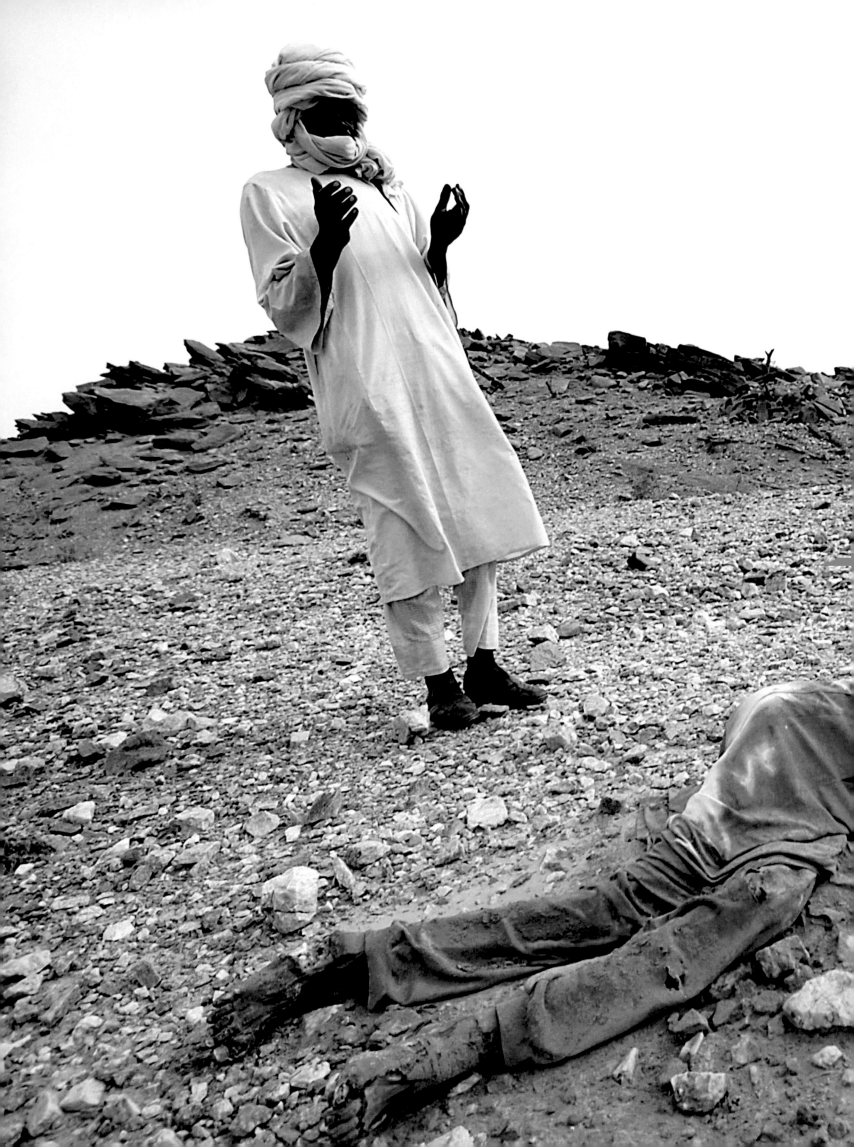

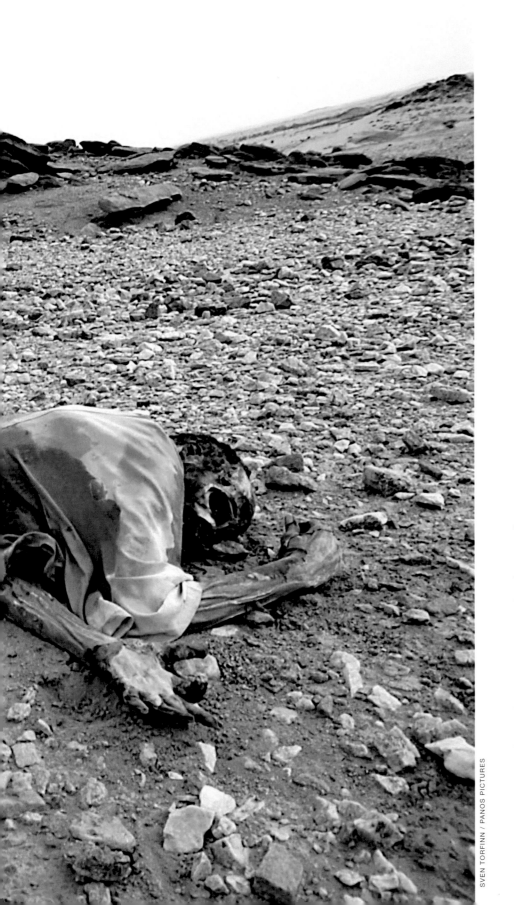

SVEN TORFINN / PANOS PICTURES

A rebel soldier of the Sudanese Liberation Army (SLA) prays next to one of twelve bodies found in a remote area of Darfur. According to local people, they were executed in April, 2004 after the *janjaweed* militias attacked a marketplace. The SLA did not bury the bodies because it is against Islamic tradition. They also intended to preserve evidence of the atrocities committed by the Sudanese government.

Overleaf: In July, 2006 the rainy season floods the temporary shelters of refugees from the Darfur region in Bahai along the Chad-Sudan border, forcing them to find new shelter.

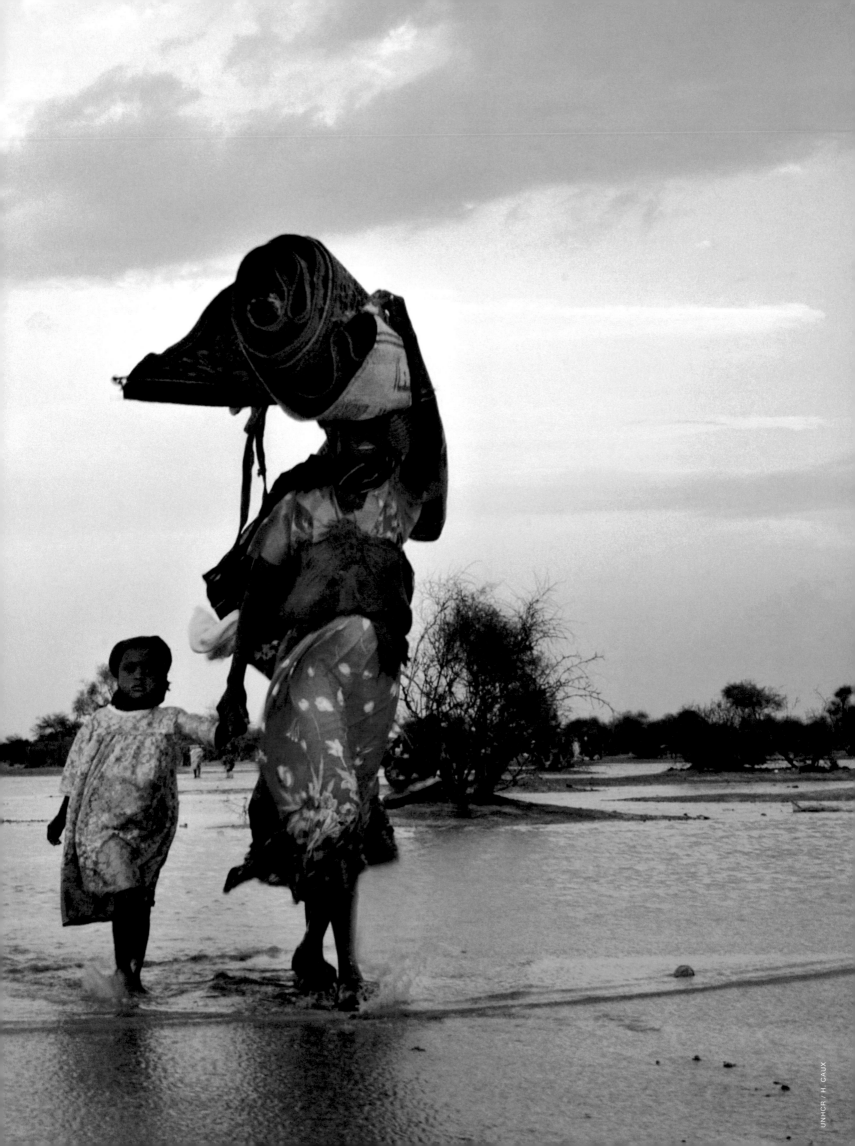

Sudanese Liberation Army soldiers walk past a dead
body left from an attack on civilians in the district of
Farawyaiah, Darfur. Sixteen bodies lay in the surrounding
ravines after men from five nearby villages were killed
by *janjaweed*.

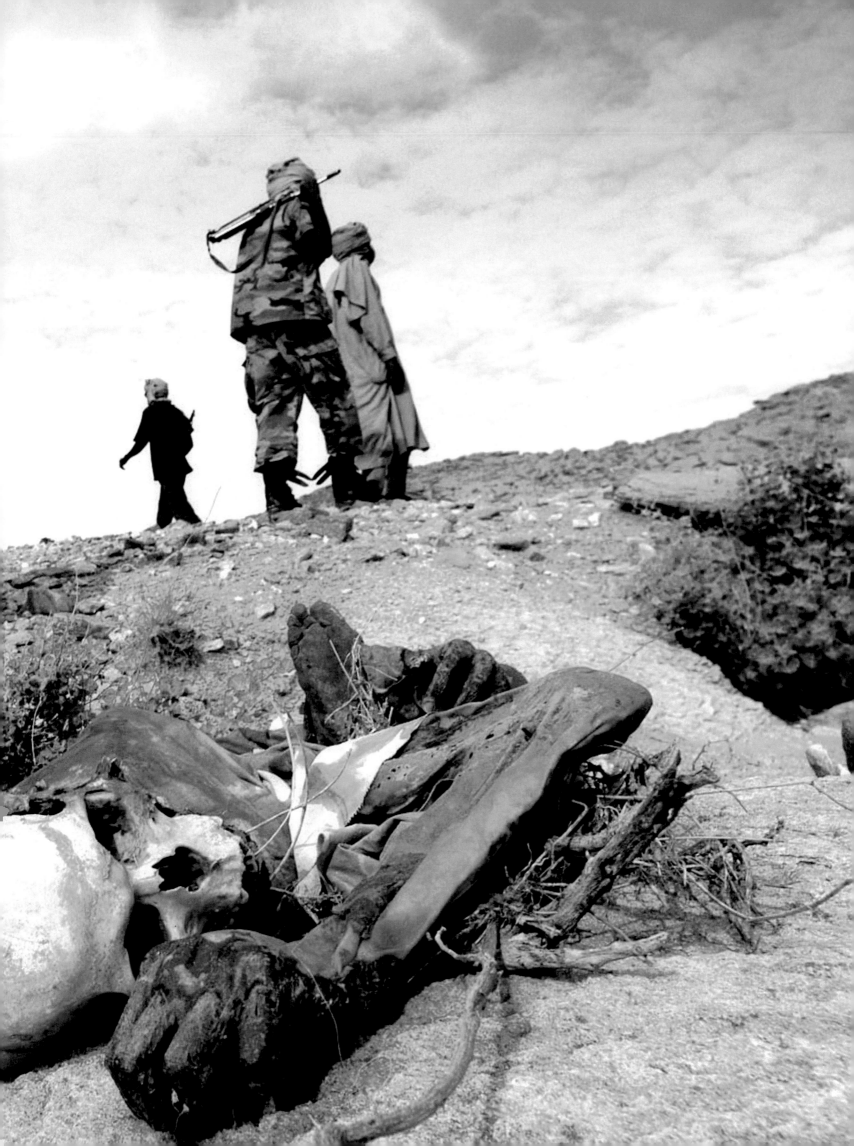

UNHCR

Under the auspices of the Cambridge-based organization Physicians for Human Rights (PHR), colleagues have traveled to Darfur and neighboring Chad to interview refugees. On a field investigation in May, 2004, they saw "mass rape and destruction of life and livelihood as evidence of genocidal intent. All of these tactics can effectively exterminate a people, in ways that leave few fingerprints."

Left: Women collect the firewood because when they stray from the village they are only raped, while the men are murdered.

Overleaf: Sudanese girls seen in Darfur, Sudan, June 25, 2005. The 12-year-old girl wearing the striped scarf, front, reported how she was separated from her two friends, and raped by soldiers from the Sudanese government.

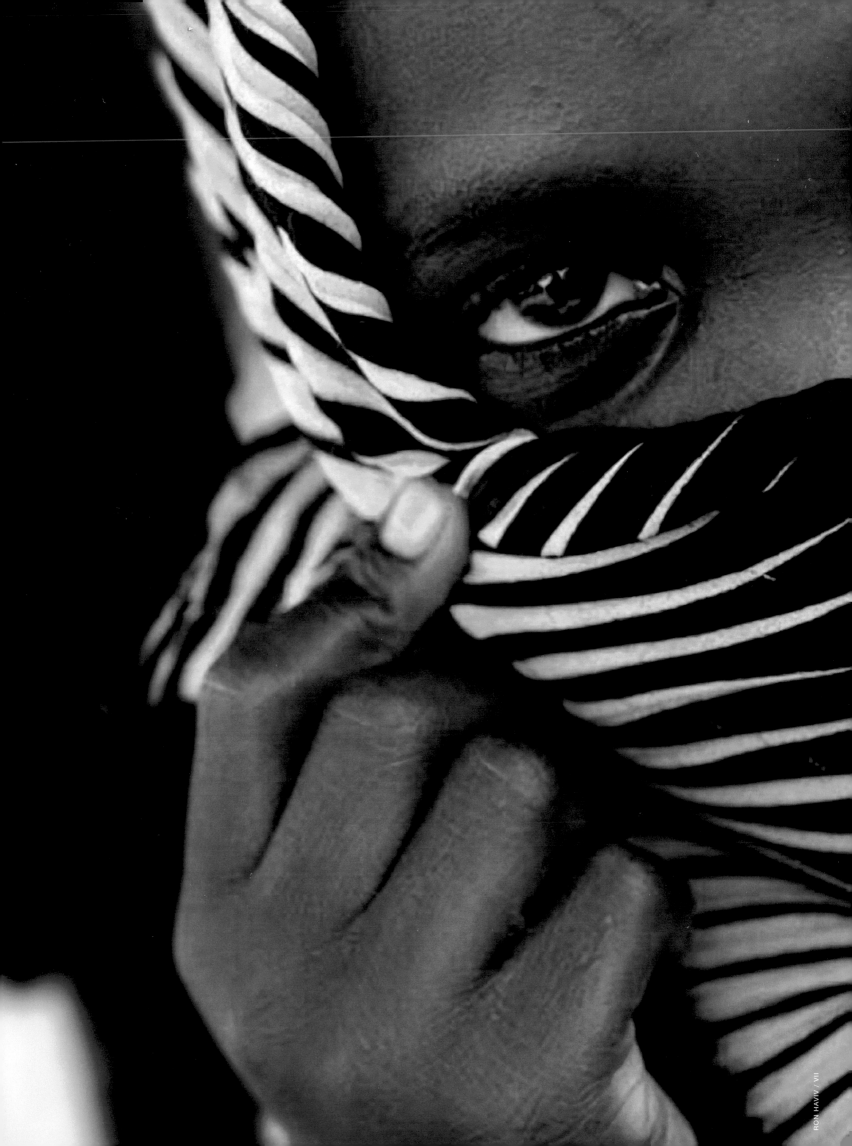

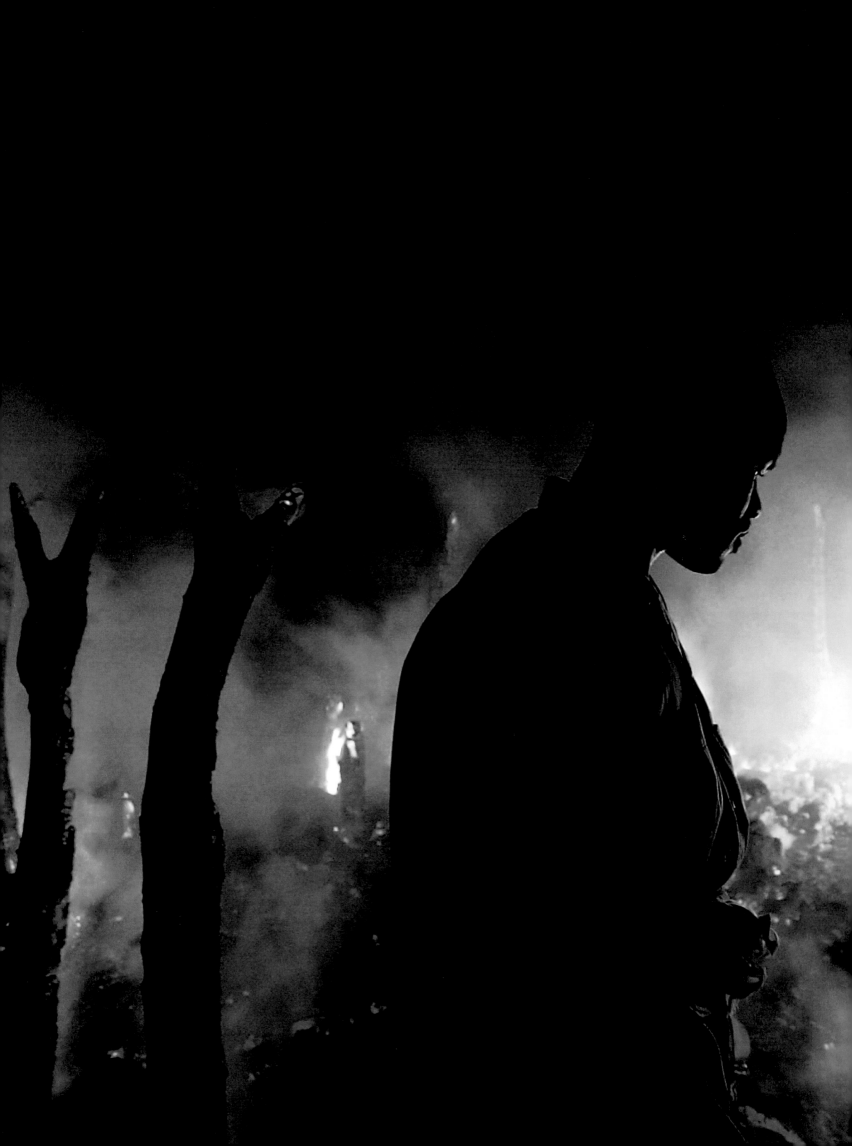

A Sudanese rebel fighter from the
Justice and Equality Movement (JEM)
somberly watches the abandoned village
of Chero Kasi burn less than an hour
after *janjaweed* militiamen set it ablaze
in the violence plagued Darfur region,
September 7, 2004.

The New York Times Magazine

APRIL 2, 2006 / SECTION 6

The U.N. is not going to
stop the genocide in Darfur.
The African Union is not going to
stop the genocide in Darfur.
The U.S. is not going to
stop the genocide in Darfur.
NATO is not going to
stop the genocide in Darfur.
The European Union is not going to
stop the genocide in Darfur.

But someday, Luis Moreno-Ocampo
is going to bring those who committed
the genocide to justice.

The Prosecutor of the World's Worst
By Elizabeth Rubin

OCTOBER 19, 2007

It is nighttime and in front of the New York Historical Society huge photographs are being projected onto the walls of the landmark building. Crowds gather on the sidewalk and spill over into Central Park to observe the images of Darfur that appear, fade and reappear. There is a cluster of teenagers with backpacks, heads tilted back, looking up.

By now the news from last weekend, reporting the rebel attack on the Darfurian village of Haskanita that killed 10 peacekeepers, has become full blown.

It is now known that the victims had their throats cut, their ammunition stolen and their base burned to the ground. It was a deliberate attempt to frighten the newly formed coalition of 26,000 peacekeepers—the largest peacekeeping group in Africa's history—before they enter Darfur. The genocide of four plus years has consumed Darfur to the point where it may be impossible to identify or reach a clearcut agreement.

Michael Clough, former director of the Africa program at the Council on Foreign Relations says, "Unfortunately, conflicts seldom end until one side loses—or realizes that it is likely to lose unless it agrees to a negotiated settlement."

In Darfur, it seems there will be no peace to keep until there is a signed agreement, and it seems unlikely that Sudanese president Omar al-Bashir will make peace until foreign interests force him to do so...

—L. H. Montgomery

Canadian General Roméo Dallaire who led the UN Mission in Rwanda during the 1994 genocide

EPILOGUE

Lieutenant-General Roméo Dallaire

Blessed are the peacemakers; for they shall be called the children of God...

—Matthew 5:9

...From the young boys I met in the demobilization camps in Sierra Leone to the suicide bombers of Palestine and Chechnya,—to the young terrorists who fly planes into the World Trade Center and the Pentagon, we can no longer afford to ignore them.

We have to take concrete steps to remove the causes of their rage, or we have to be prepared to suffer the consequences. The global village is deteriorating at a rapid pace, and in the children of the world, the result is rage. It is the rage I saw in the eyes of the teenage Interhamwe militiamen in Rwanda; it is the rage I felt in the crowds of ordinary citizens in Rwanda and it is the rage that resulted in September 11. Human beings who have no rights, no security, no future, no hope and no means to survive are a desperate group who will do desperate things to take what they believe they need and deserve.

If September 11 taught us that we have to fight and "win the war on terrorism" it should have taught us that if we do not address the underlying (even if misguided) causes of those young terrorists' rage, we will not win the war. For every Al-Qaeda bomber that we kill there will be a thousand more volunteers from all over the earth to take his place. In the next decade, terrorists will acquire weapons of mass destruction.

...Where does this rage come from?...a heightened tribalism, the absence of human rights, economic collapses, the AIDS pandemic, the effect of debt on nations, environmental degradation, overpopulation, poverty, hunger... the list goes on and on...If we can not provide hope for the untold masses of our world, then the future will be a repeat of Rwanda, Bosnia, Sierra Leone, the Congo and September 11.

No matter how idealistic this aim sounds, this new century must become the Century of Humanity, when we as human beings rise above race, creed, color, religion and national self-interest and put the good of humanity above the good of our own tribe.

After one of many presentations following my return from Rwanda, a Canadian Forces padre asked me how, after all I had seen and experienced, I could still believe in God. I answered that I know there is a God because in Rwanda I shook hands with the devil, I have seen him. I have smelled him and I have touched him. I know the devil exists, and therefore I know there is a God...For the sake of the children and of our future.

Peux ce que veux. Allons-y
(Where there's a will, there's a way.)

APPENDIX

PROFILE OF A FIGHTER:
RAPHAEL LEMKIN

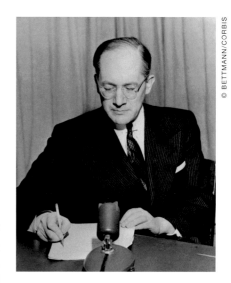

International lawyer Raphael Lemkin helped draft the Genocide Convention, which maps out prevention and punishment for the crime of genocide.

Gen.o.cide (jen'a.sid) n. {<gk.genos race.tribe + -cide: coined by Raphael Lemkin. 1944} The systematic extermination of racial and national groups. The term was first used in the indictment of German war criminals after the second World War.

Raphael Lemkin was born to Jewish parents on June 24, 1900 in Imperial Russia, an area that later became the town of Wylkowyszki, Poland (now Volkovysk in Belarus). He was home schooled before studying philosophy at the University of Lvov and earned his doctorate from the University of Heidelberg. By then he spoke nine languages and read fourteen. He was appointed a public prosecutor and for five years helped draft the criminal code of the newly independent Poland. In 1933, as Nazi Germany was evolving, Lemkin became deeply disturbed by his earlier memories of the slaughter of Armenians by Turks during the Great War. He presented his first proposal to outlaw such 'acts of barbarism' to the legal council of the League of Nations in Madrid. The proposal failed and incurred the disapproval of the Polish government, which was pursuing a policy of conciliation with Nazi Germany. Dr. Lemkin was forced to retire from his public position in 1934. He continued his private law practice until the Germans invaded Poland in 1939. He was able to witness the very acts of horror that he was working to prevent.

Lemkin was wounded while fighting the Nazis outside Warsaw. He hid in the Polish forests for six months before escaping to Sweden via Lithuania and the Baltic Sea. As a refugee in Sweden, Lemkin became a lecturer at the University of Stockholm where he studied Nazism and analyzed the legal decrees that had allowed the Nazi occupation and the systematic elimination of a people.

Lemkin's landmark 1944 book, *Axis Rule in Occupied Europe*, was used as a basis for determining the Nuremberg war trials program the following year. Lemkin served as legal adviser to the United States' Chief Prosecutor at the trials, where his definition of "genocide" was adopted.

On December 11, 1946, a year after the Armistice, the UN General Assembly unanimously passed a resolution condemning genocide and drafted a UN treaty banning the crime. According to *New York Times* writer Abe Rosenthal, "Lemkin was not naive. He did not expect criminals to lay down and stop committing crimes. He simply believed that if the law was in place it would have an effect—sooner or later."[1]

Lemkin's persistent lobbying paid off. On December 9, 1948 the General Assembly, in the Palais de Chaillot in Paris, passed the Genocide convention by a vote of 55-0.

It was the first human rights treaty ever passed by the United Nations. After the vote, Abe Rosenthal found Lemkin sitting alone in the darkened assembly hall. According to Rosenthal, "he was weeping as though his heart would break." He told Rosenthal that he grieved alone, and that the treaty was an "epitaph for his mother's grave and a recognition that the many millions did not die in vain."[2]

The effort to ratify the Genocide Convention in the U.S. Senate was more torturous, however. President Harry Truman submitted it for ratification in June, 1949, but immediately it

1 A.M. Rosenthal, *A Man Called Lemkin*, p.535 index
2 *The Importance of The Convention*, Lemkin papers, New York Public Library

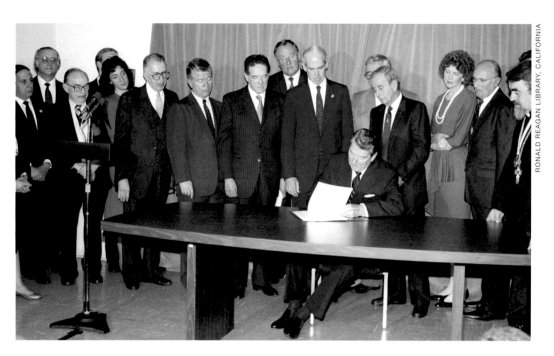

Ronald Reagan signing the Genocide Convention, 1988.

"We finally close the circle today. I am delighted to fulfill the promise made by Harry Truman to all the people of the world-especially the Jewish people."

—Ronald Reagan

became bogged down in politics. It did not help that the American Bar Association rejected the treaty because they could not agree on its wording, although they did "condemn the mass killing of innocent people." The environment became more difficult for passage when, during the McCarthy era, the Senate moved to a xenophobic posture in international relations. Key members of the Senate Foreign Relations Committee even voiced anti-Semitic and anti-foreign views about Lemkin himself.

Raphael Lemkin died penniless on August 28, 1959. The American Jewish Committee paid for his burial. An obscure gravestone in the Mount Hebron Cemetery in Queens, New York calls him the "Father of the Genocide Convention." According to those close to him, his greatest disappointment was his inability to win ratification of the Genocide Convention by the United States and Great Britain.

On January 30, 1970 Britain ratified the Genocide Convention, giving a name to the crime that Winston Churchill had called "a crime without a name." In the United States President Richard Nixon tried again, but the country was embroiled in the war in Vietnam, which eventually fanned the flames of the Cambodian genocide by the Pol Pot regime. Finally, President Ronald Reagan's sincerity on the issue neutralized right-wing opposition and on November 4,1988 the treaty was ratified by the United States.

On the centenary of his birth in June, 2001, the United Nations paid homage to Lemkin as "the man who was both father and midwife to the word 'genocide' and brought into being the Geneva Convention."[3] Yale University now awards a Raphael Lemkin Prize for International Human Rights.

3 William Korey, *An Epitaph for Raphael Lemkin*, 2001

ENSURING JUSTICE FOR ATROCITIES

Elise Keppler

Counsel with the International Justice Program at Human Rights Watch

The 1990s was a decade marked by two genocides, and also by unprecedented steps to limit the impunity associated with genocide, crimes against humanity, and war crimes.

International courts were created to hold perpetrators of these horrific abuses to account.

An Emerging System of International Justice

As the horrors in the former Yugoslavia and Rwanda unfolded, the United Nations, governments, and nongovernmental organizations worked to ensure justice for the atrocities committed. Affirming the viability of international criminal justice after an almost 50-year hiatus, the UN Security Council created two ad hoc tribunals—the International Criminal Tribunal for the former Yugoslavia (ICTY) in 1993 and the International Criminal Tribunal for Rwanda (ICTR) in 1994—to prosecute the crimes.

Suspects were arrested and tried before these new tribunals regardless of their official status, which led to the first indictment of a sitting head of state, Slobodan Milosevic, by the ICTY, as well as the indictment of the former prime minister of Rwanda, Jean Kambanda, by the ICTR.

The ad hoc tribunals revived an idea that initially gained currency after World War II: the creation of a standing forum where justice can be rendered for the most serious crimes under international law. In 1998 more than 150 countries came together and completed negotiations to establish the International Criminal Court (ICC).

The ICC is the first permanent international court with the authority to try crimes against humanity, war crimes and genocide when national courts are unable or unwilling to investigate and prosecute. One of the ICC's unique features is the role it allows victims, who can express their views and concerns distinct from serving as witnesses, and have the possibility to receive reparations.

Although it remains a relatively new institution and will likely only conduct a limited number of trials in each situation it investigates, the ICC represents a watershed development in ensuring justice for genocide and other serious crimes under international law. The court is currently conducting investigations into atrocities committed in the Democratic Republic of Congo, the Central African Republic, the Darfur region of Sudan, and northern Uganda.

Over the past decade, several European states also began to meet their obligations to prosecute those found on their territory accused of atrocities on the basis of universal jurisdiction. Cases have been initiated and have succeeded against perpetrators involved in the Rwandan genocide. In two separate cases in 2001 and 2005, six Rwandans were convicted in Belgium. Other universal jurisdiction cases relating to the genocide are ongoing in France and Spain.

At the same time, the momentum in international justice has suffered setbacks. Prompted by concerns over possible prosecutions of Americans, the United States embarked in 2002 on a worldwide campaign to marginalize the ICC. Disenchantment among

powerful UN Security Council members towards the ICTY and ICTR rose due to their costs and slow progress, sparking less costly efforts and the emergence of "hybrid" national-international courts.

Hybrid courts have been created to prosecute serious crimes committed in Sierra Leone, East Timor and Cambodia, and in Bosnia-Herzegovina and Kosovo. These courts have had mixed success, but have the advantages of being located in the countries where the crimes occurred and substantial participation by nationals of these countries. This has enhanced their potential to reach the communities most affected by the atrocities.

One major recent development is the ICC's investigation into crimes committed in Darfur, which the U.S. government has called genocide and which was brought under the jurisdiction of the ICC through a first-ever referral by the UN Security Council in 2005. The ICC has to date issued warrants against two individuals for crimes committed in Darfur. The referral has also been significant for the relationship between the United States and the ICC. The United States, as a permanent Security Council member, did not veto the referral, thereby acknowledging the practical functioning of the court. Nevertheless, the Sudanese government opposes ICC involvement and is not cooperating with the ICC. This poses enormous obstacles given that the court has no police force.

Challenges of International Justice

Despite singular advances, the emerging system of international justice has been far from a panacea. Prosecuting serious human rights crimes where there are a large number of victims is a complex and expensive process— no matter where the prosecution is conducted. Trials must comply with international human rights standards, and ensuring the fairness of these trials often results in a slow process.

National courts are the preferred venue to hold perpetrators to account and strengthening national courts to prosecute genocide, war crimes, and crimes against humanity is essential in the long term. However, all too often domestic courts are neither willing nor able to prosecute these crimes. In the meantime, the ICC, along with other international and hybrid criminal tribunals, will remain a crucial last resort. Prosecutions are essential to provide redress to victims, to contribute to deterring future crimes, and to building respect for the rule of law, especially in countries undergoing or emerging from conflict.

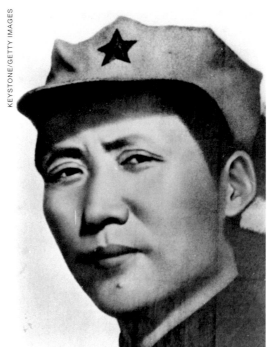

TWO OTHER TYRANTS OF GENOCIDE – JOSEF STALIN AND MAO ZEDONG

The most typical template for genocide is when a minority is massacred by a majority under the cover of war. The Armenian genocide, the Jewish Holocaust, and the Cambodian genocide all fall under this category, as do the atrocious crimes committed by Saddam Hussein against the Kurds during the end of the Iran-Iraq war.

Yet, the two worst genocides of the last century occurred during peacetime and targeted helpless people who carried no threat. These genocides took the form of forced famines under two monsters that starved to death the peasantry in Russia in the 1930s and in China in the late 1950s and early '60s.

Ukrainian independence predated Josef Stalin's rise to power. In 1931, Stalin began an aggressive program of farm collectivization in the Ukraine to increase productivity and erase the bourgeois idea of private ownership. An estimated seven million people starved to death in an area that was known as the bread-basket of Europe.

To Stalin, the loss of Soviet influence in the Ukraine was unacceptable. Ukrainian scholars, scientists, and cultural and religious leaders were arrested and shot or removed to gulags in remote areas of Russia. Stalin seized all privately-owned farms in a country where 80% of the population were wealthy farmers, known as Kulaks by the Communist regime. Fearing an insurrection led by the Kulaks, Stalin proclaimed a policy aimed at "liquidating the Kulaks as a class." Declared "enemies of the people," 10 million Kulaks were put in railroad boxcars and shipped to the wilderness of Siberia where, if they survived, they became slave laborers.

By 1932, nearly 75% of the farms in the Ukraine had been collectivized by force. Large quantities of grain were shipped to the Soviet Union until there was no food remaining to feed the Ukrainian people. The Ukrainian Communists appealed to Moscow to send an emergency food supply. Stalin replied by sending 100,000 Russian soldiers to purge the Ukrainian Communists. He then sealed off the borders, turning the Ukraine into a giant concentration camp without a food supply. Eighty percent of the Ukrainian intellectuals were shot. KGB members and Soviet troops seized food they found in individual households. As a preview of what was to come in the 1941 siege of Leningrad by the Nazis, starvation became another type of genocide. Mothers in the countryside resorted to tossing their emaciated children onto slowly-passing railroad cars traveling toward cities like Kiev in the hope that someone would take pity on them before they starved to death. But in the cities, people were already dropping dead in the streets, while nearby the Soviet-controlled granaries were bursting with "reserve grain" to be shipped out of the Ukraine. By the spring of 1933, twenty-five thousand people were dying of starvation every day. Villages disappeared. The Kulaks, as a class, were extinguished.

Unlike the Jews of the Holocaust, the victims of the vast Russian and Chinese genocides never had the satisfaction of judgment against their perpetrators.

The police and Communist party officials grew round bellies while the desperate Ukrainians ate leaves off bushes and resorted to killing their dogs and cats. To the Stalinists, this was considered a cost effective way to kill off a country. At the same time, they denied the famine. Anyone who claimed there was a famine was accused of anti-Soviet propaganda, bringing to mind the denial of the Turks during the genocide of the Armenians. When Nazi troops stormed the Ukraine in 1941, they only replaced one reign of terror with another.

Mao Zedong began his life as a student. By the time he was becoming a leader inside his group of communist peers, he presented himself as ruthless, calculating, and extremely egotistical. He would lose battles, force retreats, and defeat stated goals, just to prevent his comrades a victory. His six thousand mile "Long March" was planned to escape control by the Nationalist troops under Chiang Kai-shek. It took untold human lives, including the lives of his doubting comrades. However, this was only a prelude to Mao's "Great Leap Forward," an economic and social plan aimed at transforming China's vast population from a primarily agrarian economy of peasant farmers into a modern, industrialized communist society. The resulting famine took the lives of more than 30 million peasants between 1958 and 1961. Mao was so proud of marginalizing the population of China that he advised Iron Curtain leaders to follow suit. But with the exception of Albania, even the communist leaders of eastern Europe held Mao's method of starving the peasants in contempt. Mao Zedong's "Great Leap Forward" became his "Great Leap Backwards," as it killed off the cream of China's youth and imprisoned the country in total poverty.

Unlike the Jews of the Holocaust, the victims of the vast Russian and Chinese genocides never had the satisfaction of judgment against their perpetrators. Josef Stalin decimated Russia's population and continued to rule as the benevolent Uncle Joe until his death in 1953. Chairman Mao decimated China's population and went on to rule as the mystical man with his little red book of laws and wisdom until his death in 1976. Genocides always serve a functional purpose. They are not spontaneous. They occur because governments or tyrants perpetrate them for their own purposes.

ACKNOWLEDGEMENTS

I am grateful to the following for their sponsorship of "Never Again, Again. Again..."
Miles Morland, John Whitehead, Janet and Arthur Ross, Richard Jenrette, Jack and Peggy Crowe, Felix Harvey, Stephen DuBrul, William Zabel, Alban Barrus, Andrew Thomson, Bill and Jayne Gilligan, Jane Gould, Antoinette Guerrini- Maraldi, Robin Duke, Shirley Lord Rosenthal, and Patricia Robert.

I am fortunate to have had generous participation from such knowledgeable and invested people as Dr. Richard Hovannisian, Rabbi Arthur Schneier, Ambassador James Rosenthal, Terry George, Chuck Sudetic and Ruth Messinger.

I wish to thank the United Nations High Commission for Refugees in Geneva (UNHCR), The International Rescue Committee (IRC), and Medecins Sans Frontieres for their contribution of photography and for the good and brave work they do all over our world.

I appreciate the interest and research compiled by Dr. Rouben Adalian of the Armenian National Institute in Washington, DC., Dr. Tessa Hoffman of the Armin T. Wegner Collection and Documentation Center in Berlin, and the United States Holocaust Memorial Museum (USHMM), Washington, DC.

I am also grateful for the photographic eyes of Michael Connors and Fred Eberstadt.

Finally, I wish to acknowledge the dedication and effort contributed by the entire team at Ruder Finn Press and especially their talented, unflappable art director, Emily Korsmo.

My heartfelt appreciation goes to Deborah McQuiston of McQuiston Books in San Diego; Laurie Dolphin of D and J Books in Los Angeles and New York; the special brother and sister editing team of Jessica Jones and John Dorfman (who edited 400 pages of text in large caps); Joanna Barnes and her tactfulness with permissions agents everywhere; and to my daughters, Laura and Bryan, for insisting that I replace the book jacket with my own photograph. In the end, they were right.

BIBLIOGRAPHY

Balakian, Peter, *The Burning Tigris*, Harper-Collins Publishers, New York, NY, 2003

Bauer, Yahuda, *A History of the Holocaust*, Franklin Watts, New York, NY, 1982

Berthon, Simon and Joanna Potts, *Warlords*, Da Capo Press, Cambridge, MA, 2007

Bizot, Francois, *The Gate*, The Harvill Press, London, England, 2003

Burke, Carolyn, *Lee Miller*, Alfred A. Knopf, New York, NY, 2005

Courtemanche, Gil, *A Sunday at the Pool in Kigali*, Alfred A. Knopf, New York, NY, 2003

Dadrian, Vikhan N., *Armenian Relationiship with Hitler*, Yerevan Museum, Yerevan, Armenia, 2004

Dallaire, Roméo, *Shake Hands with the Devil*, Carroll & Graf Publishers, New York, NY, 2003

Davies, Norman, *Rising '44*, Viking Penguin, New York, NY, 2005

Davies, Norman, *No Simple Victory*, Viking Penguin, New York, NY, 2007

Dawidowicz, Lucy S., *The War Against the Jews*, Holt, Rinehart and Winston, New York, NY, 1975

Falk, John, *Hello to All That*, Henry Holt and Company, New York, NY, 2005

Farley, Peter, *A Subtler Kind of Genocide*, Harvard School of Public Health, Cambridge, MA, Sep-06

Friedlander, Saul, *The Years of Extermination*, HarperCollins Publishers, New York, NY, 2007

Gaddis, John Lewis. *The Cold War*, The Penguin Press, New York, NY, 2005

Gilbert, Martin, *Churchill and the Jews*, Henry Holt and Company, New York, NY, 2007

Goldberg, Andrew, *The Armenian Genocide* (television documentary), Two Cats Productions in association with Oregon Public Broadcasting, New York, NY, 2006,

Gourevitch, Philip, *We Wish to Inform You That Tomorrow We Will Be Killed with our Families: Stories of Rwanda*, St. Martin's Press, New York, NY, 1998

Grzesiuk-Olszewska, Irena, Translation by Anna Gorelova, *Warszawska Rzezba Pomnikowa*, Wydawnictwo Neriton, Warsaw, Poland, 2003,

Grossman, Vasily, *A Writer at War*, Pantheon Books, New York, NY, 2005

Gruber, Ruth, *Witness*, Schocken Books, New York, NY, 2007

Gunman, Israel and Schumer Krakowski, *Unequal Victims: Poles and Jews during World War II*, Holocaust Library, New York, NY, 1986

Hilberg, Raul, *The Destruction of the European Jews*, Holmes and Meier, New York, NY, 1985

Honig, Jan Willem and Norbert Both, *Srebrenica*, Penguin Books, New York, NY, 1997

Kiernan, Ben, *Blood and Soil*, Yale University Press, New Haven, CT, 2007

Korey, William, *An Epitaph for Raphael Lemkin* (monograph), Jacob Blaustein Institute, New York, NY, 1971

Kristof, Nicholas, "A Tolerable Genocide," *The New York Times*, New York, NY, 11/27/05

Kristof, Nicholas, "Uncover Your Eyes," *The New York Times*, New York, NY, 6/5/05

Lanzmann, Claude, *Shoah*, Da Capo Press, Cambridge, MA, 1995

Laqueur, Walter, *Russia & Germany*, Transaction Publishers, New Brunswick, NJ, 1990

Lemkin, Raphael, *Axis Rule in Occupied Europe*, Carnegie Endowment for International Peace, New York, NY, 1944

Malcolm, Noel, *Bosnia: A Short History*, New York University Press, New York, NY, 1994

MacMillan, Margaret, *Paris 1919*, Random House, Inc., New York, NY, 2001

Martin, James J., *The Man Who Invented 'Genocide'*, Institute for Historical Review, Torrance, CA, 1984

Mendelsohn, Daniel, *The Lost*, HarperCollins Publishers, New York, NY, 2006

Mikolajczyk, Stanislaw, *Letter to Clement Attlee*, The Hoover Institution, Stanford, CA, 1/10/44

Metzger, Rainer, *Berlin in the Twenties*, Harry N. Abrams, Inc., New York, NY, 2007

Moran, Lord, *Churchill at War 1940-45*, Constable & Robinson Ltd., London, England, 2002

Morgenthau, Henry, *Ambassador Morgenthau's Story*, Wayne State University Press, Detroit, MI, 2003

Overy, Richard, *The Dictators: Hitler's Germany, Stalin's Russia*, W.W. Norton and Company, New York, NY, 2006

Paldiel, Mordecai, *Diplomat Heroes of the Holocaust*, Yeshiva University/KTAV Publishing House, Jersey City, NJ, 2007

Radzilowski, John, *A Traveller's History of Poland*, Interlink Books, Northampton, MA, 2007

Rhodes, Richard, *Masters of Death*, Vintage Books, New York, NY, 2002

Rosenthal, A. M., *A Man Called Lemkin*, New York, NY

Saint-Exupery, Antoine de, *Wartime Writings 1939-1944*, Harcourt, Inc., New York, NY, 1986

Salisbury, Harrison E., *The 900 Days*, Da Capo Press, New York, NY, 2003

Schoenberner, Berhard, *The Yellow Star*, Fordham University Press, New York, NY, 2004

Sereny, Gitta, *Into That Darkness*, Vintage Books, New York, NY, 1983

Simons, Lewis M., *Genocide and the Science of Proof*, National Geographic Society, Washington, DC, January 2006

Staub, Ervin, *The Roots of Evil*, Cambridge University Press, New York, NY, 2006

Steidel, Brian, *The Devil Came on Horseback*, Perseus Books Group, Cambridge, MA, 2007

Szpilman, Wladyslaw, *The Pianist*, Phoenix, London, England, 2000

Weitz, Eric D., *Weimar Germany – Promise and Tragedy*, Princeton University Press, Princeton, NJ, 2007